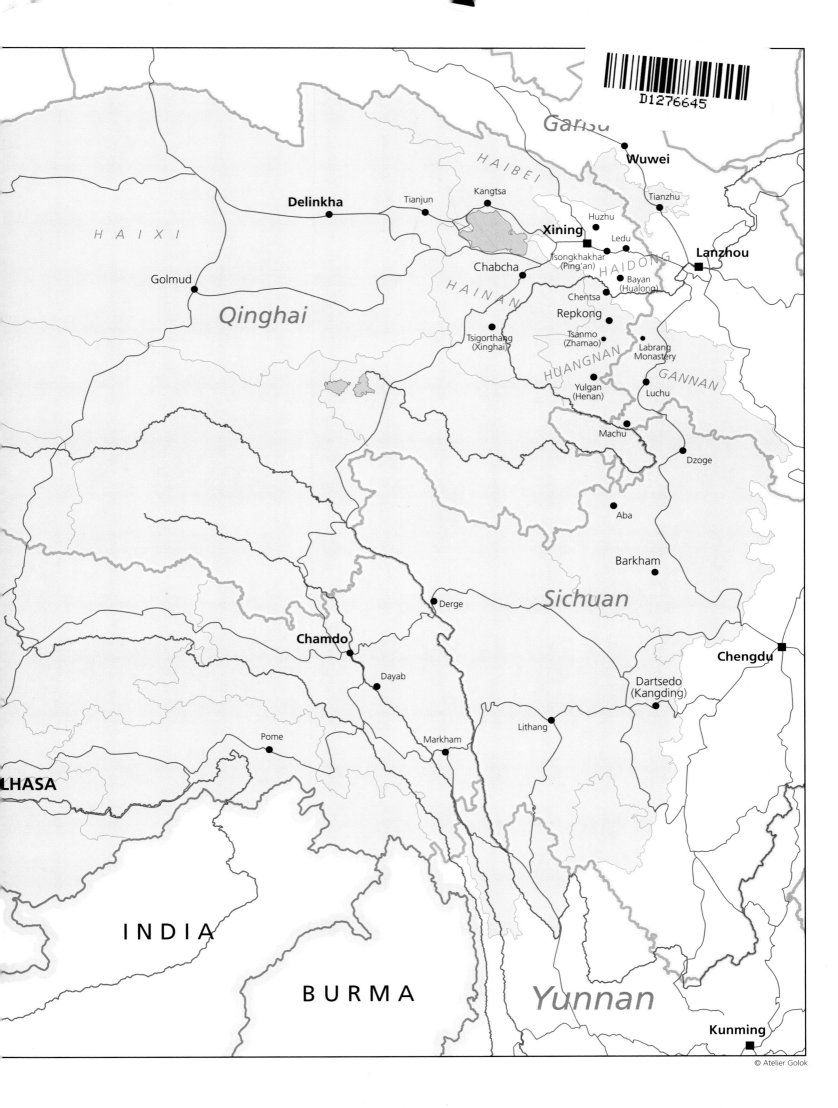

TIBET SINCE 1950

SILENCE

PRISON

OR EXILE

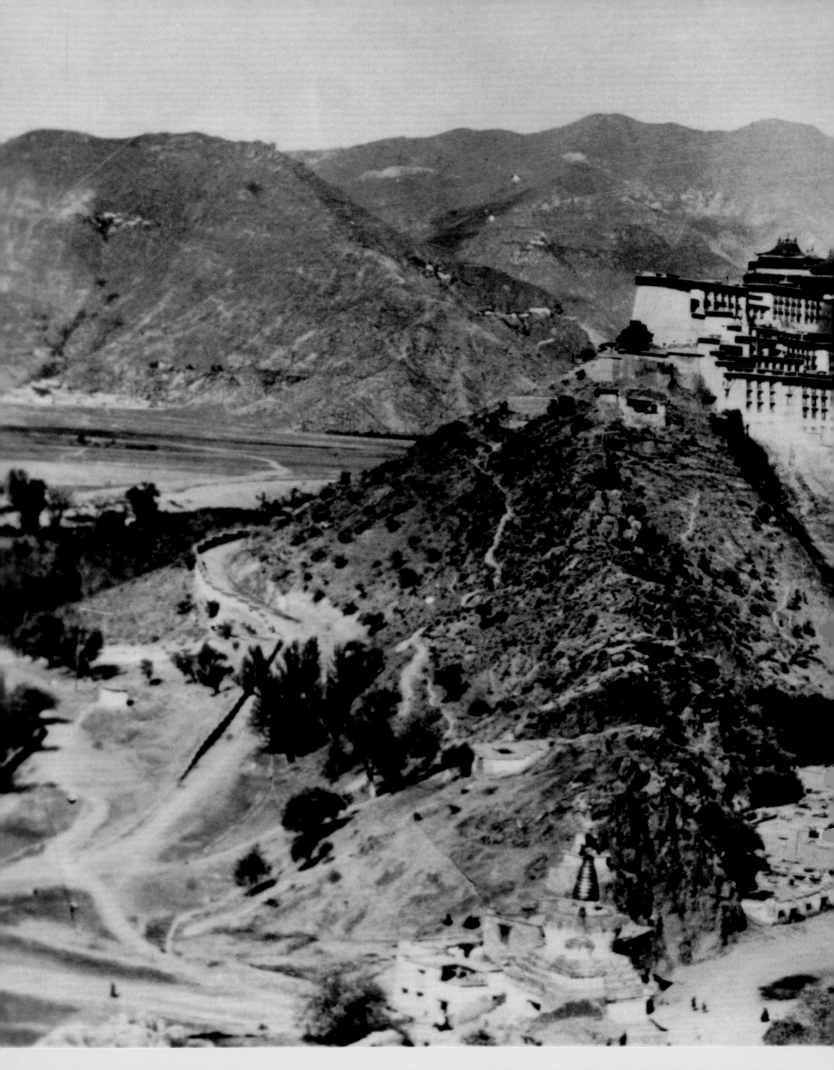

OCTOBER 1, 1949: IN BEIJING, MAO ZEDONG PROCLAIMS

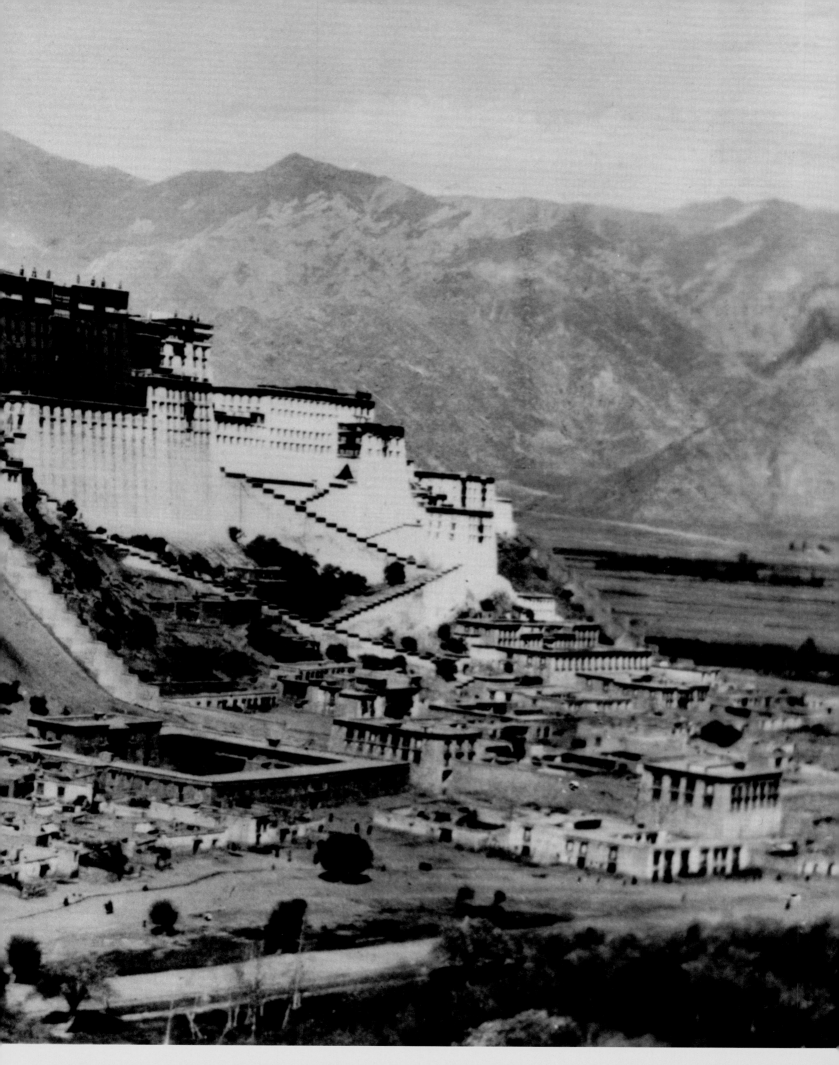

THE ESTABLISHMENT OF THE PEOPLE'S REPUBLIC OF

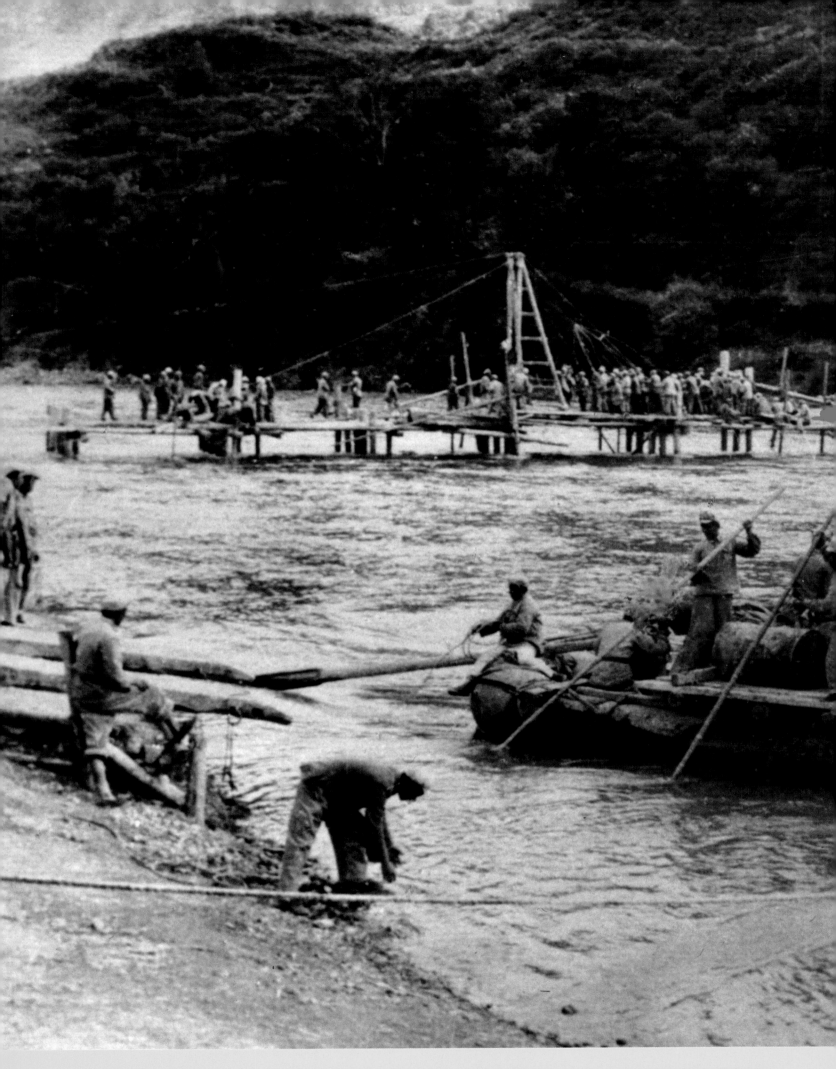

CHINA (PRC). SOON AFTER, THE PEOPLE'S LIBERATION

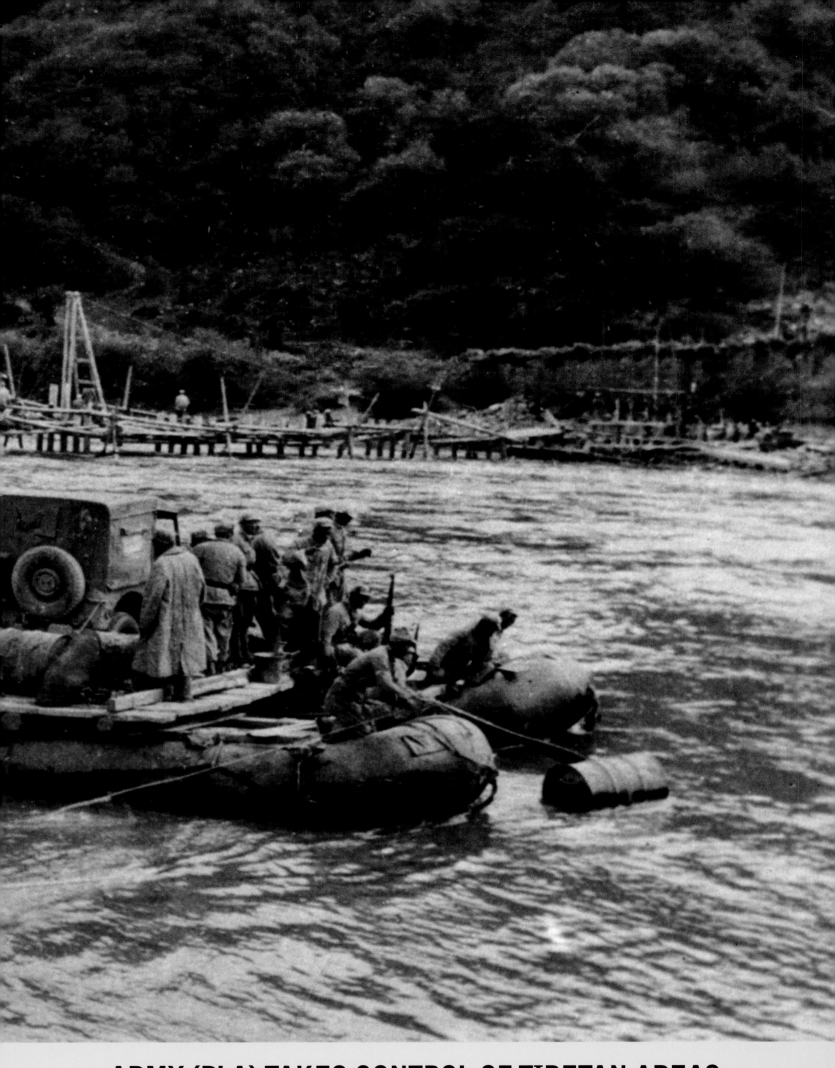

ARMY (PLA) TAKES CONTROL OF TIBETAN AREAS

IN THE EASTERN PARTS OF THE TIBETAN PLATEAU

PREVIOUSLY UNDER CHINESE NATIONALIST

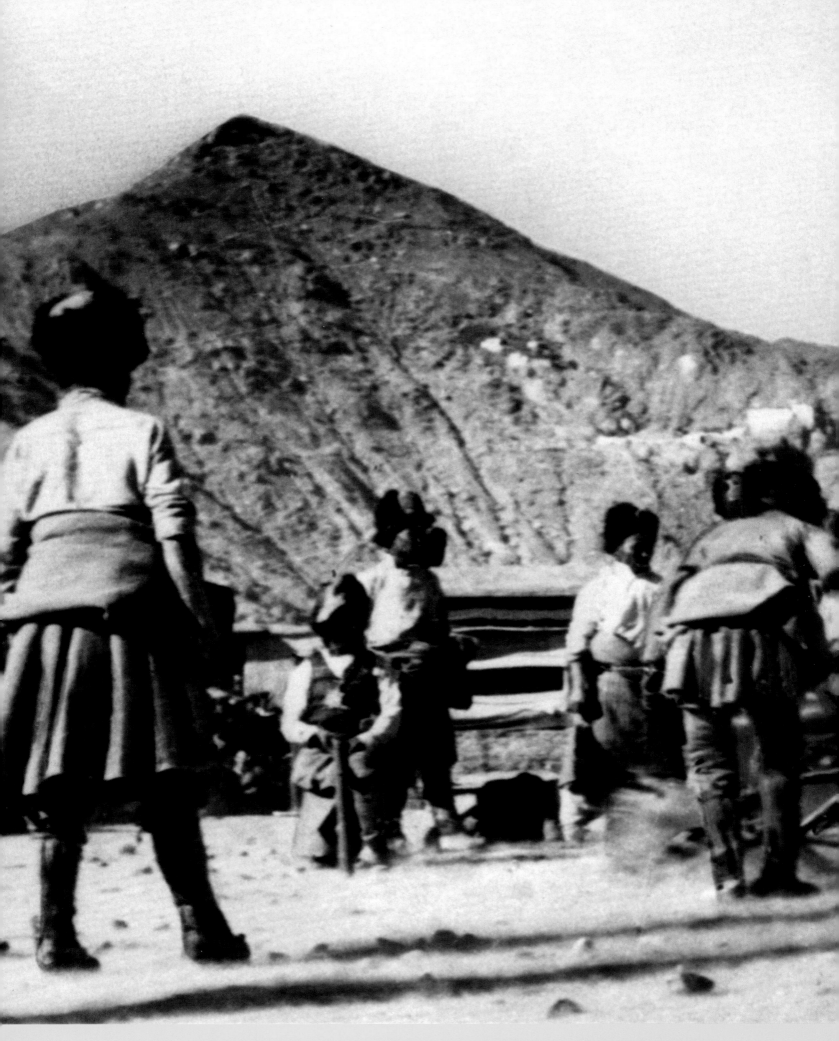

AUTHORITY AND OUTSIDE THE JURISDICTION

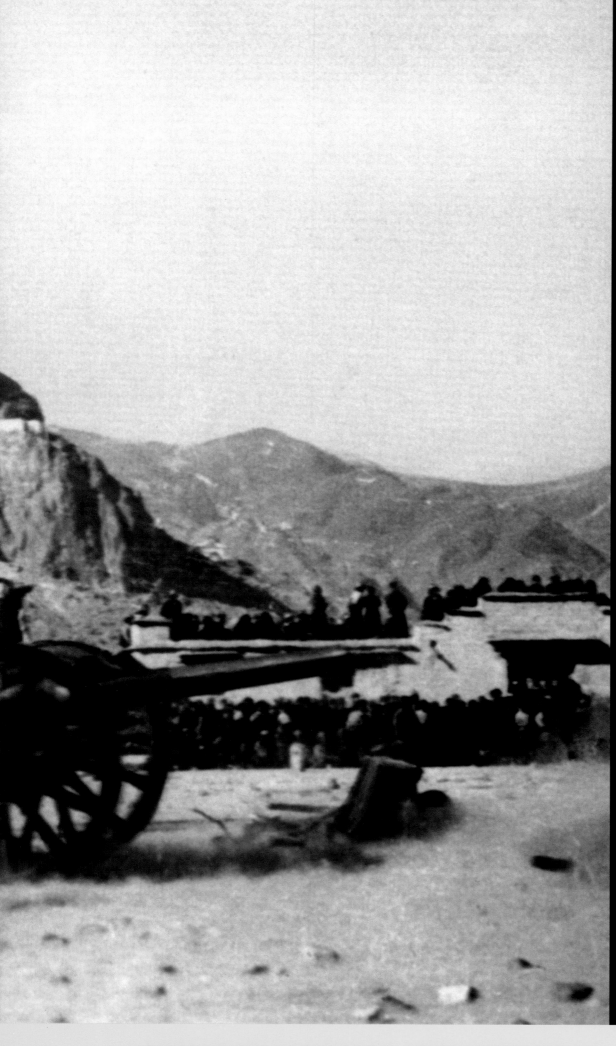

2–3: **Photographer unknown,** pre-1949. The Potala Palace is one of the most imposing edifices in Inner Asia. Over the centuries, the Potala has served as a monastery with three hundred resident monks, a college of statecraft, a treasury, a museum, and the private quarters of the Dalai Lama.

4–5: **Photographer unknown,** December 5, 1950. Invading forces build a bridge across a river in Tibet, while an army vehicle and troops are transported across on rubber rafts.

6–7: **Photographer unknown,** December 5, 1950. Trucks transport soldiers and supplies toward the front lines in Tibet.

8–9: **Photographer unknown,** February 20, 1951. News of the Chinese invasion of Tibet reaches Lhasa, and the Dalai Lama's bodyguard troops of the Tibetan Army fire a twelve-pounder gun—Tibet's largest weapon—during exercises.

OF THE DALAI LAMA. ON JANUARY 1, 1950,

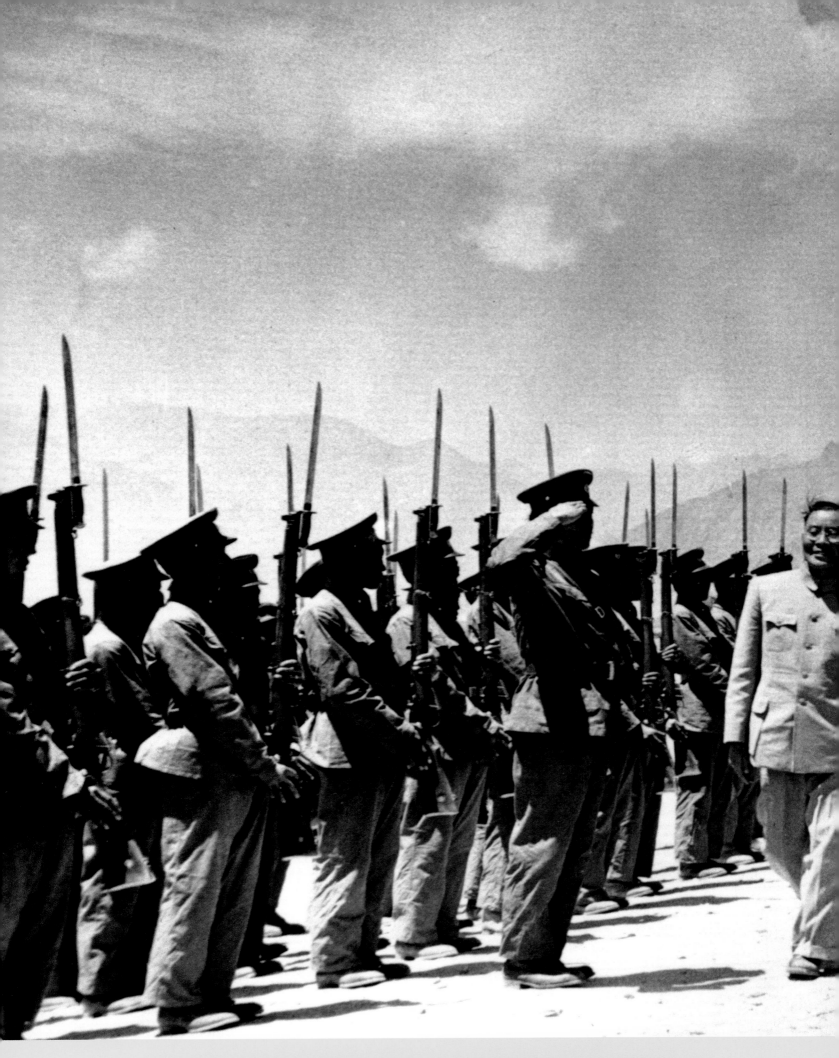

THE CHINESE GOVERNMENT DECREES THE

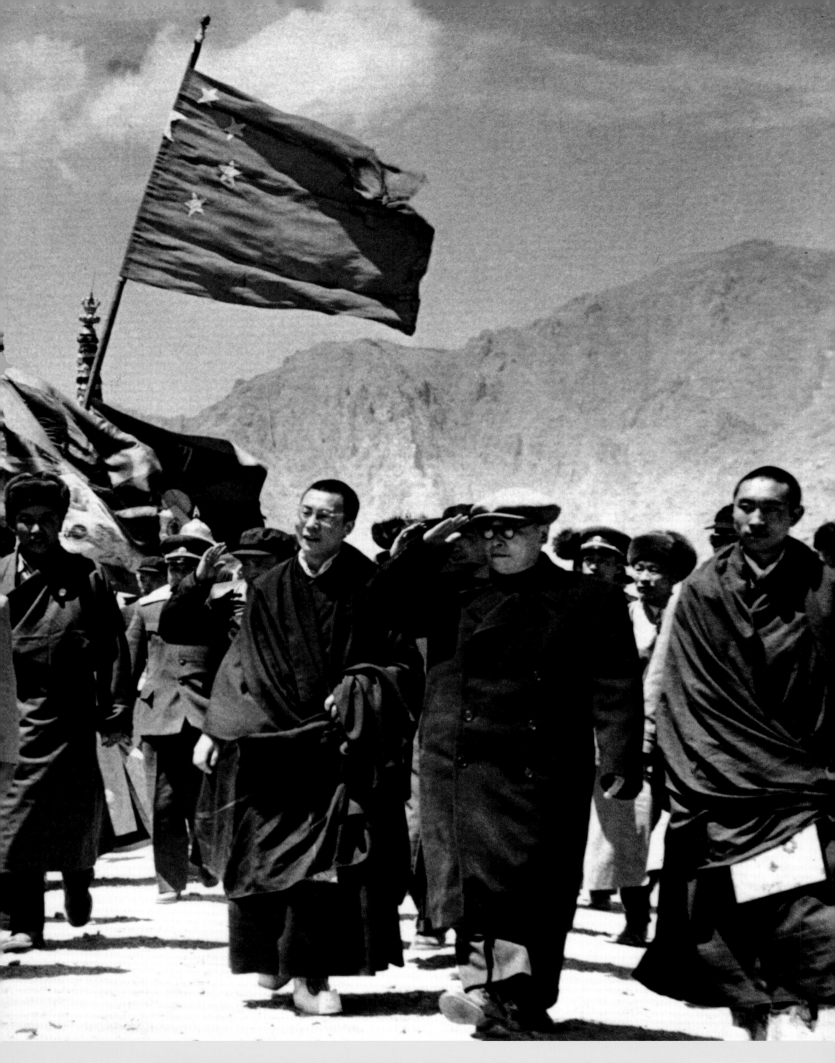

"LIBERATION" OF TIBET TO BE ONE OF ITS

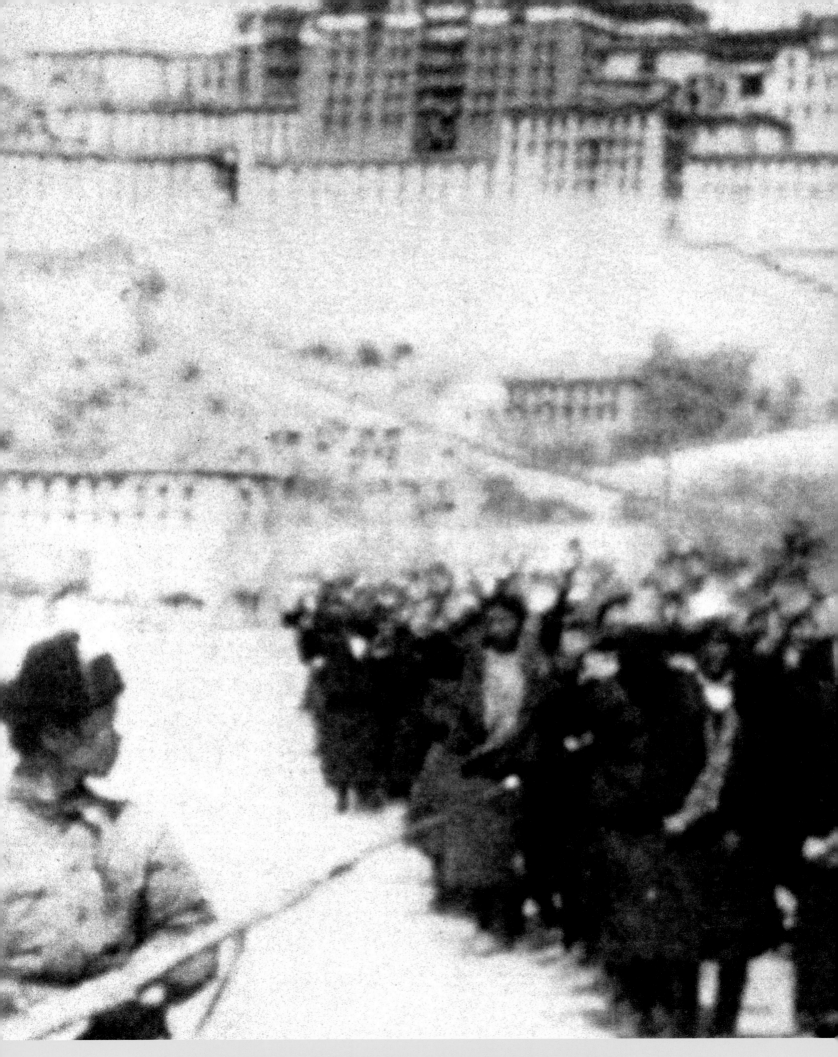

TWO MAJOR REMAINING TASKS. IN OCTOBER 1950,

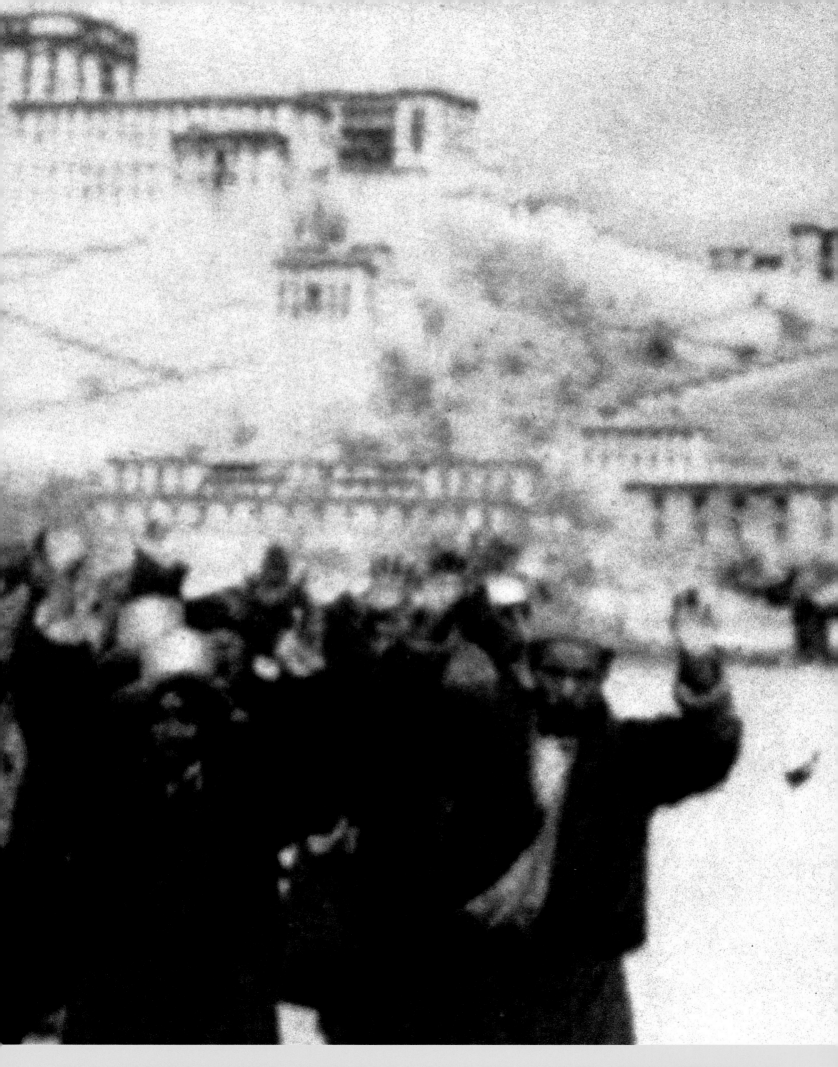

PLA FORCES STORM ACROSS THE DE FACTO FRONTIER OF

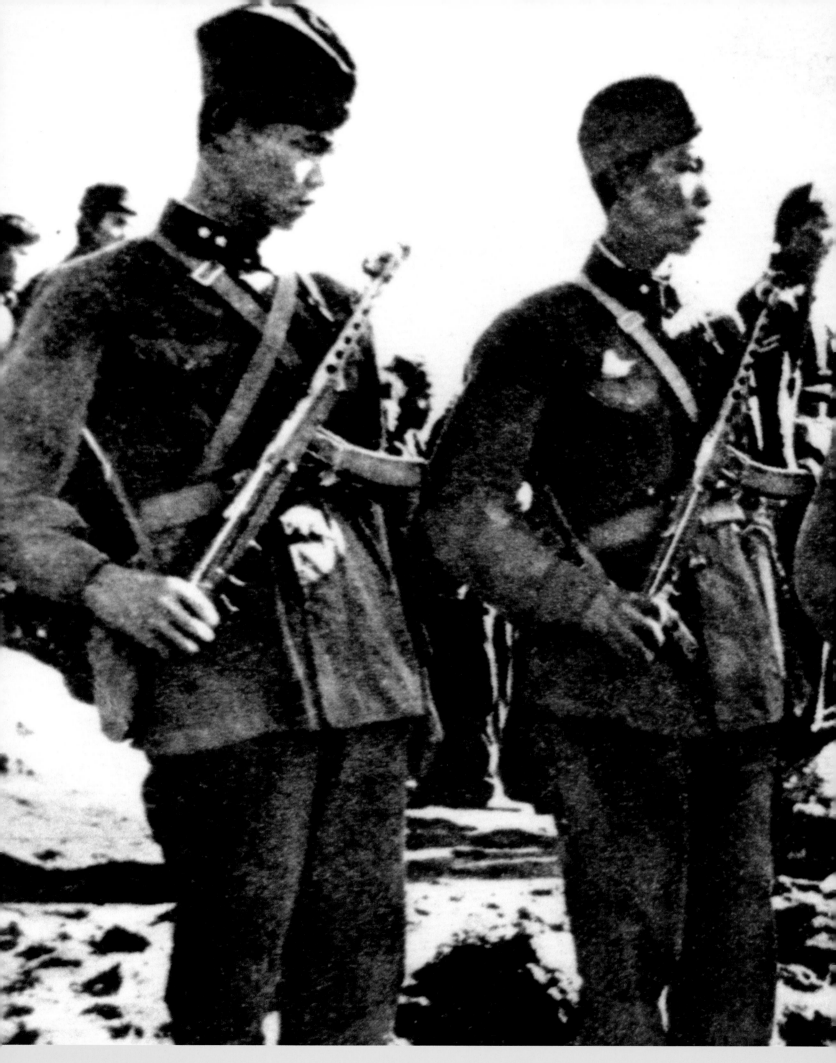

THE DALAI LAMA'S REALM. TIBETAN APPEALS

10–11: Photographer unknown, Lhasa, April 17, 1956. The vice-premier of China, Chen Yi (saluting, second from right), visits Tibet to attend the inauguration of a committee to formally incorporate Tibet into the framework of China. Reviewing local troops with Chen Yi are the Dalai Lama (third from right), spiritual leader and chairman of the committee, and the Panchen Lama (right), the committee's first vice-chairman.

12–13: Photographer unknown, October, 1950. Tibetans surrendering.

Left: Photographer unknown, 1959. On a mountain pass leading from Tibet to India, Chinese soldiers attempt to prevent hundreds of refugees from fleeing.

TO THE UNITED NATIONS FALL ON DEAF EARS.

THROUGHOUT THE 1950s, CHINA FOLLOWS

DUAL POLICIES IN THE TIBETAN AREAS OF

THE PRC. IN 1955, REGIONS PREVIOUSLY

UNDER THE DALAI LAMA'S JURISDICTION

ARE PLACED WITHIN THE PURVIEW OF A

"PREPARATORY COMMITTEE FOR THE

TIBET AUTONOMOUS REGION." TIBETAN

AREAS IN EASTERN TIBET REMAIN

ATTACHED TO THE CHINESE PROVINCES OF

QINGHAI, GANSU, SICHUAN, AND YUNNAN.

THERE, CHINESE-STYLE SOCIAL AND

POLITICAL REFORMS ARE IMPOSED

THROUGH OFTEN BRUTAL CLASS STRUGGLE.

IN CENTRAL TIBET, ESSENTIALLY

COMPRISING THOSE AREAS UNDER THE

DALAI LAMA'S JURISDICTION, THE PRC ALLOWS EXISTING SOCIAL AND POLITICAL STRUCTURES TO REMAIN IN PLACE WHILE INEXORABLY ASSERTING ITS SOVEREIGN AUTHORITY. BY THE EARLY 1950s, TIBETAN RESISTANCE TO CHINESE RULE HAS ALREADY TAKEN ROOT. ARMED RESISTANCE SPREADS FROM THE EASTERN PORTIONS OF THE TIBETAN PLATEAU TO CENTRAL TIBET. A MAJOR UPRISING IN LHASA IS SUPPRESSED IN 1959, LEADING TO THE DEATHS OF TENS OF THOUSANDS OF TIBETAN FIGHTERS, THE IMPRISONMENT OF LARGE NUMBERS OF TIBETANS, AND THE FLIGHT OF MORE THAN 100,000 PEOPLE INTO EXILE.

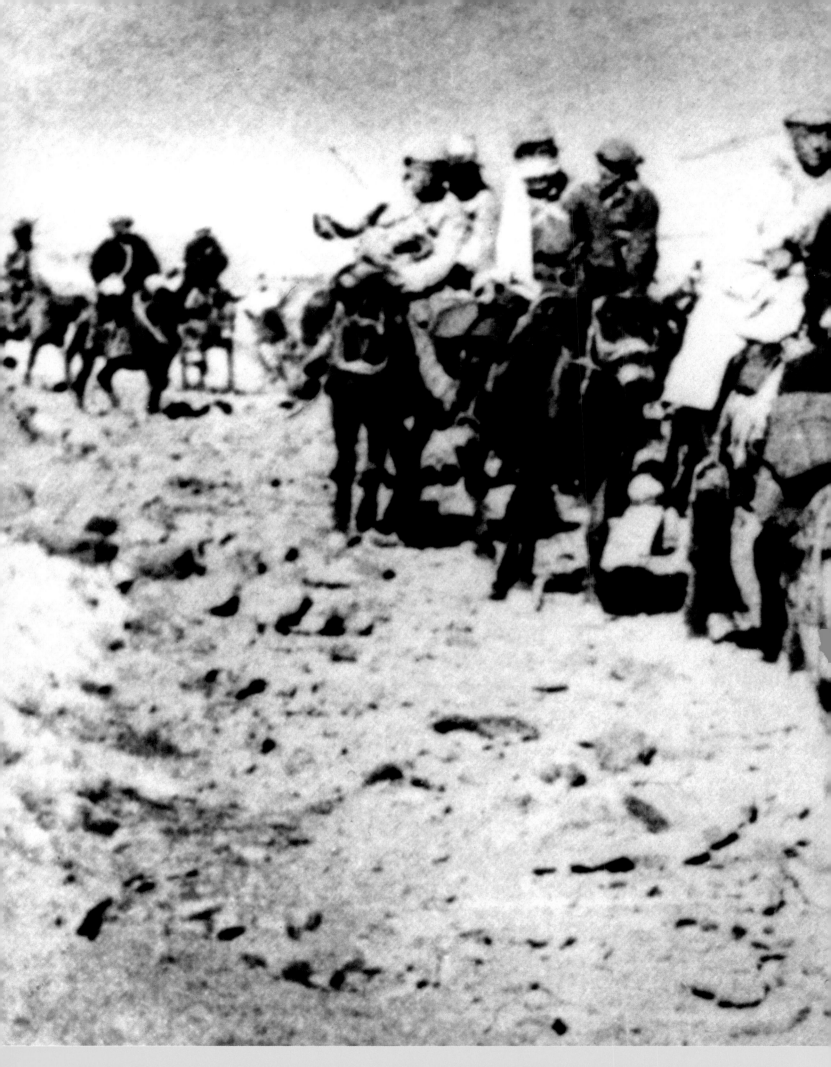

THE DALAI LAMA'S ESCAPE INTO EXILE IN 1959 DRAWS

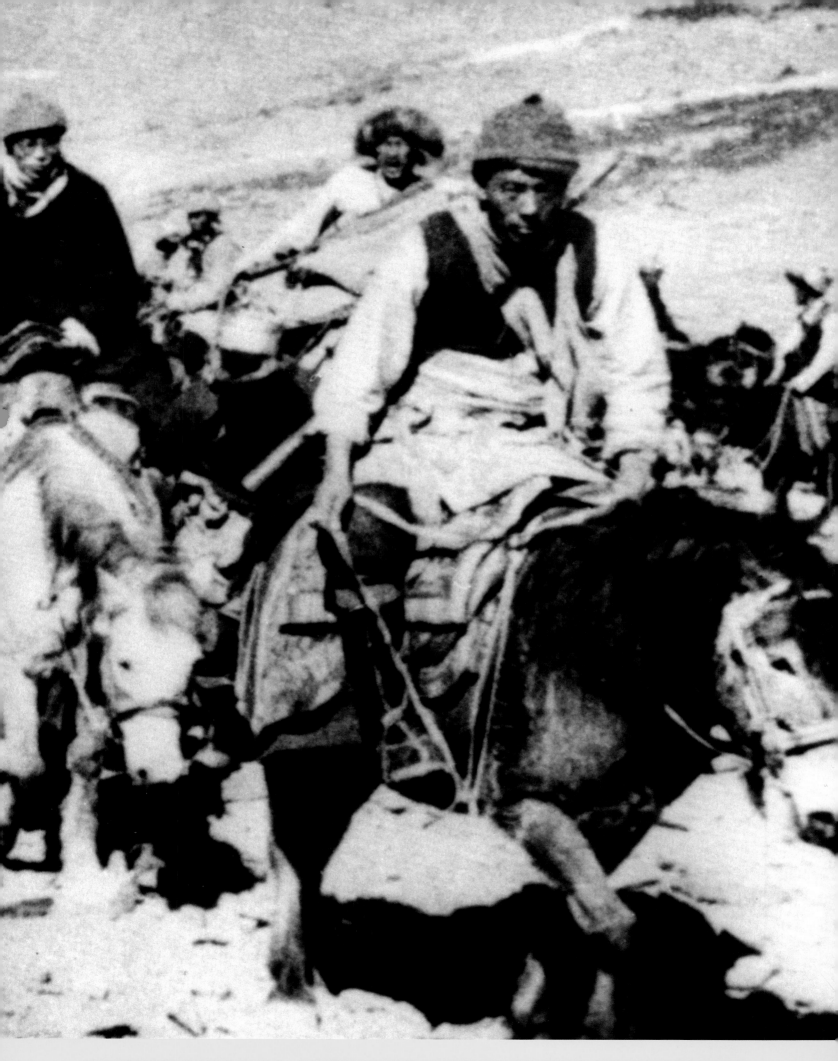

INTERNATIONAL ATTENTION TO THE TRAGIC EVENTS

18–19: Photographer unknown, March 1959. Protected by an entourage, the Dalai Lama leaves Tibet to go into exile in India.

Right: Photographer unknown, Lhasa, April 17, 1959. In front of the Potala Palace, the Dalai Lama's former home, a staff member of the Military Control Committee explains to citizens of Lhasa the State Council's order to end rebellion in Tibet, to dissolve the local Tibetan government, and to restore order.

IN TIBET. IN THE AFTERMATH OF THE DALAI LAMA'S

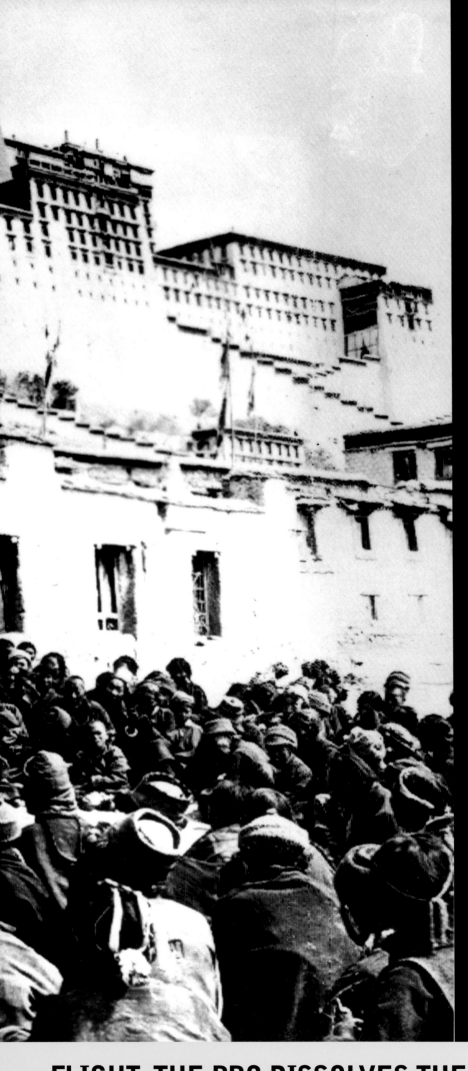

FLIGHT, THE PRC DISSOLVES THE TIBETAN GOVERNMENT.

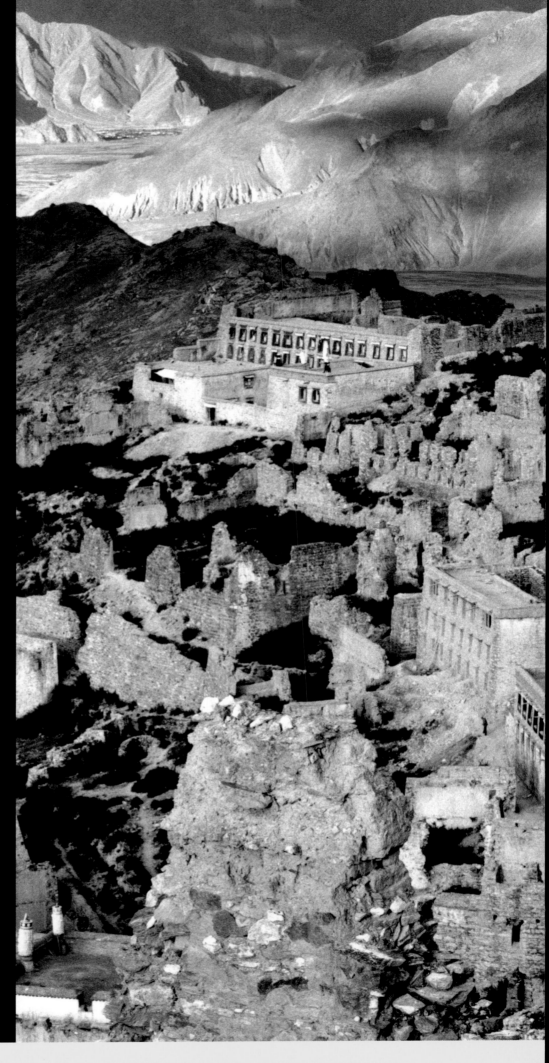

Marcos Prado,
Ruins of Garden Monastery, 1986. Garden, one of the largest monasteries in Tibet, was bombed by Chinese airplanes in 1959. Only three hundred of the four thousand monks living there survived the attack. Portions of Garden have been restored to active use.

THE DESTRUCTION, VIOLENCE, AND SOCIAL

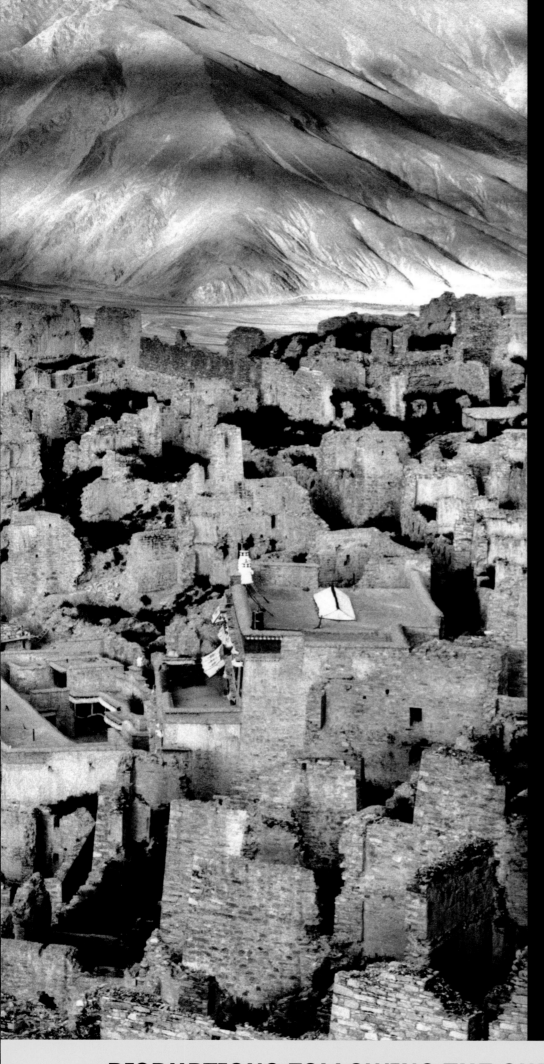

DISRUPTIONS FOLLOWING THE SUPPRESSION OF

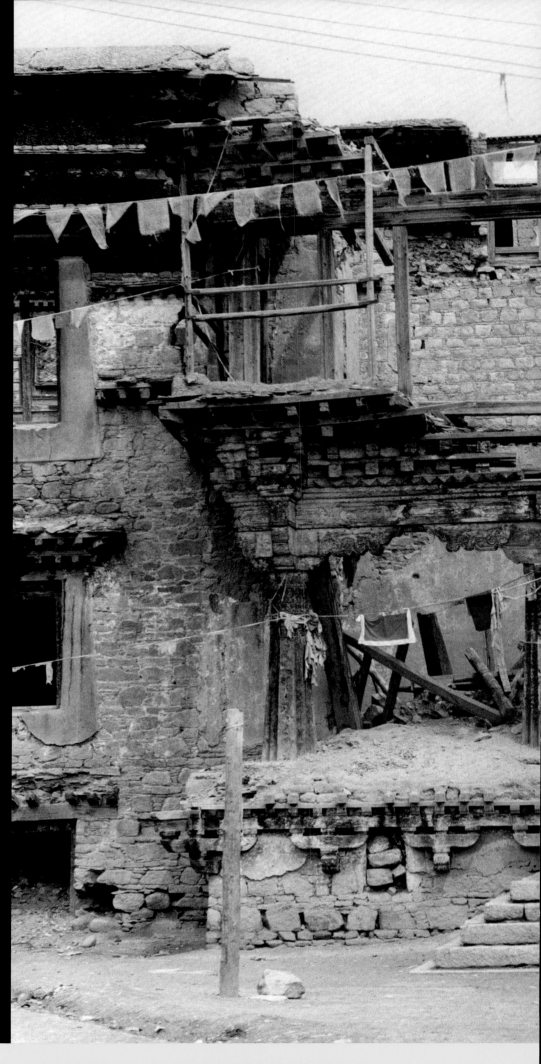

Right: Marcos Prado,
Lhasa, 1993. Of the more than six thousand monasteries and temples in Tibet, only twelve were left untouched by the Cultural Revolution.

26–27: John Ackerly,
Lhasa, May 1997. Founded in the ninth century, Shide Monastery was one of the six principal monasteries surrounding the Jokhang Temple in downtown Lhasa. It was never rebuilt after its destruction.

TIBETAN RESISTANCE IN 1959 RECUR DURING

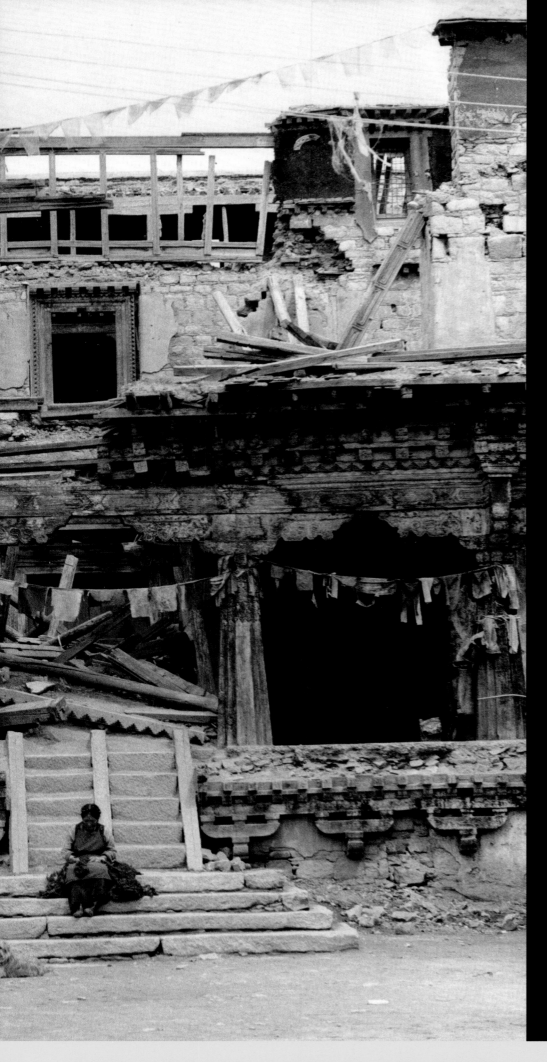

THE CULTURAL REVOLUTION (1966–1976). IT HAS BEEN

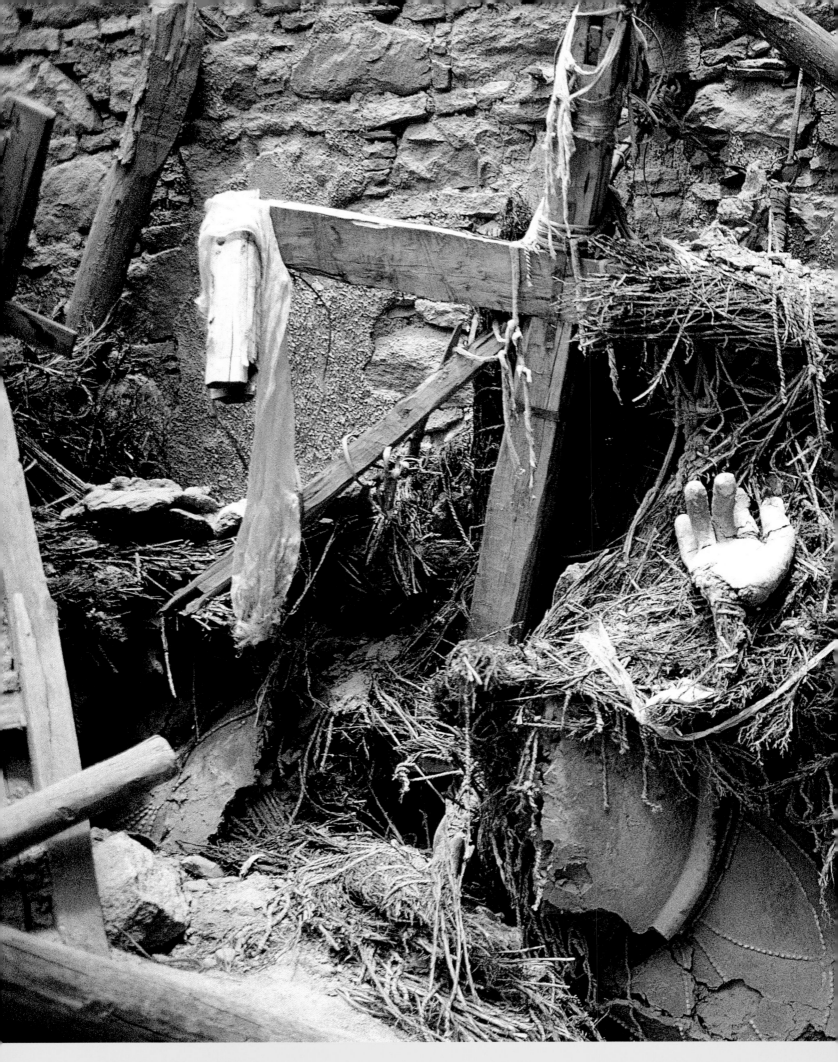

ESTIMATED THAT BY 1976, ALMOST ALL OF TIBET'S

TEMPLES AND MONASTERIES WERE DESTROYED.

Editors' Note:
For the sake of clarity,
Chinese terms and names
appear in standardized
Pinyan romanization.
Tibetan words are
phoneticized to make
pronounciation easier for
English-speaking readers.

TIBET SINCE 1950

SILENCE

PRISON

OR EXILE

PHOTOGRAPHERS INCLUDE:
Jeffrey Aaronson, John Ackerly, Diane Barker, Kevin Bubriski,
Kathryn Culley, Ian Cumming, Carl de Keyzer, Raphaele Demandre,
Guy Dinmore, Stuart Franklin, Richard Gere, Alberto Giuliani,
Catherine Henriette, Lynn Johnson, Russell Johnson,
Steven Marshall, Marcos Prado, Matthieu Ricard, Galen Rowell,
Michael Springer, and Franz Stich

INTRODUCTION BY ELLIOT SPERLING
ESSAYS BY ORVILLE SCHELL AND STEVEN MARSHALL
EXILE ACCOUNTS BY MICKEY SPIEGEL

EDITED BY MELISSA HARRIS AND SIDNEY JONES

APERTURE
·
HUMAN
RIGHTS
WATCH

EXILE AND DISSENT

The Historical and Cultural Context

ELLIOT SPERLING

Four decades after a failed uprising against Chinese rule and almost five decades since Tibet's incorporation into the People's Republic of China, no single story encapsulates the experience of exile from Tibet—certainly not as it is experienced by Tibetans today. To speak with a range of Tibetans who have come out of Tibet in the late 1990s is to be firmly jolted from the common image of the Tibetan escapee as neither more nor less than a devout Buddhist seeking simple religious freedom and the possibility of seeing the Dalai Lama. This introduction will touch on some of what makes exile from Tibet more complex than is often perceived: the history of Tibet, and its role within the intellectual and nationalist struggle over Tibet's identity; the place within this history of "eastern Tibet" (the area of the Tibetan plateau that has been home to most Tibetans for centuries, but that lies outside the borders of the modern Tibet Autonomous Region); the new cultural milieu of the dissent that often precipitates exile; and the dissonance that develops when the images and expectations of dissidents encounter the reality of exile in India.

There are exiles, of course, whose situation and history might well fit the plain description of the refugee in search of religious liberty. But for many, if not most, flight across Tibet's borders into Nepal and India is a much more complicated experience, and the images and accounts of exile contained in this volume reflect this fact. Religious feeling and sentiment is present; this is undeniable. But there is much more here that can bring to light a little bit of the complexity of life in Tibet that often goes unremarked in much of what is written about it. In essence, the issue of exile from Tibet cannot be characterized solely in terms of religious liberty, nor by the formula of "cultural preservation" that has gained currency in recent years. Exile for many is undoubtedly linked to nationalism, and this in turn is often expressed by Tibetans, both within the Tibet Autonomous Region and in the areas of eastern Tibet, who have benefited from real opportunities for education and intellectual activity—Tibetans who are acting within a Tibetan cultural milieu and with definite perceptions of their history as Tibetans.

Tibetan intellectual life, expressed in a distinctly secular manner, cannot be ignored. Across the Tibetan plateau a significant number of cultural and literary journals are published, some in rather out-of-the-way places. Yet balanced against this is the fact that educational and cultural opportunities still remain inaccessible to large numbers of Tibetans. And even more sobering is the undeniable evidence that when intellectual activity develops into serious dissent from Chinese policy on Tibet, particularly as it concerns China's historical rights to Tibet, the state does not hesitate to visit severe repression on dissidents. Freedom of expression is not extended to those who can in any way be construed as acting to "split" China. Imprisonment and torture are commonly used against Tibetans who take active nationalist positions, whether in secular or religious settings. This aspect of intellectual life in Tibet also cannot be ignored.

• • • •

The historical argument largely underlies Tibetan nationalism, and nationalism in turn becomes the basis for proscribed dissent in Tibet (and thus a major reason for exile). As a result, the question of Tibet's history is a critical focus of strife between Tibetan dissidents

Opposite: Raphaele Demandre, Kathmandu, January 1997. While journeying to Nepal, a group of twenty-one escapees from Tibet were caught in an unexpected snowfall. Several of the men froze to death in the night, and two children died as the group continued their journey. This refugee's frostbitten feet were amputated at the hospital in Kathmandu.

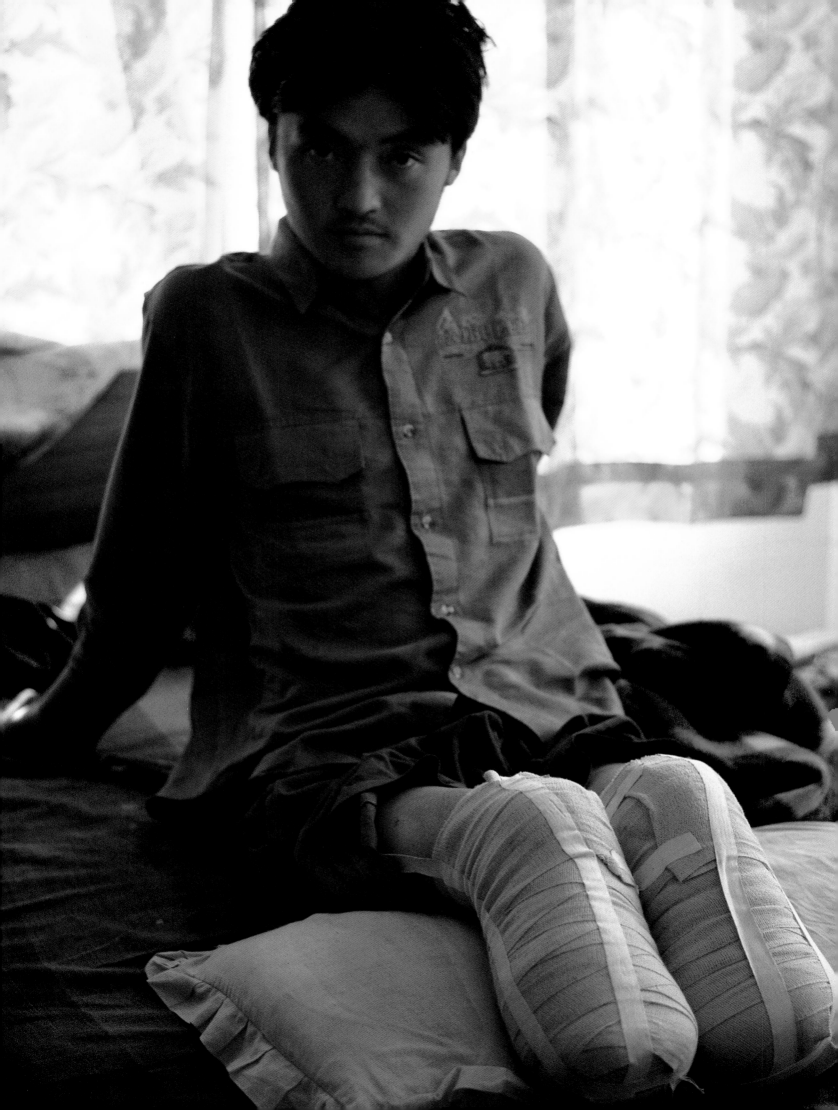

and the government that rules them. One can easily conclude that China's insistence on its historical right to sovereignty over Tibet has itself inspired a Tibetan impetus to contest the issue on that same field. We can find many examples of Chinese rhetoric on the subject—echoes of the common theme that Tibet, as everyone knows, has been an integral part of China since the thirteenth century. Against this sweeping statement, Tibetan dissidents have been arguing that history actually shows Tibet to be an independent state. And in fact, viewed from beyond the confines of the polemical struggle over Tibet's past, the briefest outline of Tibetan history clearly shows that the considerable contact between Tibet and China that has ensued for well over a millennium does not obscure the distinct path Tibet has taken quite independently of China. Indeed, a strong case can be made that prior to 1951, Tibet was at best one part of the empires built by the Mongol and later Manchu emperors who conquered China, but never an "integral" part of China itself.

The earliest substantive body of information on Tibet dates from Tibet's imperial period, the era during which the country became a serious international power. From the mid-seventh to the mid-ninth centuries the Tibetan empire was one of the great powers of the Eurasian landmass, extending beyond the Tibetan plateau into Inner Asia, controlling the silk road centers north of Tibet in what is today Xinjiang for long periods, and, along the Chinese border, absorbing into its domains large swaths of what were once Chinese territories. During this period, too, Buddhism developed into a substantive part of Tibetan society and Tibet's spiritual, political, and cultural life.

The collapse of the Tibetan empire in the mid-ninth century left the Tibetan plateau without a single unifying regime. Power fragmented quickly, and there arose a number of Tibetan principalities in different parts of the plateau. At times, some of these small states played significant international roles in a shifting political and economic climate that found China beset by strong foreign forces and states to its north and conquest dynasties established in part on its territories. During this period of fragmentation, the transmission of Buddhism from India to Tibet continued, giving rise to broader developments of the faith as it grew within Tibet. Clear sectarian divisions appeared, signs not of degeneration and breakdown, but of vibrant, intense spiritual and intellectual engagement with the tenets coming into the country. With the decline of Buddhism in India, Tibetan Buddhism came to be seen as the preeminent esoteric vehicle for empowerment. And with that came the beginnings of Tibetan Buddhism's involvement with political power in the wider world beyond the plateau.

First in the realm of the Tanguts—a people whose state was to be so utterly destroyed by the Mongols in 1227 that the reconstruction of its history and language remains an ongoing enterprise at the end of the millennium—Tibetan lamas became the spiritual instructors to the emperors at the end of the twelfth and the beginning of the thirteenth centuries. With the appearance of the Mongols, lamas began to fulfill a similar function at the courts of several Mongol Khans. In an age of faith, this did not mean simply imparting aphoristic homilies or bare articles of faith: it meant intimate, esoteric religious initiations that would, within the Buddhist worldview, empower the ruler in the mundane world to serve the dharma. As such, Tibetan Buddhism took on a distinct role in the realms of political and religious power, well beyond Tibet's borders. It is this phenomenon that lies behind Marco Polo's descriptions of the marvels that Tibetan lamas were able to work at the court of Khubilai Khan. They were held to be, quite simply, in possession of supramundane powers.

The imperial fascination with Tibetan Buddhism can be seen not only in the Mongol Yuan Dynasty (1271–1368) but also in the Chinese Ming Dynasty (1368–1644) and the Manchu Qing Dynasty (1644–1911). As a result, some have described the nature of Tibet's relationship with China as uniquely religious, circumscribing it within the bounds of Buddhist roles and characterizing it as a "priest-patron" relationship between a lama and a ruler. However, this cannot obscure the fact that there were indeed political links binding Tibet to the Mongol and Manchu rulers of China resulting from the actual incorporation of Tibet into the Mongol Empire in the thirteenth century and its absorption into the Qing realms in the eighteenth.

Both Tibetan and Chinese pre-modern sources testify to the reality of Tibet's subordination. But this domination leaves much space for arguing, as many do, that being part of the Qing Empire—which collapsed only in 1911 and is thus a significant factor in perceptions of Tibet's status in the twentieth century—was in no way equivalent to being an "integral part of China," the preferred formulation for Tibet's status in modern Chinese polemics. Indeed, Mongolia, which was in many ways far more closely bound to the Qing state and to Qing structures, emerged from the Qing collapse as an independent state, which it remains today, recognized as such by China.

After 1911, too, the Dalai Lama's government, which had governed Tibet since the mid-seventeenth century, ruled independently in the area under its jurisdiction. But the large areas in the eastern portion of the Tibetan plateau, which the Qing had placed outside the purview of the Tibetan government in the early eighteenth century, fell under the sometimes anarchic rule of officials and warlords of the Republic of China and were attached to or converted into Chinese provinces. This division remains a particularly sore spot: Tibetans remain attached to "the eastern areas" as part of Tibet, while China considers only the modern Tibet Autonomous Region (essentially the area that had been ruled by the Dalai Lama's government since the eighteenth century) to be Tibet.

In October 1950, following the victory of Chinese Communist forces over the Nationalist government and the establishment of the People's Republic of China (PRC) one year earlier, the Chinese army crossed into Tibetan government–controlled territory. Routing the small Tibetan forces there, they left the Tibetan government with little choice but to accede to terms for the "peaceful liberation" of Tibet. The situation that followed was very much affected by the cleavage between central Tibet, under the Dalai Lama, and "eastern Tibet," under Chinese provincial rule. The region ruled by the Dalai Lama was shielded by the terms of the "peaceful liberation" agreement from the harsh methods of imposed class struggle and land reform implemented in the east. Economic and social structures viewed by cadres elsewhere in the PRC as feudal and backward remained largely untouched in the Dalai Lama's realm. At the same time, the application of policies derived from conditions in China proper (where land ownership in the midst of tremendous population density was in great measure inherently exploitative) to "eastern Tibet" (where the fact of sparse population strongly mitigated the situation) had an effect wholly opposite to what the Chinese government had hoped for. Rather than fostering class solidarity that would link Tibetan peasants and herders to the Chinese peasantry, it fostered allegiances between socially and geographically distinct Tibetan groups that all faced harsh measures introduced from China. And this in turn focused attention on the divide between Tibetan populations in the east and in central Tibet.

During the 1950s a revolt against Chinese policies developed in the east, inevitably spilling over into central Tibet and erupting in Lhasa in 1959. Clearly, this uprising would

not have occurred or taken the direction it did had Tibetans from the eastern portions of the plateau not considered themselves Tibetan. One might add that both the Dalai Lama and the then Panchen Lama were drawn from the eastern regions—the Dalai Lama himself coming from an area and a family that were not Tibetan-speaking.

In the wake of the Lhasa uprising, the Dalai Lama's government was abolished and central Tibet ceased to enjoy the protections it had previously had against many of the harsh policies implemented in "eastern Tibet." The Dalai Lama and tens of thousands of Tibetans went into exile in India, beginning a new phase in the confrontation between Tibet and China. While armed Tibetan resistance was carried on at a much reduced and sporadic level into the early 1970s, the polemical struggle over Tibet's history took on greater emphasis in both the internationalization of Tibet's case and in the shaping of fixed views. The Chinese government studiously ignored the difference between historical influence and sovereignty, as well as the implications of Tibet's place as an imperial possession of Manchu and Mongol rulers, rather than as an "integral" part of China. For their part, Tibetan exiles highlighted facts that supported their case (e.g., the thirteenth Dalai Lama's proclamation of Tibetan independence in 1913), while those that damaged it (e.g., the Tibetan government agreeing to have its representatives in China in the 1930s and 1940s paid by the Chinese government, essentially making them Chinese officials) were suppressed. The received truths of Tibet's history shaped within the Tibetan exile community have filtered back into Tibet. Positions on the historical status of Tibet from inside Tibet generally make use of the same facts as those voiced in exile.

• • • •

In this environment, the position of "eastern Tibet"—the regions placed outside the jurisdiction of the Dalai Lama's government in the early eighteenth century, which are today outside the boundaries of the Tibet Autonomous Region—has taken on particular significance, so much so that the exile account of when China launched its initial attack on Tibet has had to be altered to accommodate the incorporation of "eastern Tibet" within Tibetan territory.

Of course, when those territories were transferred from Guomindang provincial domination to rule by the PRC in 1949, the Tibetan government in Lhasa sounded no alarms and sent out no appeals. That only occurred in October 1950, when the Chinese army crossed into the area actually ruled by the Tibetan government. In fact, for years afterwards the exile government dated the Chinese attack to 1950, only later altering its position on when it happened. There was effectively no Tibetan government rule over most of "eastern Tibet" for more than two centuries before 1949. But Qing and Nationalist Chinese rule there was often light, and for most of its duration the identity of the local populations as "Tibetans" was not an issue. As noted above, much that has happened in Tibet in the twentieth century would not have transpired had the people in these regions not considered themselves Tibetan. In short, "eastern Tibet," though standing outside the geographical limits of Tibetan government control and the borders of the modern Tibet Autonomous Region, has played a large and crucial role in much of Tibet's modern history. It cannot be written out of that history.

These regions have had their own distinctive identities and fates since the fall of the Tibetan empire. Indeed, from the debris of that collapse, Tibetan states emerged in the northeast that played a significant role in international affairs in the period before the rise of the Mongols in the thirteenth century, sustaining vital trade routes and supplying

horses to trading partners in China. Though subsumed into the Mongol Empire, "eastern Tibet" became by the fourteenth century economically important as contact with India decreased with the demise of Buddhism there. As a result, Tibet's eastern border, the Sino-Tibetan frontier, took on greater economic and demographic significance. From around the thirteenth century the burgeoning trade in Chinese tea for Tibetan horses received renewed impetus. These developments most likely precipitated a demographic change felt even today: up to the end of the twentieth century, the majority of the Tibetan population has lived in the eastern portions of the Tibetan plateau.

For centuries "eastern Tibet," with its mix of effectively independent petty states, large and small monasteries, towns, and nomad groups, has been quite distinct, socially, politically, and linguistically, from central Tibet. At the same time it has had to deal much more intimately with China along the traditional Sino-Tibetan frontier. Over the centuries, local Tibetan rulers in various places along that border have often found themselves dependent upon dynastic China, with titles and duties that bound them to the Chinese state. At the same time, the nature of these bonds has ultimately been quite feeble. This was evident in the last years of the Qing Dynasty. During the 1950s, when the PRC tried to assert its own norms of class struggle over the area, eastern Tibet became ground zero for the outbreak of armed Tibetan resistance to China.

Today eastern Tibet is firmly under Chinese provincial administration. However, it is organized within Tibetan or semi-Tibetan autonomous units, and remains very much a center of Tibetan cultural activity. Particularly in the area known as Amdo, which has long been famous for the many scholars and cultural figures who have sprung from its soil, serious modern cultural and literary activity continues. To some this might seem an odd statement, given the charges of "cultural genocide" in Tibet that are common in exile circles and in the West. But the cultural activity taking place all over the Tibetan plateau cannot be ignored, even though it takes place against a background of harsh political repression directed at expressions of separatist sentiment, and with a growing, deleterious Chinese presence in many Tibetan areas.

· · · ·

The severe repression of previous decades eased considerably in the late 1970s, and by the early 1980s it was clear that Chinese policies in Tibet had changed drastically—as they had throughout the PRC. Education, using Tibetan as the language of instruction, at least in fields such as Tibetan language and literature, started to receive greater emphasis than in previous years (though this has assuredly not been the case in fields such as the modern sciences). Traditional scholars began to teach again—some of them within the setting of higher education and research institutions—and monasteries that had been shut or destroyed began to function again.

These developments are offset by the migration of Chinese people into Tibetan areas. This influx has had—and continues to have—a marginalizing effect on the role of the Tibetan language, not to mention its effect on Tibetan economic aspirations and expectations or its role in diluting the Tibetan character of such crucial hubs as Lhasa. Nevertheless, Tibetan publications continue to circulate and grow in numbers. This is in part due to the development of secular educational and cultural institutions accessible to Tibetans within the PRC—though it should be noted that access to education for large numbers of Tibetans

is still limited, and most of the higher education opportunities for Tibetans involve study outside the Tibetan areas of the PRC. Still, this is something unprecedented in Tibet and has brought about the growth of what for Tibetans are new literary forms. Modern novels and short stories are being written by a new breed of Tibetan literati, born and raised under PRC rule, while essays and research articles on a wide variety of subjects find homes in the increasing number of new Tibetan-language journals and magazines.

This cultural activity demands to be noticed. All too often people outside Tibet equate Tibetan culture largely with clerical and monastic life, or with what might be termed folk culture. In Tibet today this is no longer tenable. It is this petrified view, though, that seems to lurk behind many of the calls for the preservation of Tibetan culture as the goal of both the Dalai Lama's government and foreign diplomatic moves. Tibetan culture, like any other, is dynamic. Calling for its "preservation" automatically brings forth the need for it to be defined, which in turn evokes a stuffed-and-mounted item fit for a museum. Tibetan culture does not need to be frozen in time, but Tibetan cultural life needs to be protected from measures that repress literary and artistic expression. In Tibet today secular writers and artists, working with modern forms, are every bit a part of the Tibetan cultural scene.

The contours of dissent in Tibet and its repression by China are not shaped by calls for cultural preservation or cultural autonomy, but by calls for Tibetan independence. In fact, within certain limits the PRC does make efforts to accommodate Tibetan cultural expression. But when perceptions of separatism (which Chinese documents have termed "splittism") are brought into play, repression is harsh indeed. Thus, while the government has allowed Tibetans leeway in various areas of religious practice, there is no space for any move perceived to undermine the state's authority. When the government puts monasteries under surveillance, tries to limit the numbers of monks and nuns, and conducts "patriotic education" campaigns, it is trying not so much to interfere in religious practice or doctrinal issues, but to prevent any effort to undermine the state's position as the ultimate controlling power over religion. A key aim of the ongoing repression in Tibet is to purge Tibetan religious life of the authority of the Dalai Lama, who continues to symbolize an alternate authority to the Chinese government.

. . . .

For Tibetans involved in nationalist activities, exile often does become the sole option. But here, too, popular notions tend to diverge from the reality of exile. For many Tibetans who do reach India, exile is not, in fact, a final decision. A number of those who leave Tibet for non-political reasons do indeed go back to Tibet, even if they left Tibet illegally. This is more common now than one might imagine, since changes in India's regulations governing the entry of Tibetans into India no longer guarantee residency for them. Not all who leave Tibet do so for political reasons; some want simply to have an audience with the Dalai Lama or to bring children into the exile Tibetan school system. Others come for economic reasons, although they may well blame the Chinese government for their economic circumstances. Some manage to travel to India several times, even though the border

crossing from Tibet must be done surreptitiously and at great risk. Again, such facts underline the nuanced way in which the situation in Tibet must be understood. It is not one of absolute despair and oppression for all around. But for those believed to have crossed the line into active and overt nationalism, whether centered around simple allegiance to the Dalai Lama and the child recognized by him as the Panchen Lama, or the assertion of Tibet's historical right to independence, the weight of oppression can be heavy indeed. As is obvious from some of the narratives in this volume, under these circumstances flight from Tibet looms as the only viable alternative.

The risks taken by political exiles are by nature greater than those taken by others. Capture, particularly when one is already wanted, can lead to horrendous consequences. But once in exile different anxieties can come to the fore. Some are particular to the very state of exile and not unique to the Tibetan community, though they have their own distinctive manifestations within it. It is not unusual to find a sense of letdown setting in for exiles after some time. There are a number of circumstances in which this happens: some find the educational qualifications they acquired in Tibet insufficient to guarantee a reasonable job in the crowded job market of the exile community; some don't have an adequate knowledge of English; some find their intellectual capabilities and accomplishments underappreciated or ignored in exile.

These sentiments are exacerbated by other aspects of Tibetan life in exile. Those who struggled and suffered for Tibetan independence inside Tibet are certainly aware of the irony of the repudiation of independence as a goal by both the Dalai Lama and the Tibetan government-in-exile. The corruption and nepotism at high levels in the exile government have given many pause for reflection about the gap between what they were trying to do in Tibet and the often unsavory aspects of Tibetan exile politics.

• • • •

And so we return to the original point: that the experience of exile among Tibetans is more complex than often presented. Dissent in Tibet and the exile it causes grow out of an environment that includes new cultural developments, specific views of Tibet's history, and a definite sense of nationalism. The accounts and images compiled in this volume illustrate this, but it is important to note that those profiled in these accounts are not the only ones who have suffered. The arrests and torture of Tibetan dissidents affect families and friends who also must contend with the heavy hand of the government, and with the suspicion and harassment such arrests generate. Moreover, the depredations experienced by dissidents in Tibet resonate broadly among Tibetans within and beyond the borders of the Tibet Autonomous Region. They serve to link those in the present with widespread communal memories of brutalities suffered during earlier years of PRC rule, and imbue the notion of nationalist dissent in Tibet with a strongly felt sense of resistance to oppression and injustice. And this, in turn, adds to a milieu in which nationalism, dissent, and exile are generated anew. ■

China's State Nationalities Affairs Commission Opposes Dalai Lama's Plan

—September 28, 1987

Beijing, September 28, 1987 (XINHUA)—Following is the full text of a statement China's State Nationalities Affairs Commission issued today on the question of the "independence of Tibet" called for by the Dalai Lama at the House Human Rights Subcommittee of the Congress of the United States:

At a subcommittee meeting on September 21, 1987, the Dalai Lama issued a statement and proposed a "five-point plan" on the question of the "status of Tibet." In response to his statement, the State Nationalities Affairs Commission issued the following statement:

The Dalai Lama's "five-point plan" on the question of the "status of Tibet" is aimed to pursue the "independence of Tibet," splitting the motherland and sabotaging unity among China's various nationalities. In the "plan," the Dalai Lama has said nothing new, but the action is just a continuation of his constant attempts to split the motherland and call for the "independence of Tibet."

We hereby point out, any attempts to split Tibet away from the motherland and sabotage unity among China's various nationalities are firmly opposed by all the Chinese people of various nationalities, including Tibetans, so this will never succeed.

The People's Republic of China is a unified, multinational country founded jointly by the people of all China's nationalities. Tibet has been part of China's territory since ancient times, and since the mid-thirteenth century, China's central government has been exercising full sovereignty over Tibet.

The People's Republic of China was founded in 1949, Tibet realized peaceful liberation in 1951, and the Tibet Autonomous Region was founded in 1965. The Tibet Autonomous Region and all other regions where autonomy by nationalities is practiced are inalienable parts of the People's Republic of China.

The Tibetan nationality, like China's other nationalities, enjoys equality and regional autonomous rights, and the Tibetan people elect their own deputies, who manage state affairs along with deputies representing China's other nationalities. The Tibetan people have never before enjoyed such full democracy and freedom as today, and these facts cannot be changed by lies or slander.

Concerning Tibet's economic and cultural development and improvements in the Tibetan people's standard of living, the central people's government has always paid great attention, and actively supported and pursued a series of special policies in Tibet. Now, Tibet has achieved marked, unprecedented development in all areas and the living standard of the Tibetan people has constantly improved.

In China, equality, unity, mutual help, love, and aid among the country's various nationalities serve as important conditions for overall development and prosperity. Technical personnel sent by nationalities in other parts of China and by related provinces and municipalities to help Tibet develop its economy, culture, and construction have been warmly welcomed, actively supported, and praised by the Tibetan people.

The Dalai Lama's distortion of this is an attempt to spread dissension among the Tibetan people and the people of China's other nationalities and is entirely futile.

Our policy towards the Dalai Lama is consistent and definitive, and our principle previously announced still holds. He and Tibetan compatriots now residing abroad are welcome

Opposite: John Ackerly, Lhasa, October 1, 1987. A monk, Jampa Tenzin, is placed above the crowd after being burned during an attempt to rescue other monks from a police station that was set on fire. He is waving a *khata*—a traditional white Tibetan scarf.

(continued on page 41)

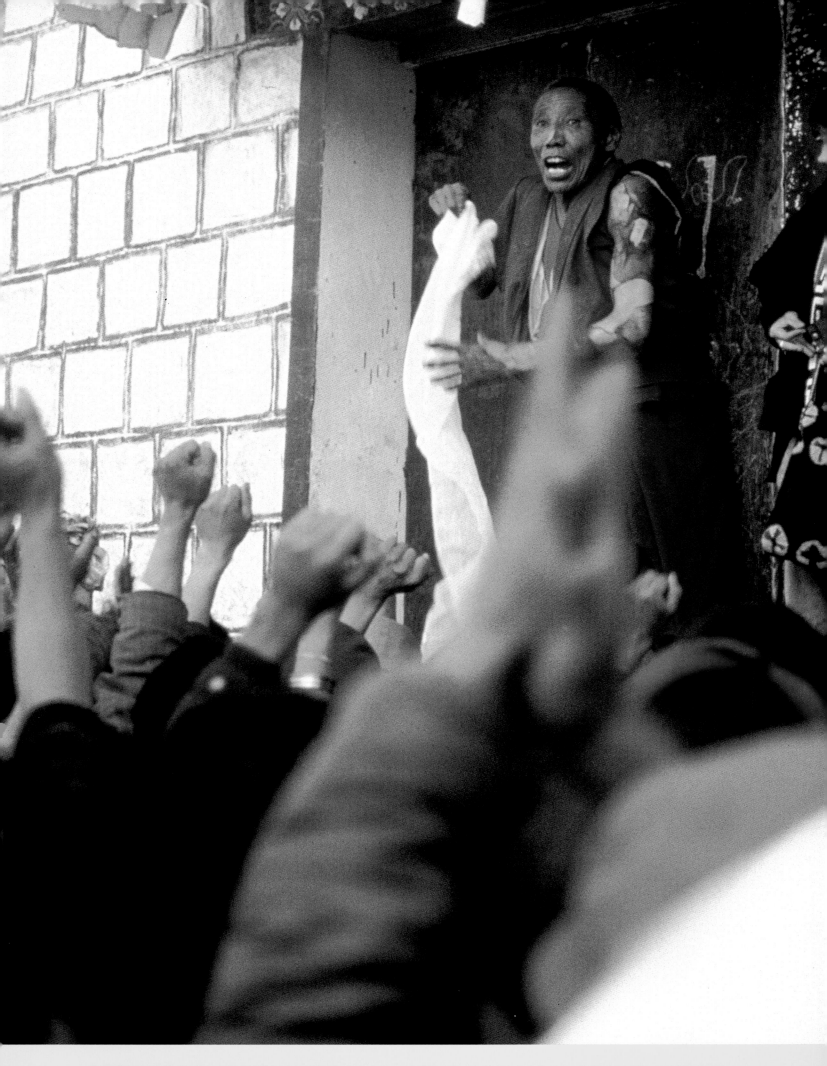

MOVEMENT FOR TIBETAN INDEPENDENCE FLARES.

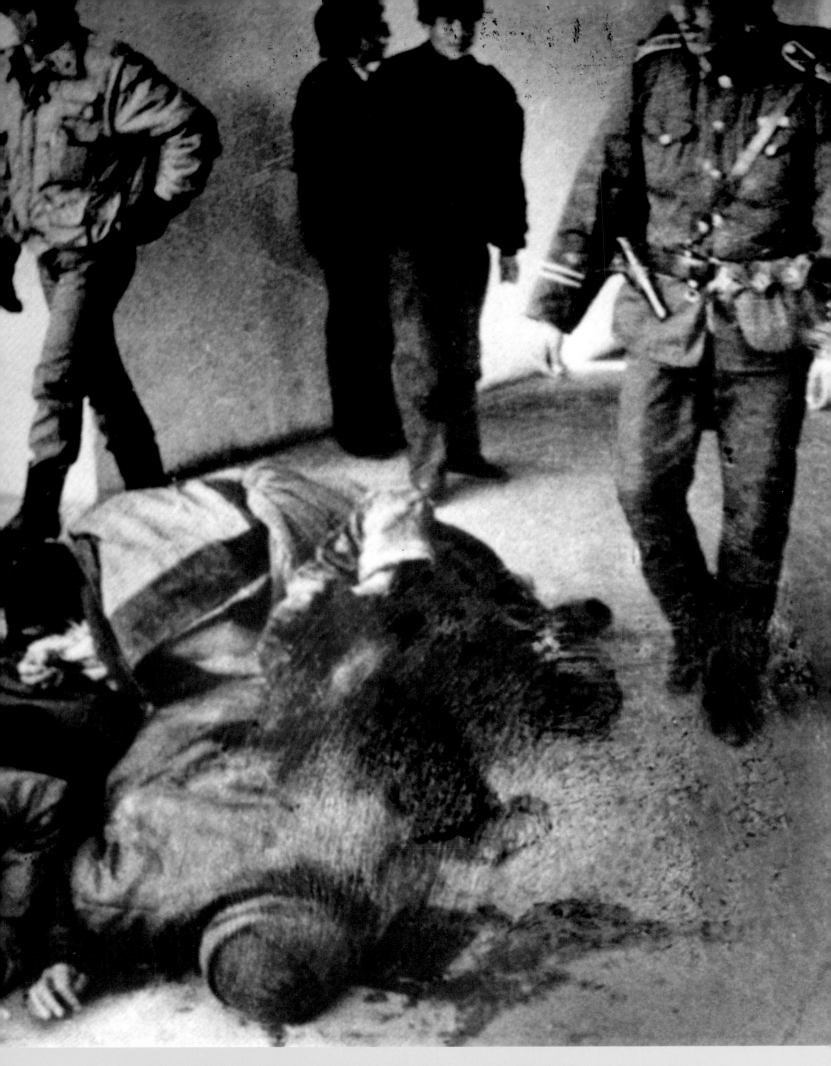

CHINESE SECURITY FORCES FIRE ON PEACEFUL

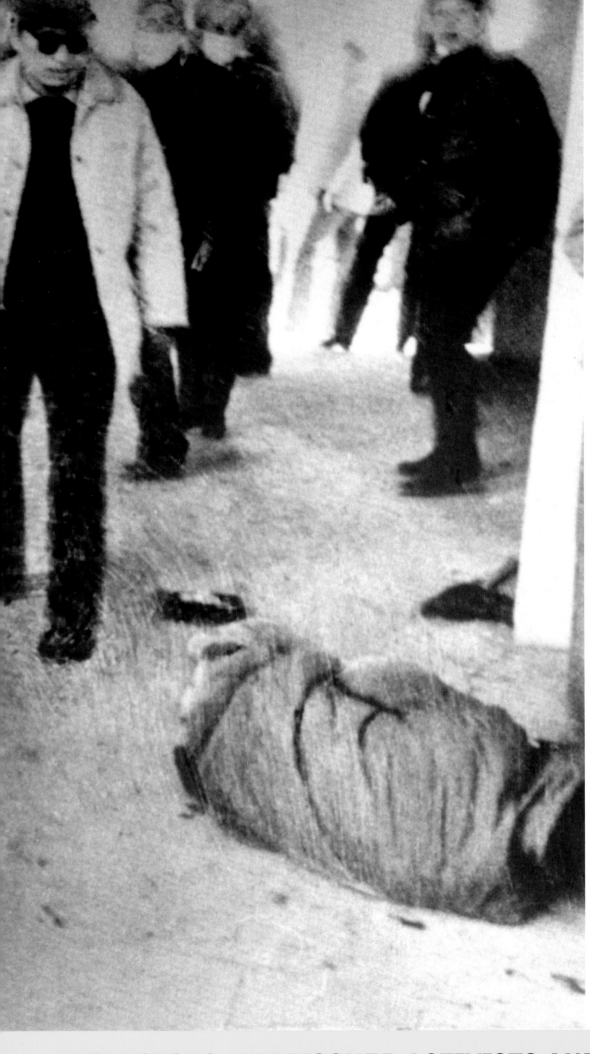

to come back to contribute to safeguarding unification of the motherland, promoting unity among various nationalities, and building Tibet, but we are firmly opposed to any activity aimed at splitting the motherland and sabotaging unity among various nationalities, and we hope he will make a wise choice.

We must hereby point out, the House Human Rights Subcommittee of the U.S. Congress brazenly let the Dalai Lama use its forum to conduct political activity which called for the sabotage of China's unification, and harmed the feelings of the Chinese people. This action is wanton interference in China's internal affairs, and we hereby express strong dissatisfaction over the fact that the United States Government did not prevent the Dalai Lama from conducting political activity in the United States.

We hope authorities in the United States will, based on the general situation of Sino-U.S. friendly ties, do more things conducive to furthering Sino-U.S. ties and promoting understanding and friendship between the people of the two countries, and will not do anything to harm the interests of the Chinese people of all nationalities. ■

Left: Photographer unknown, Lhasa, 1988. Chinese policemen and an interrogator (in sunglasses) walk among injured demonstrators.

42–43: Photographer unknown, Spring 1989. Arrest of a Tibetan demonstrator.

PROTESTORS. IMPRISONED ACTIVISTS AND PROTESTORS

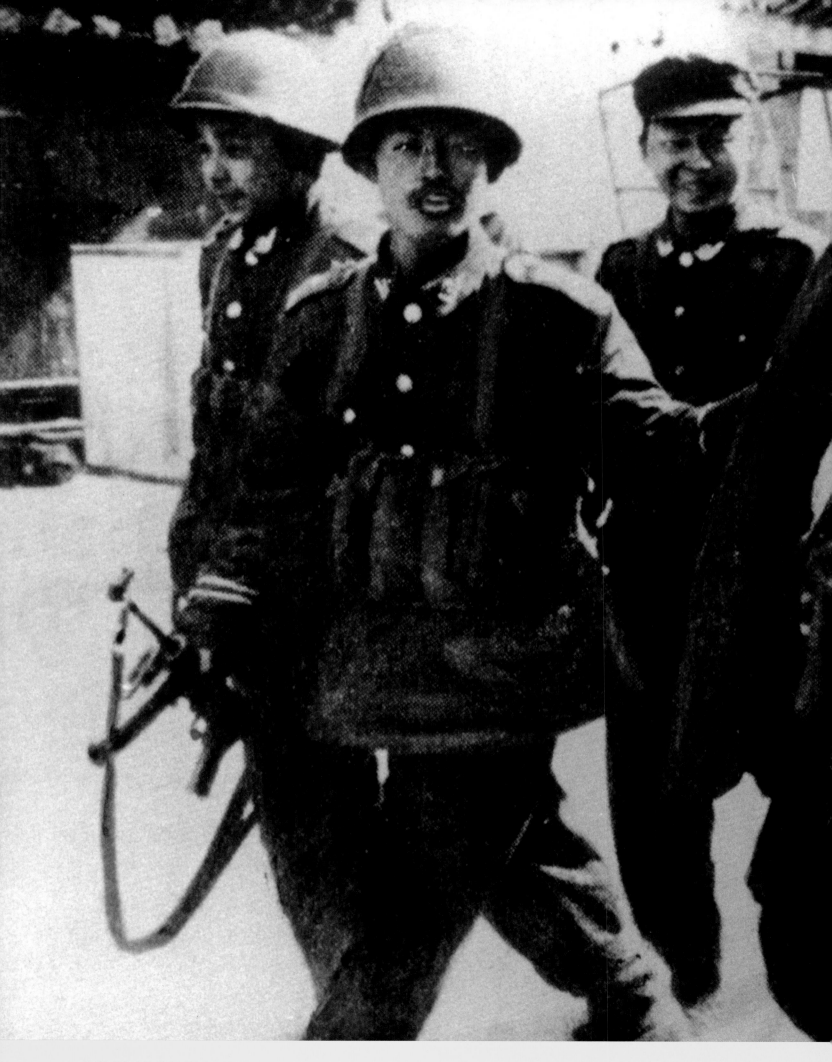

ARE TORTURED AND BEATEN. MONKS AND NUNS PLAY

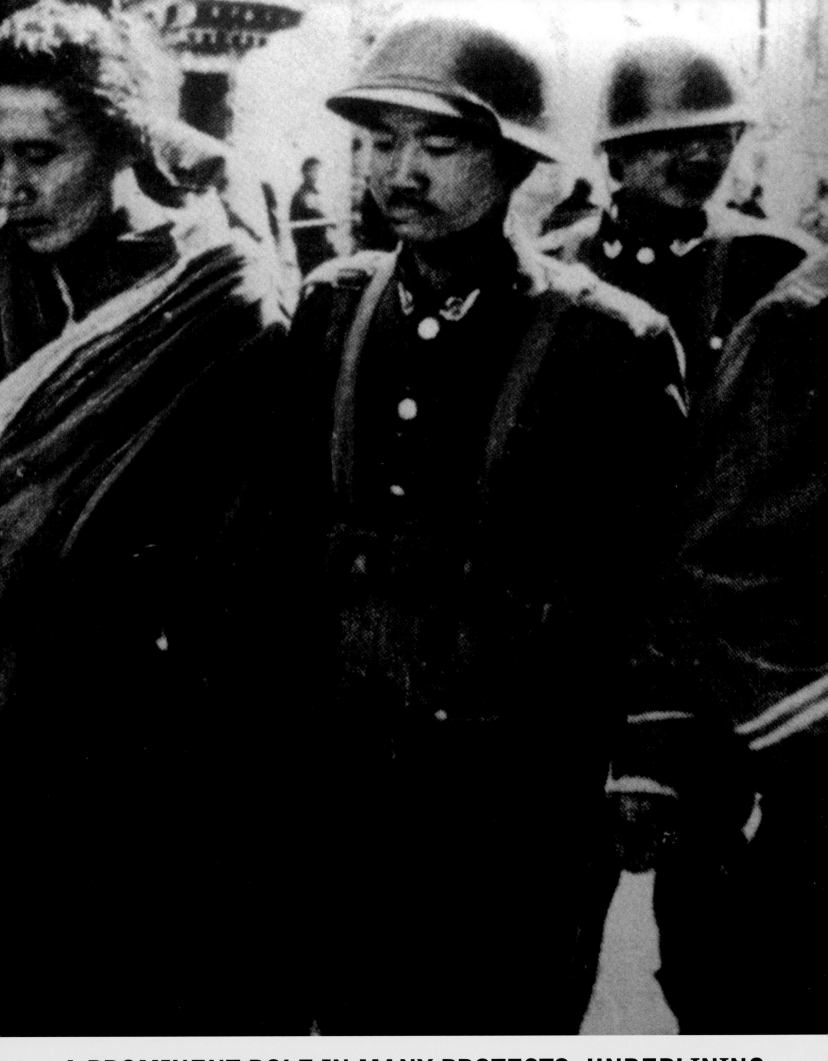

A PROMINENT ROLE IN MANY PROTESTS, UNDERLINING

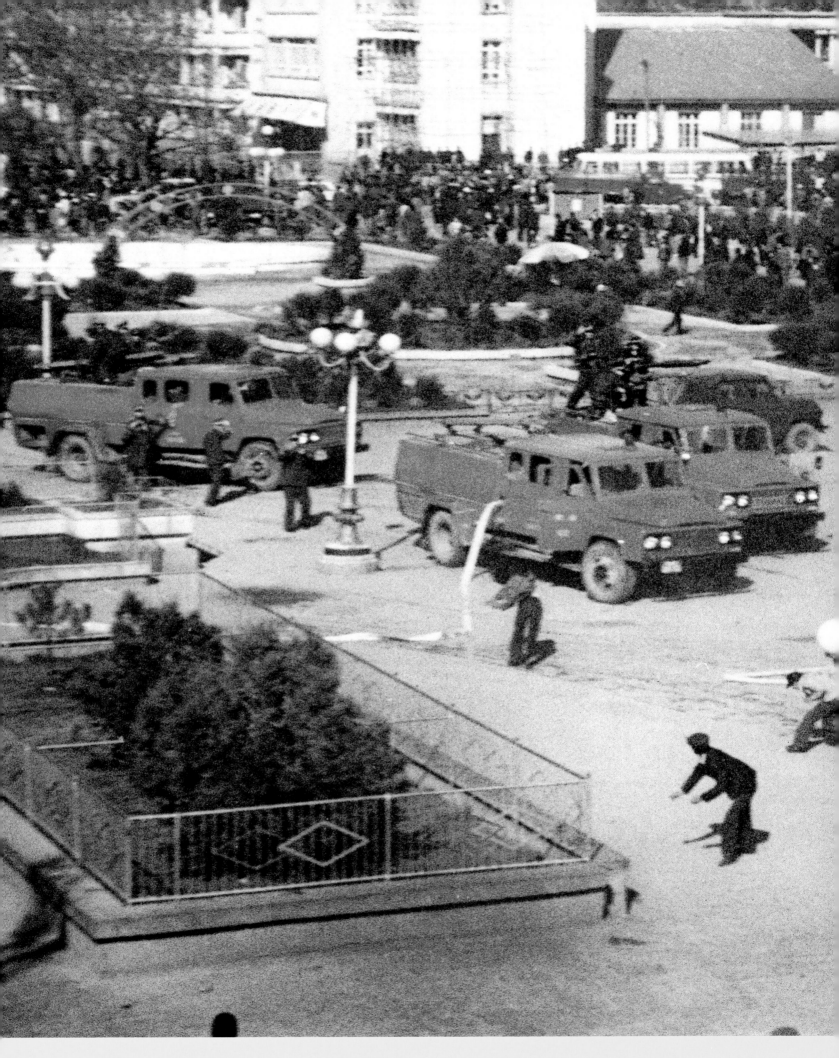

BOTH TIBETANS' REJECTION OF OFFICIAL CHINESE ATHEISM

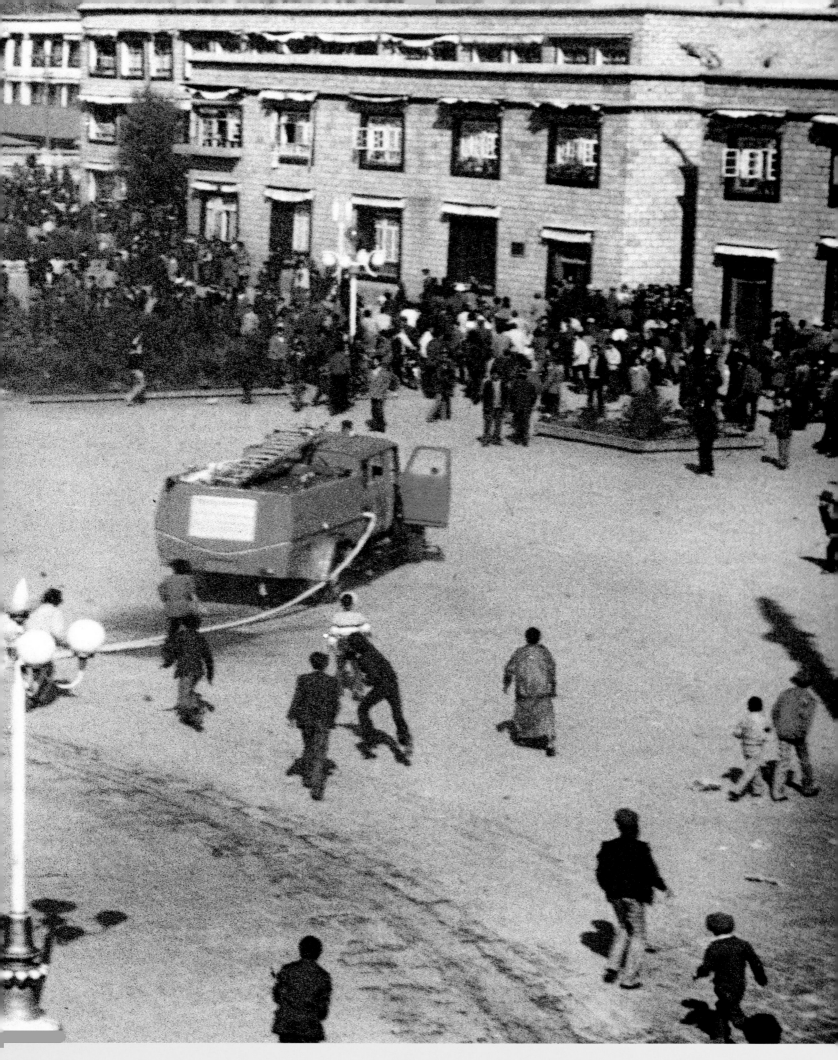

AND THEIR PERCEPTION OF BUDDHISM AS A MARKER

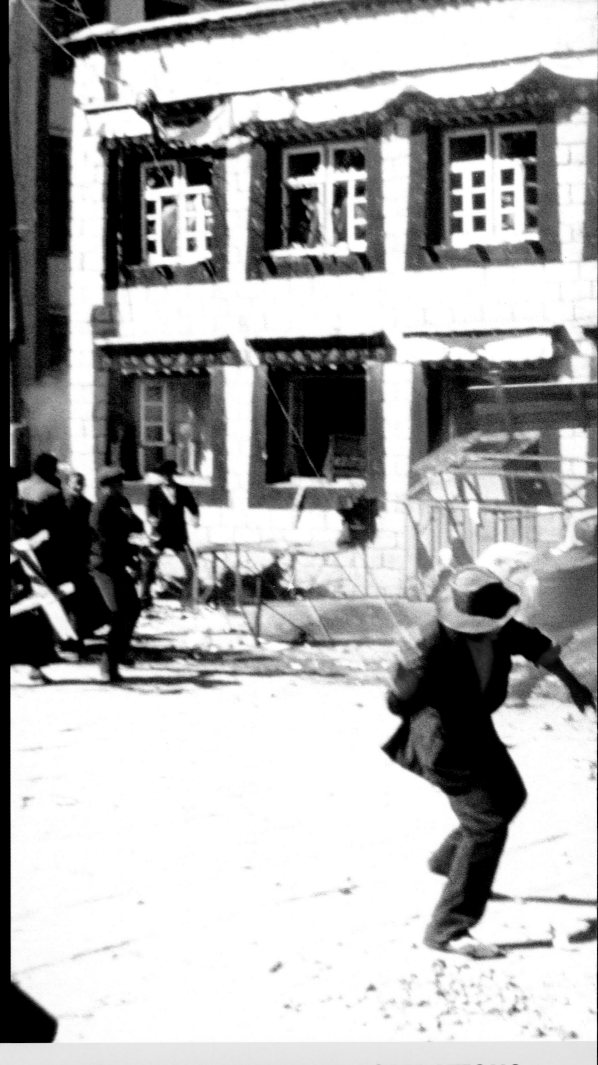

44–45: Photographer unknown, Lhasa, 1987. Anti-Chinese demonstration.

Right: Photographer unknown, Lhasa, 1987. Anti-Chinese demonstration.

48–49: Photographer unknown, Lhasa, 1987. Tibetan killed during an anti-Chinese demonstration.

OF THEIR OWN NATIONAL IDENTITY AND ASPIRATIONS.

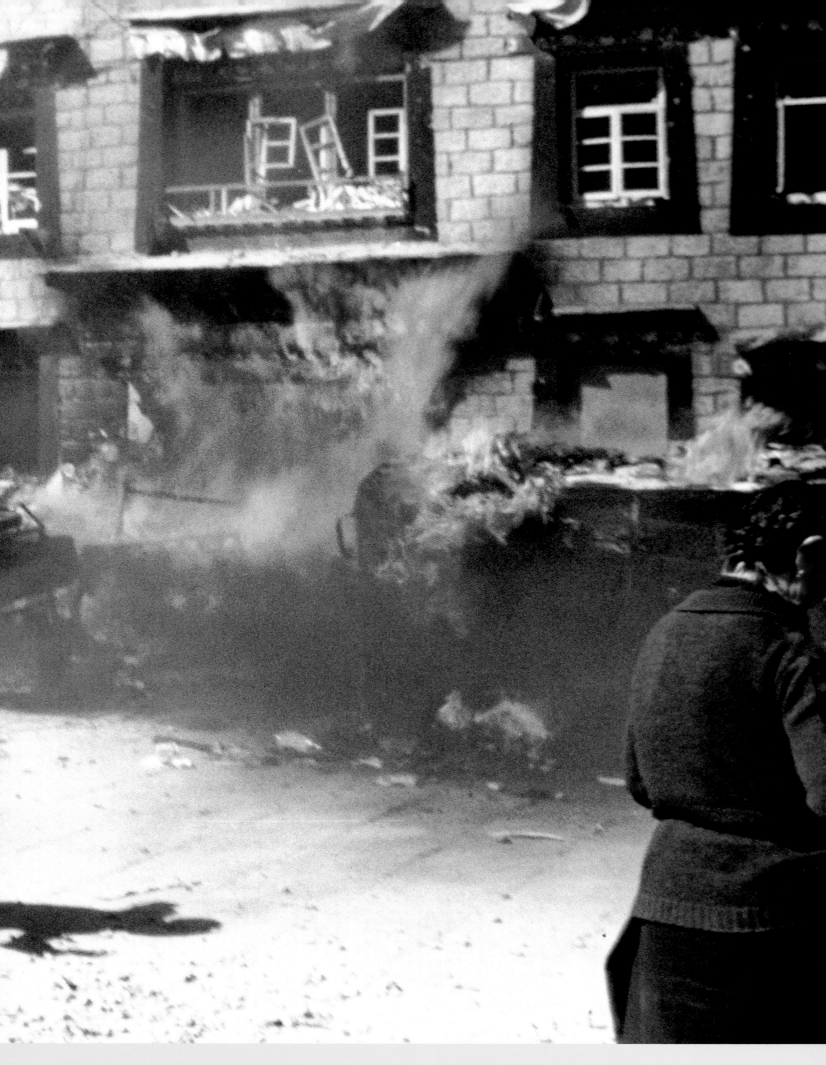

DEMONSTRATIONS CONTINUE IN LHASA, WITH FORCE

BEING USED AGAINST UNARMED DEMONSTRATORS. IN

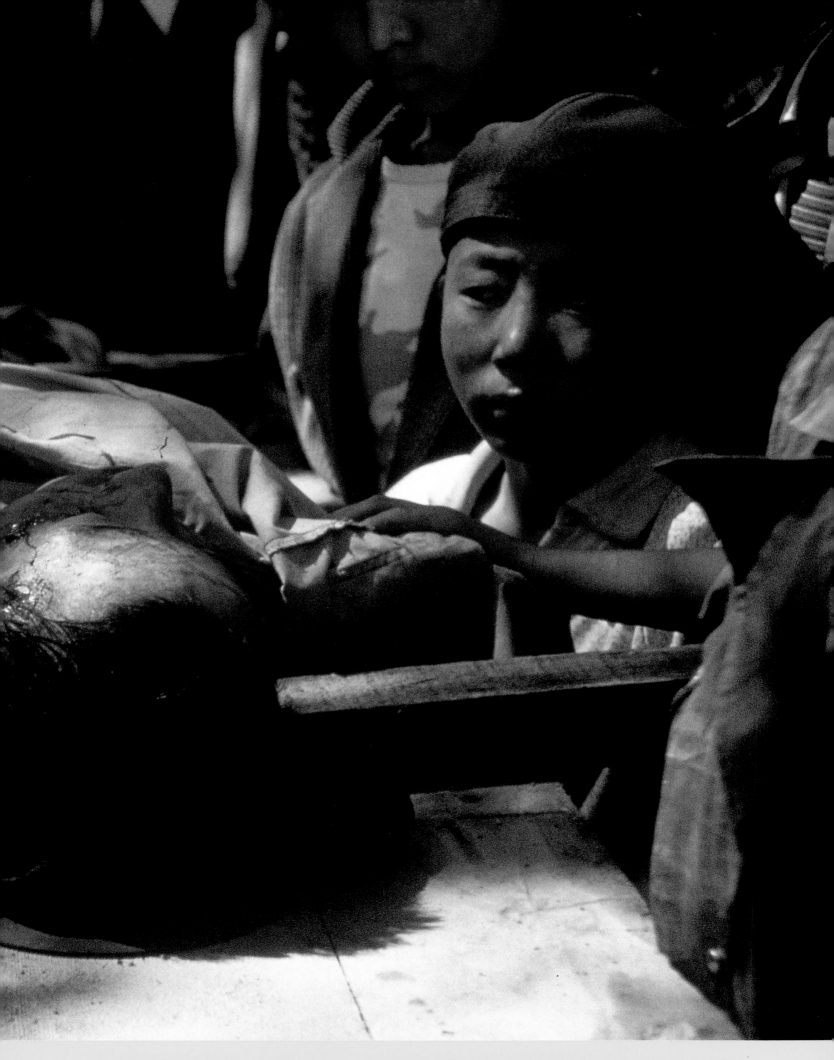

MARCH 1989, CHINA DECLARES MARTIAL LAW IN TIBET.

Right: Lynn Johnson, Lhasa, 1993. Confrontation between a Chinese storeowner and a Tibetan.

52–53: Photographer unknown, March 8, 1989. Tibetan protestors assault a Chinese man in the Tibetan quarter.

THE DECLARATION OF MARTIAL LAW

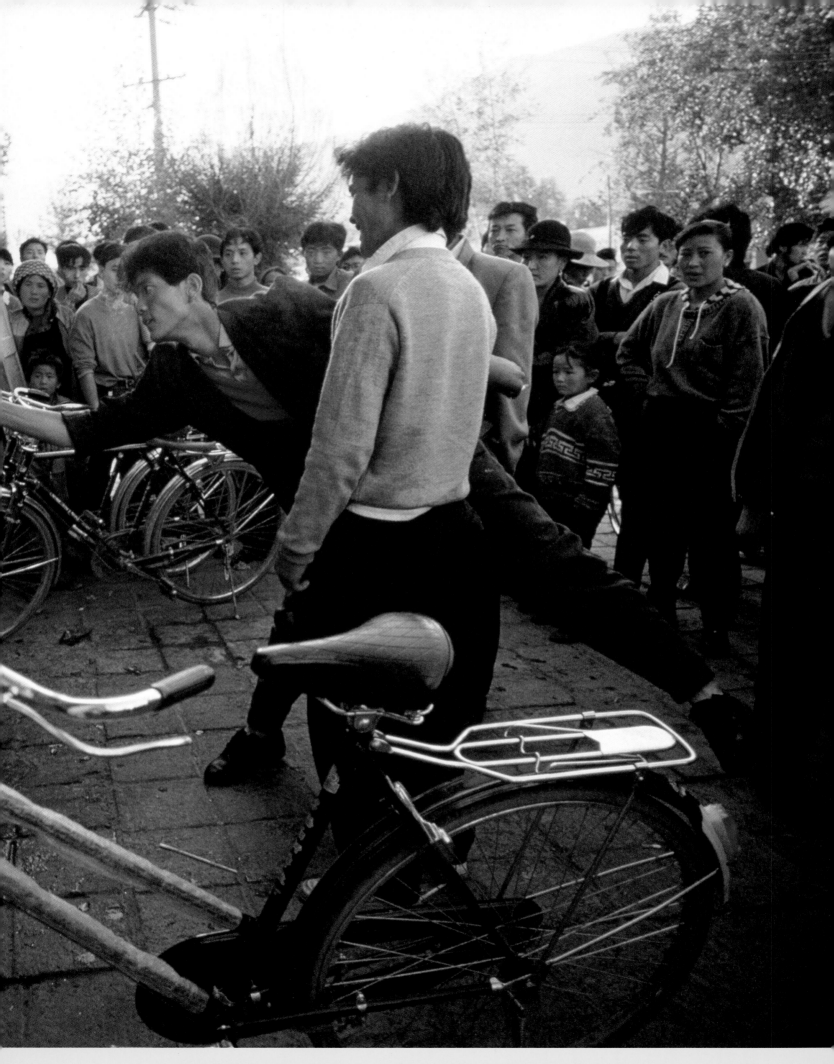

EXPONENTIALLY ESCALATES TENSIONS

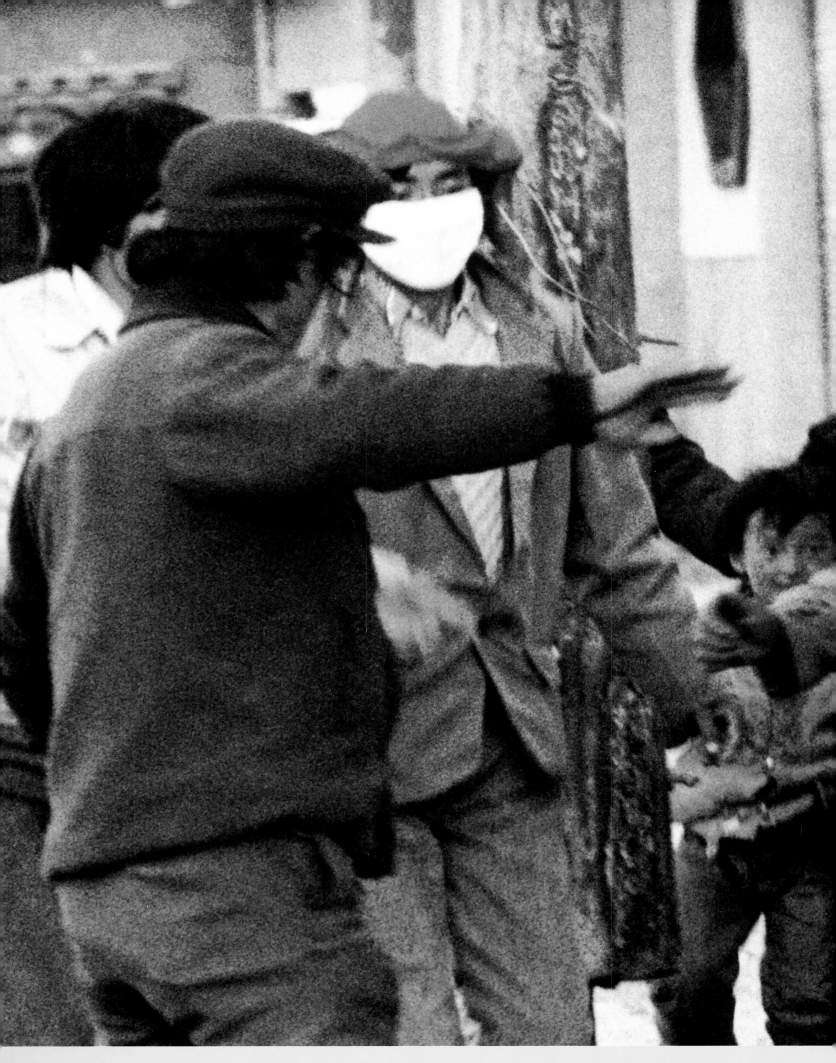

BETWEEN TIBETANS

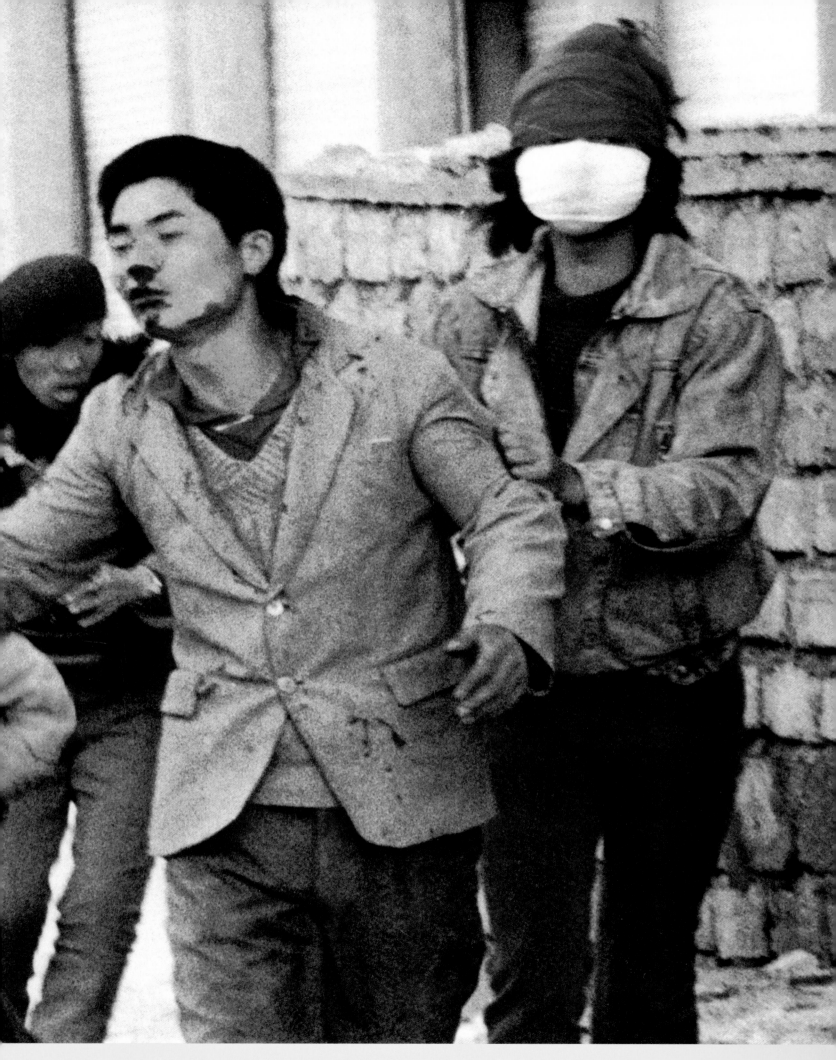

AND CHINESE IN TIBET.

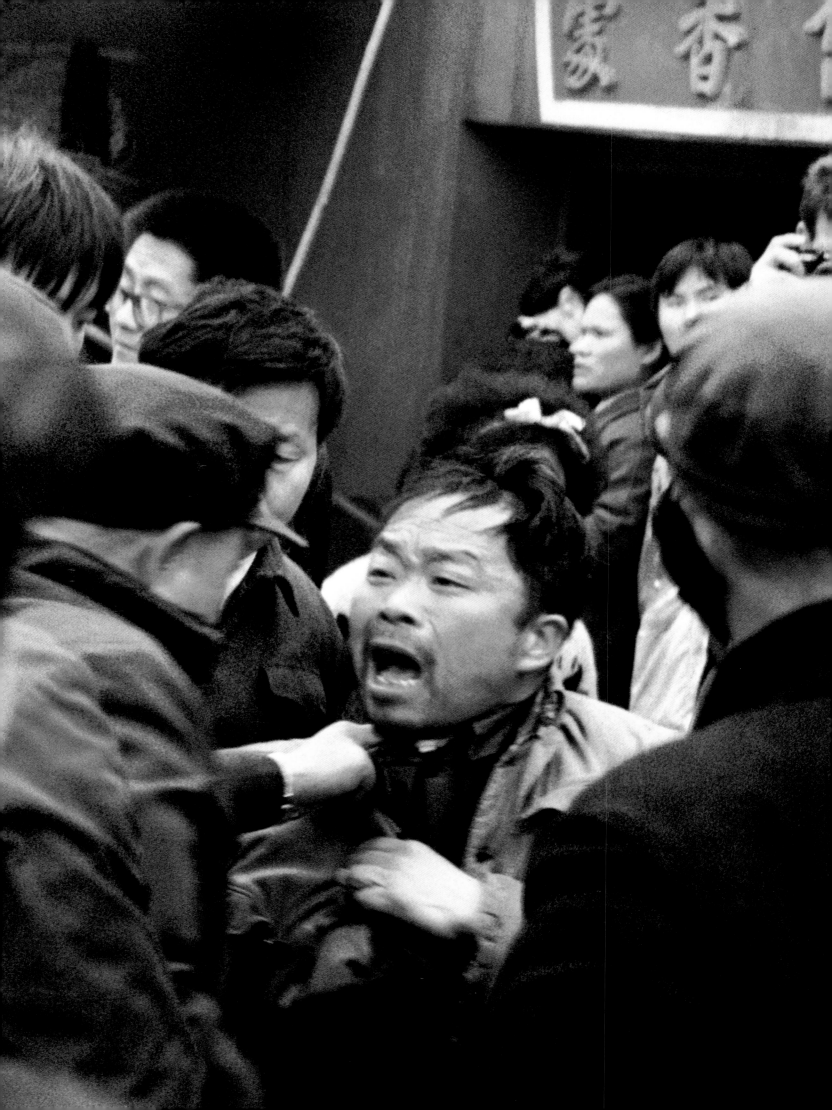

On March 7, 1989, the Chinese government issued three martial law decrees for Tibet, followed by three more the next day. All were signed by Dorje Tsering in his capacity as chairman of the regional Tibetan government. The texts of the martial law resolutions are as follows.

The texts of these decrees are copied verbatim, except for amending place names in the first decree, from photocopies of the English-language versions of the decrees circulated by the authorities in Tibet. These copies are appended to the International Human Rights Law Group's "Communication to the United Nations Commission on Human Rights and Sub-Commission on Prevention of Discrimination and Protection of Minorities Concerning Human Rights Violations by the Government of the People's Republic of China," dated June 15, 1989. Cf. the texts translated from broadcasts on Radio Lhasa in the Foreign Broadcast Information Service, March 8 and 9, 1989.

Chinese Martial Law Decrees for Tibet
—March 1989

Martial Law Decree 1:

In accordance with the martial law issued by the State Council, the People's Government of the Tibet Autonomous Region has issued the following orders:

1. Starting from zero hour of March 8, 1989, a martial law will be enforced in Lhasa city proper and in the area west of Lhamo Township, Dazi County and east of Dongga Township, Duilong Dequing County.
2. During the time of the enforcement of the martial law, assemblies, demonstrations, strikes by workers, students and other people, petitions, and other get-togethers are strictly forbidden.
3. Traffic control measures will be implemented in the martial law enforced area. People and vehicles entering or going out of the area must go through formalities according to the regulations and receive security inspections.
4. Without permission, foreigners are not allowed to enter the martial law enforced area. Foreigners who are now in the martial law enforced area must leave within a definite time, except those who have permission.
5. Firearms and ammunition possessed illegally should be taken over. People who are not entrusted with the task of enforcing the martial law are not allowed to carry firearms and ammunition and other dangerous articles.
6. Public security organs and people entrusted with the task of enforcing the martial law have the right to search the riot-creating suspects and places where criminals are possibly hidden.
7. Those who resist to carry out the martial law and instigate others to do the same will be severely punished according to the law.

Martial Law Decree 2:

In order to safeguard the unity of the motherland, ensure the safety of citizens and personal property and protect public property from violation, the People's Government of the Tibet Autonomous Region specially issues the following orders:

1. It absolutely bans anyone in any case and in any form to instigate a split of the country, create riots, group people to attack government offices, damage public property, and undertake such sabotaging actions as fighting, smashing, robbing, and arson, etc.

2. Once the above-mentioned action happens, public security and police force and the PLA men on patrol have the right to take necessary and strong measures to put the action down at once. Those who make the above-mentioned actions will be detained right on the spot, and if resistance occurs, police and armymen on duty can deal with them according to the law.

3. Any government institutions, units, mass organizations, and citizens must immediately send criminals either found in operation or detected afterwards to judicial organs.

4. The judicial organs should make investigations of the crimes as soon as possible, handle cases without delay, and give them heavy punishment in accordance with relevant decisions and articles of "The Decision of the Standing Committee of the National People's Congress on Heavy Punishment to Criminals Who Seriously Violate Public Security" and "Criminal Law."

Martial Law Decree 3:

In accordance with the martial law of the State Council, the People's Government of the Tibet Autonomous Region has decided that traffic control will be enforced during the time of martial law. It specially issues the following orders:

1. All kinds of motor-driven vehicles cannot pass without the special permit or provisional passes issued by the traffic police brigade of the Lhasa Public Security Bureau. The persons who have the provisional pass must go through the designated way and within the fixed time.

2. Cadres, staff members must have identity cards or certificates issued by their units; the officials and soldiers of the People's Liberation Army and police force must have army-man's permits; the officials and soldiers of the public security departments must have employees' cards or the identity cards on patrol duty; students in schools must have their student identity cards or their school's certificates; those without jobs must have their resident identity cards or their certificates issued by the household committees or relevant organs; those from out of Lhasa must have temporary residence certificates; monks and nuns must have the certificates issued by the democratic management committees of their monasteries; the preschool children should move about with adults.

3. All kinds of motor-driven vehicles on entering the martial law enforced area must show the certificates issued by the people's government of county level or above and apply for provisional passes; persons from out of Lhasa on entering the martial law enforced area must have certificates issued by the people's government of county level or above and must go through formalities for temporary residence within 5 hours after entering the area; cadres, workers and staff members of the Tibet Autonomous Region back from holidays and official business can enter the area with certificates which establish their identities.

4. Motor-driven vehicles and persons leaving the martial law enforced area must be approved by leaders of county level or above and have their unit's certificates.

5. Motor-driven vehicles and persons passing within the martial law enforced area or entering and going out of the area must receive security inspection by police and armymen.

6. If any persons violate the above-mentioned orders, the people on patrol duty have the right to examine them according to the different cases, adopt mandatory measures on the spot, and even look into responsibility for a crime.

Martial Law Decree 4:

In order to ensure the security of aliens in the martial law–enforced area the People's Government of the Tibet Autonomous Region issues the following orders:

1. During the time of the enforcement of the martial law in Lhasa city, aliens cannot enter the area without permission. Aliens now in Lhasa must observe "martial law" issued by the State Council of the People's Republic of China and Orders of the People's Government of the Tibet Autonomous Region.
2. Foreign guests to Lhasa invited by the People's Government of the Tibet Autonomous Region and by other government organs must show "the Pass of the People's Republic of China" (which is called "Pass" for short below) issued by the Foreign Affairs Office of the People's Government of the Region when entering and going out of the area.
3. Foreign specialists and foreign staff members of joint ventures working in Lhasa must show "Pass" issued by public security authorities when entering and going out of the area.
4. Aliens who have obtained the right of residence in Lhasa must show valid residence identity cards when entering and going out of the area.
5. Foreign tourist groups organized by tourist agencies now staying in the Region can enter and go out of the area only if they are accompanied by Chinese guides with "Pass" issued by the public security authorities.
6. Unorganized foreign tourists now staying in Lhasa must leave in the time fixed by the public security authorities.
7. The "Pass" will be obtained at the Foreign Section of the Lhasa Public Security Bureau with "Residence Identity Card for Alien" issued by the public security authorities.

Martial Law Decree 5:

In order to fully reflect the policy of "leniency towards those who confess their crimes and severe punishment to those who refuse to do so, atone for a crime by good deeds and render outstanding service to receive rewards," and to resolutely crack down on the separatists and those who have committed serious crimes of fighting, smashing, robbing, and arson, the People's Government of the Tibet Autonomous Region has issued the following orders:

1. Those who have plotted, created, and participated in the riots, who have committed fighting, smashing, robbing, and arson, and who have given shelter to criminals and booty, must surrender themselves to the police at once, so that they can receive leniency.
2. Those who know the facts of separatists' activities and crimes of fighting, smashing, robbing, and arson, etc. should expose and report the cases to their units or to the public security authorities. These people should be protected. Those who retaliate against people who inform against them shall be severely punished.

Martial Law Decree 6:

All the people on patrol from the public securities, the police force, and the People's Liberation Army must strictly keep discipline in order to fulfil every task under the martial law. The People's Government of the Tibet Autonomous Region issues the following orders:

1. Obey orders in all actions.
2. Stand fast at posts, and perform obligations faithfully.
3. Strengthen unity and cooperate closely.
4. Carry out politics firmly and patrol in a proper way.
5. Implement strictly "The Regulations for the use of Weapons and the Police Instruments by the People's Police."
6. Protect earnestly the public property and the life and the property of the people. ■

58–59: Photographer unknown, Lhasa, 1989. Chinese People's Liberation Army troops on the streets of the city.

60–61: Photographer unknown, Lhasa, May 24, 1993. Chinese police watch Tibetans demonstrating. What started as a protest against a rise in local food prices and medical and education fees flared into a demonstration against Chinese rule; the police quelled the crowd using tear gas.

62: Photographer unknown, Lhasa, 1989. Armored personnel-carriers in the city streets. The Potala Palace, the Dalai Lama's former home, is in the background.

63: Photographer unknown, 1989. Dawa Wangdu, a monk, is arrested for taking part in a demonstration.

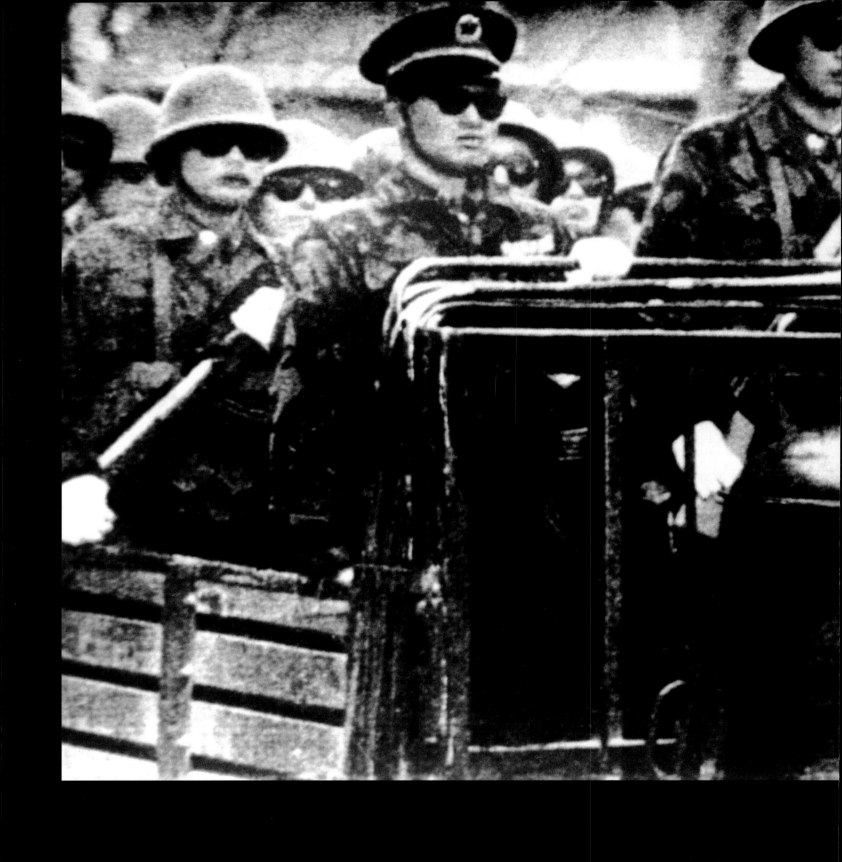

IN A 1990 PUBLICATION,

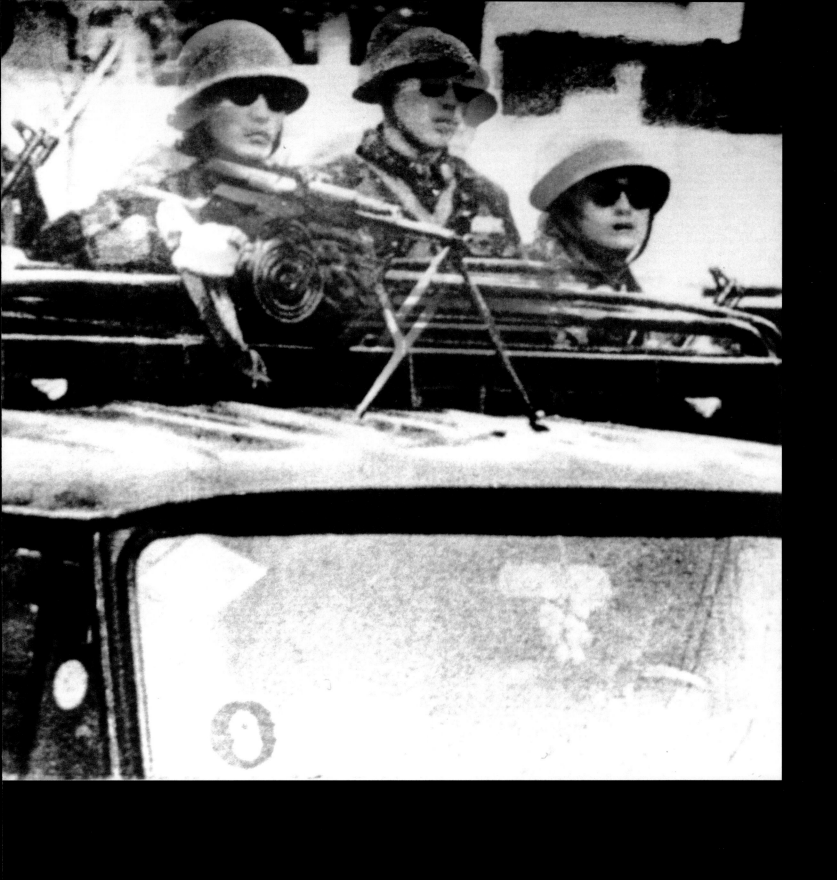

HUMAN RIGHTS WATCH REPORTED

THAT "SINCE THE IMPLEMENTATION

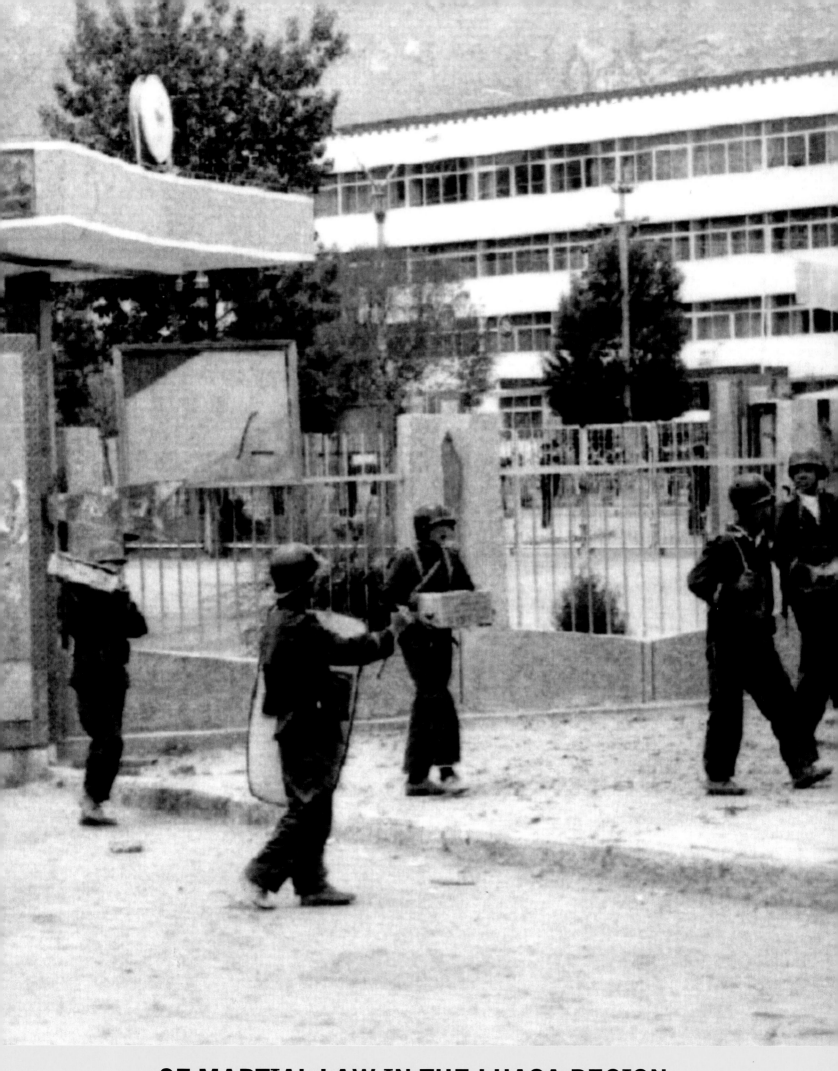

OF MARTIAL LAW IN THE LHASA REGION,

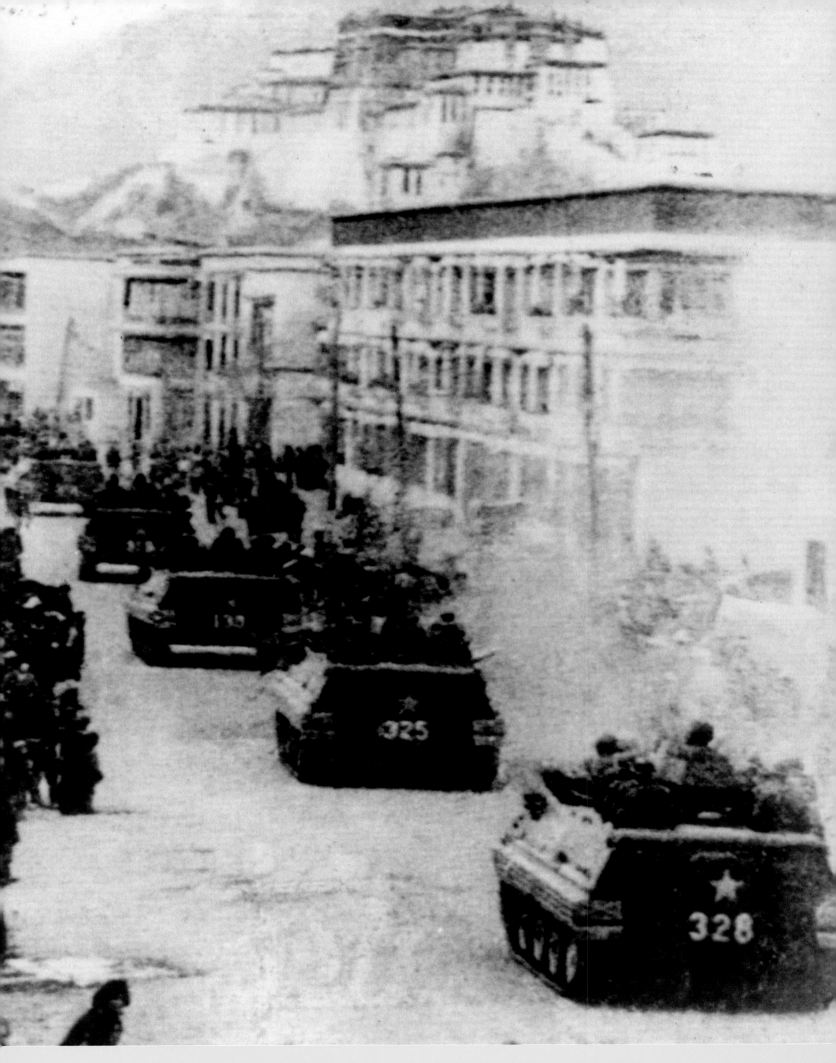

ALL THE PREVIOUS LONG-STANDING

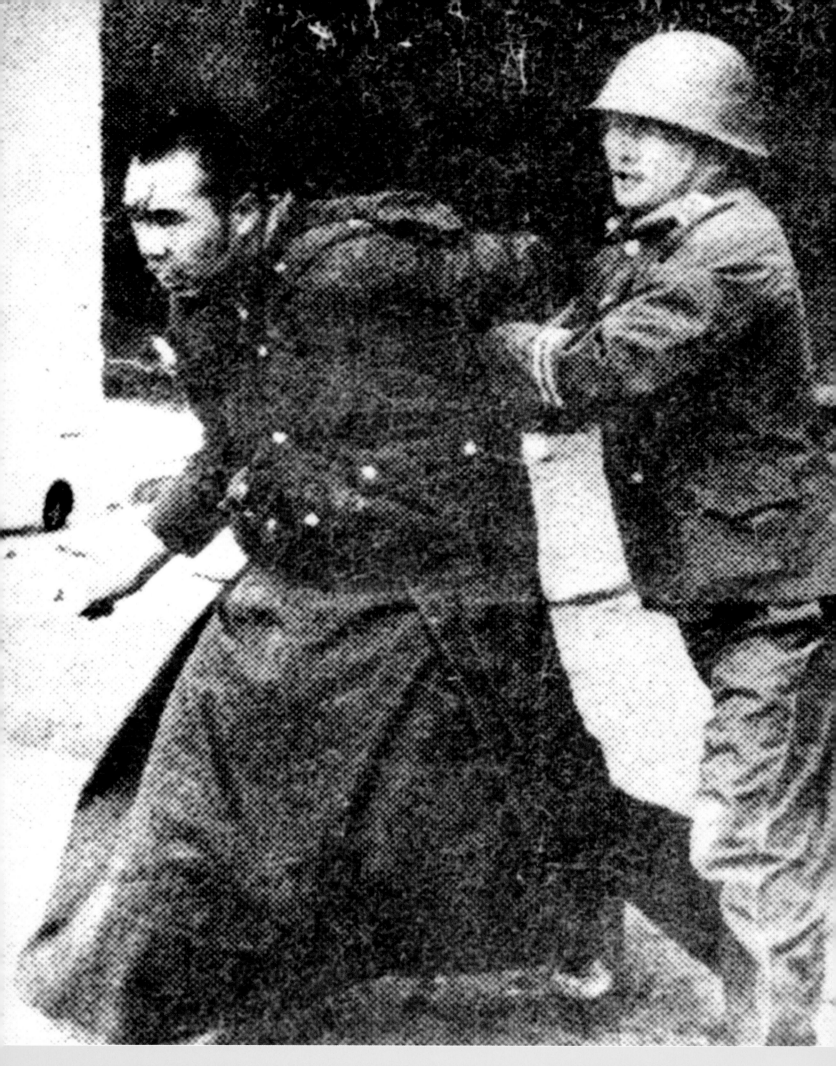

MECHANISMS OF GOVERNMENTAL INTERFERENCE

IN RELIGIOUS AFFAIRS IN TIBET

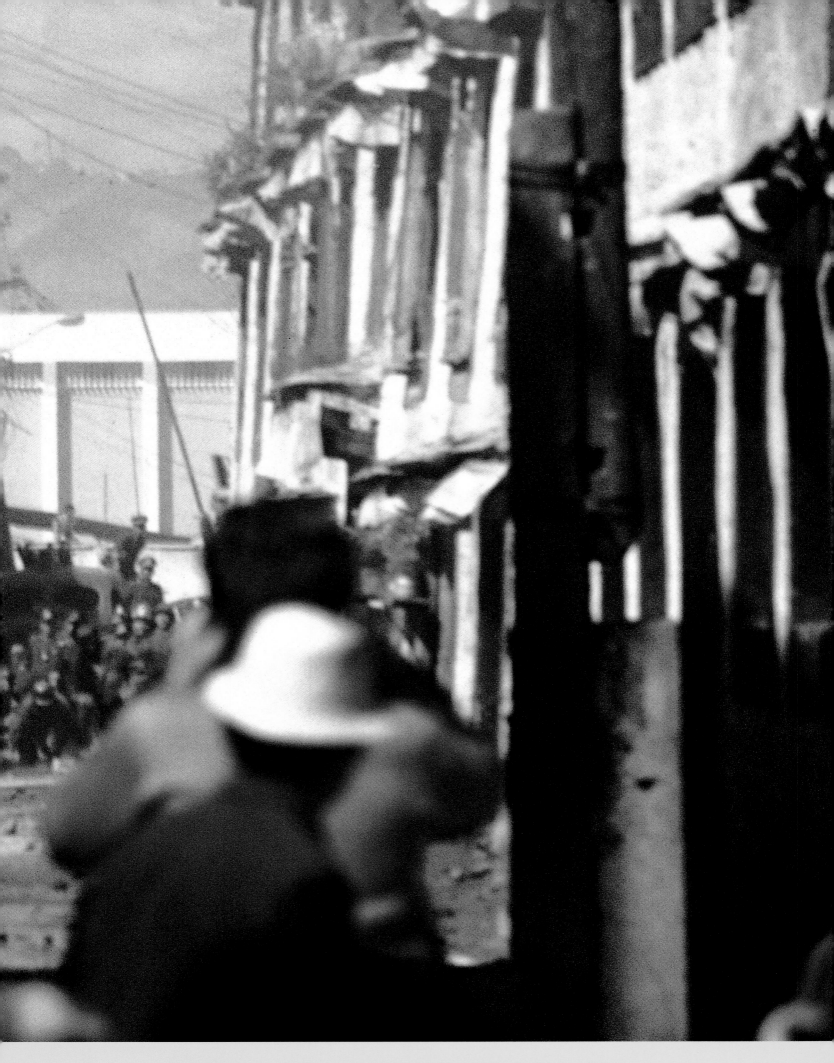

HAVE BEEN FURTHER INTENSIFIED.

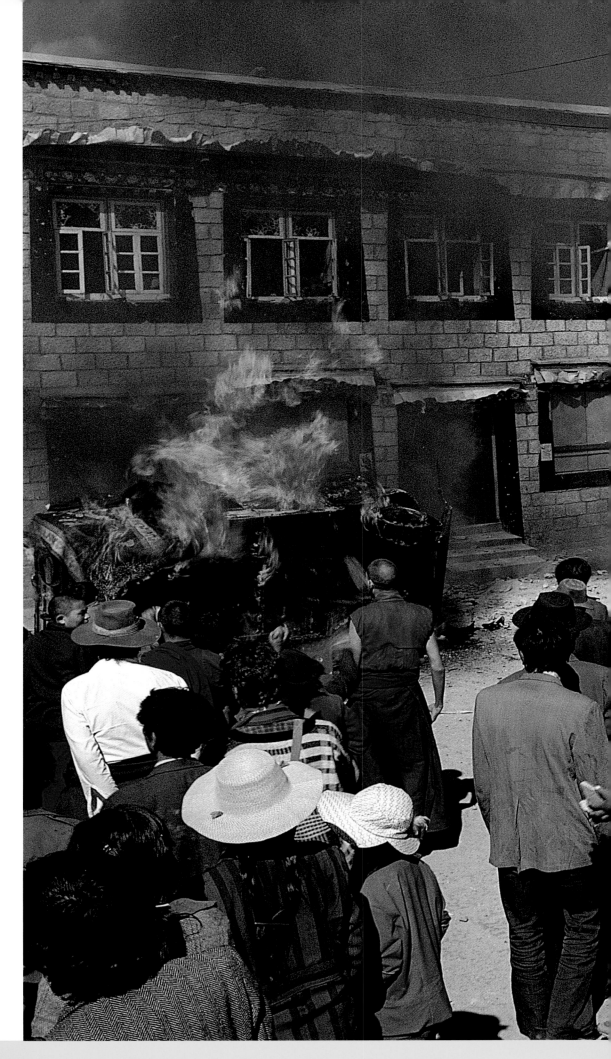

64–65: John Ackerly,
Lhasa, October 1, 1987.
Chinese police and Tibetans
exchange volleys of stones and
take turns charging an alleyway.

Right: John Ackerly,
Lhasa, October 1, 1987.
Abandoned Chinese and Tibetan
police and military vehicles
are overturned and ignited
by demonstrators, who are
triumphant after police have
retreated into the police station.

ANY ATTEMPTS FROM WITHIN THE MONASTIC

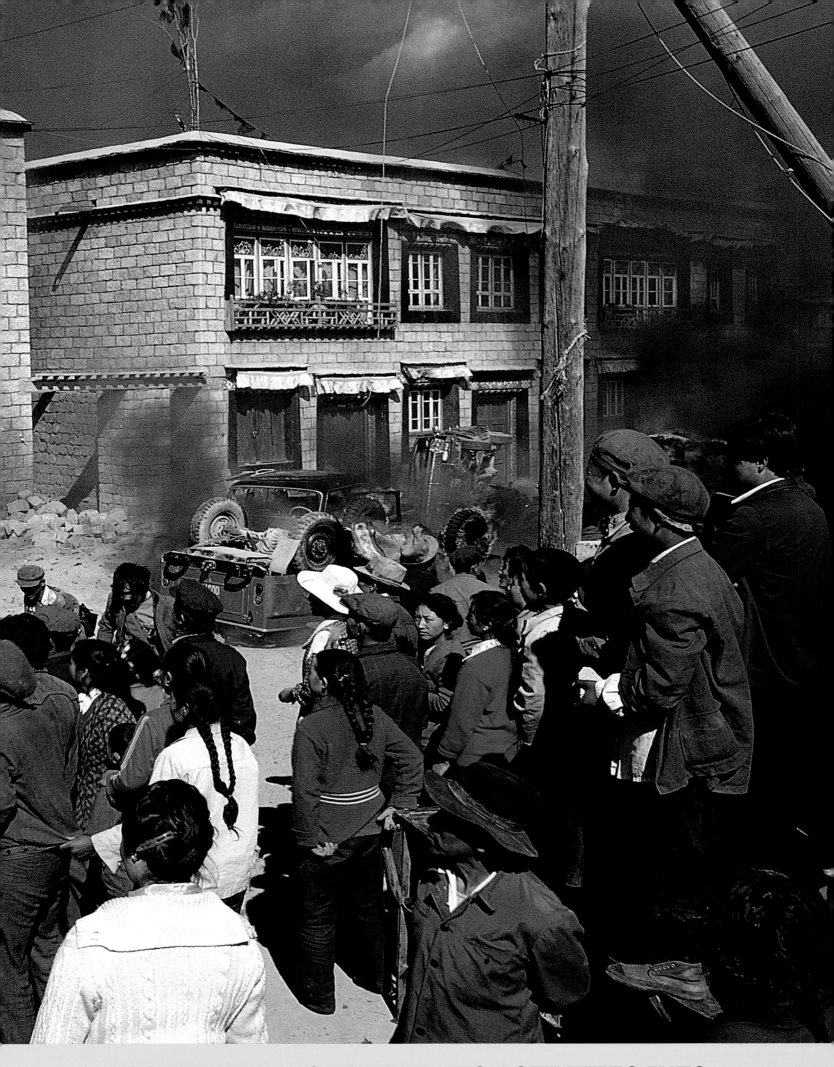

COMMUNITY TO EXTEND ITS ACTIVITIES INTO

Right: Guy Dinmore,
Lhasa, March 8, 1989.
Demonstrators stand near a
bonfire outside a ransacked
Chinese restaurant.

70–71: John Ackerly,
Lhasa, October 1, 1987. The
body of a young man is removed
after police fired on the crowd.

72–73: John Ackerly, Lhasa,
1987. A monk, Jampa Tenzin,
is lifted by the crowd after he
was badly burned by a fire set
in the police station. After being
carried around the Jokhang—
Tibet's holiest temple—he
disappeared into hiding. To
avoid arrest, Jampa Tenzin did
not go to the hospital despite
his need for medical attention.
Somehow, he survived.

THE REALM OF DISSENTING POLITICS

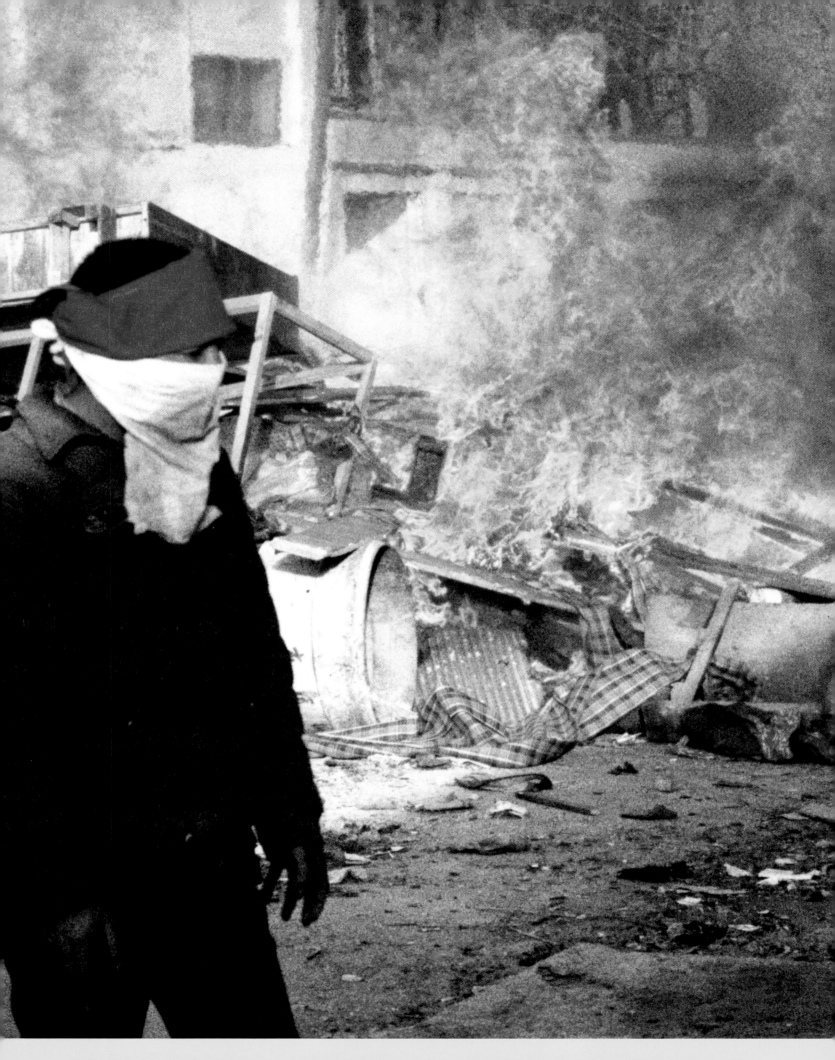

IS REWARDED BY HARSH AND VIOLENT SUPPRESSION

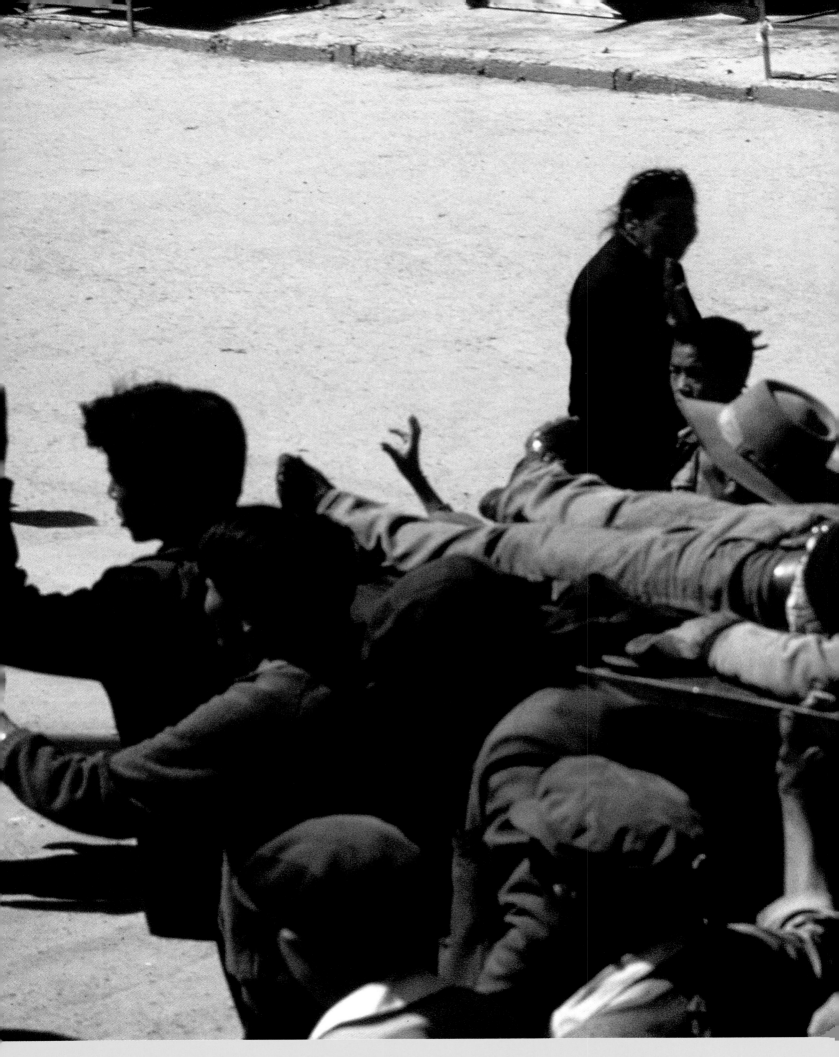

AND BY POLITICAL IMPRISONMENT OR WORSE.''

IN SPITE OF INCREASING PRESSURE

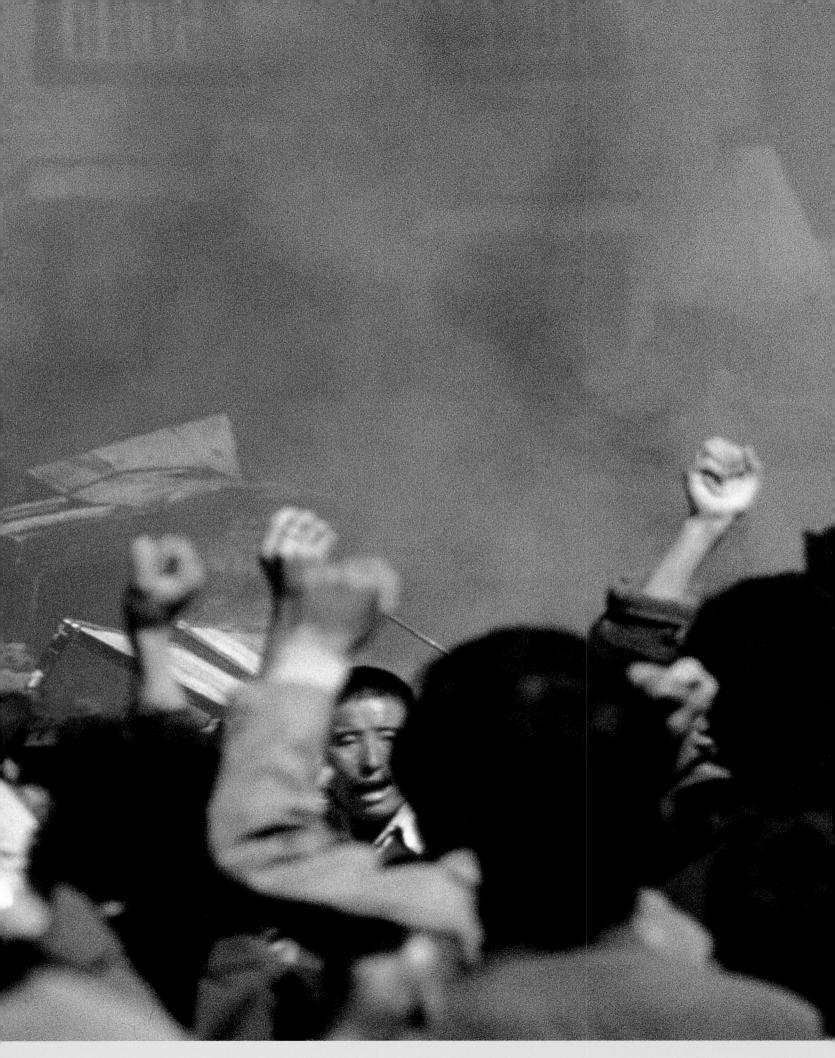

FROM THE CHINESE GOVERNMENT,

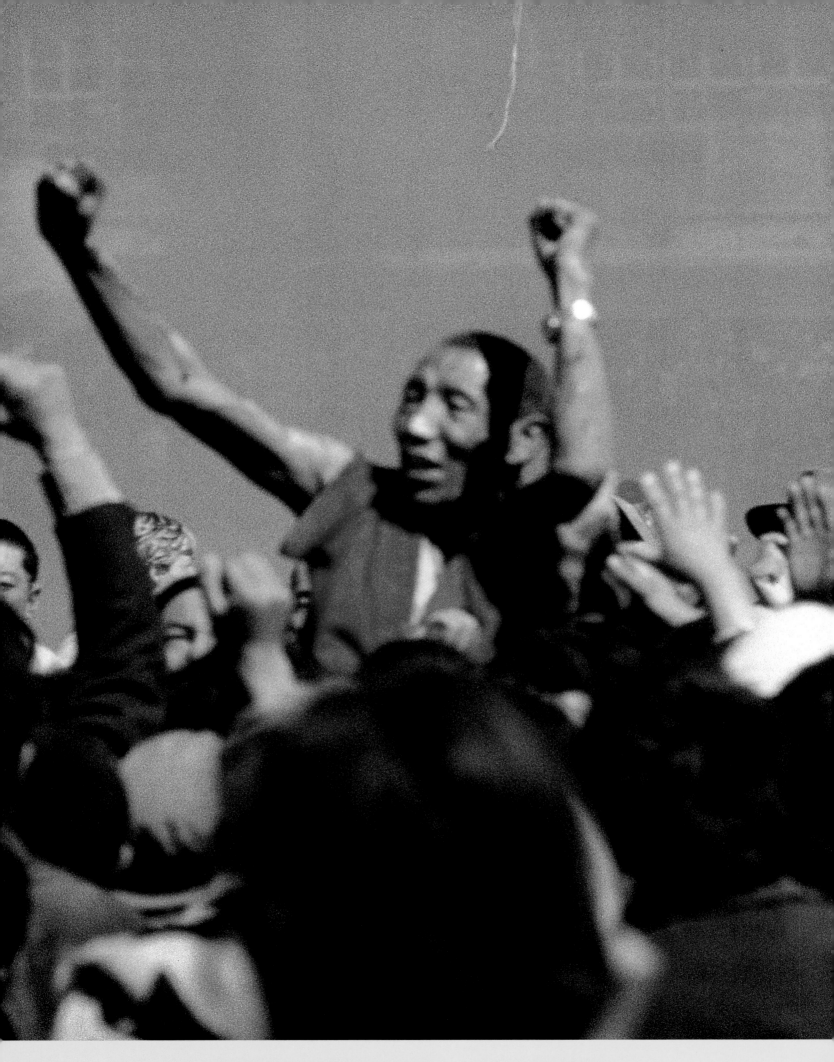

THE TIBETAN RIOTS CONTINUE.

Right: Stuart Franklin, Tiananmen Square, Beijing, 1989. Students on a hunger strike protest against Chinese government policies.

76 top: Catherine Henriette, Tiananmen Square, Beijing, June 4, 1989. Beijing residents inspect the interiors of armored personnel-carriers, which were burned by pro-democracy demonstrators to prevent troops from moving into Tiananmen Square. On the previous night, Chinese troops and tanks forcibly entered the square to end the weeks-long occupation by student protestors. Hundreds of demonstrators were killed in the crackdown.

76 bottom: Catherine Henriette, Tiananmen Square, Beijing, June 4, 1989. Two demonstrators, injured during the clash between the army and civilians, are carried out in a cart.

77 top: Catherine Henriette, Beijing, June 4, 1989. Near Tiananmen Square, a wounded girl is carried out in a cart.

77 bottom: Photographer unknown, Tiananmen Square, Beijing, June 4, 1989. Chinese People's Liberation Army soldiers jumping over bicycles in their retreat from rock-throwing protestors. Hours later, troops opened fire on the demonstrators in Tiananmen Square.

A FEW MONTHS AFTER MARTIAL LAW IS DECLARED IN

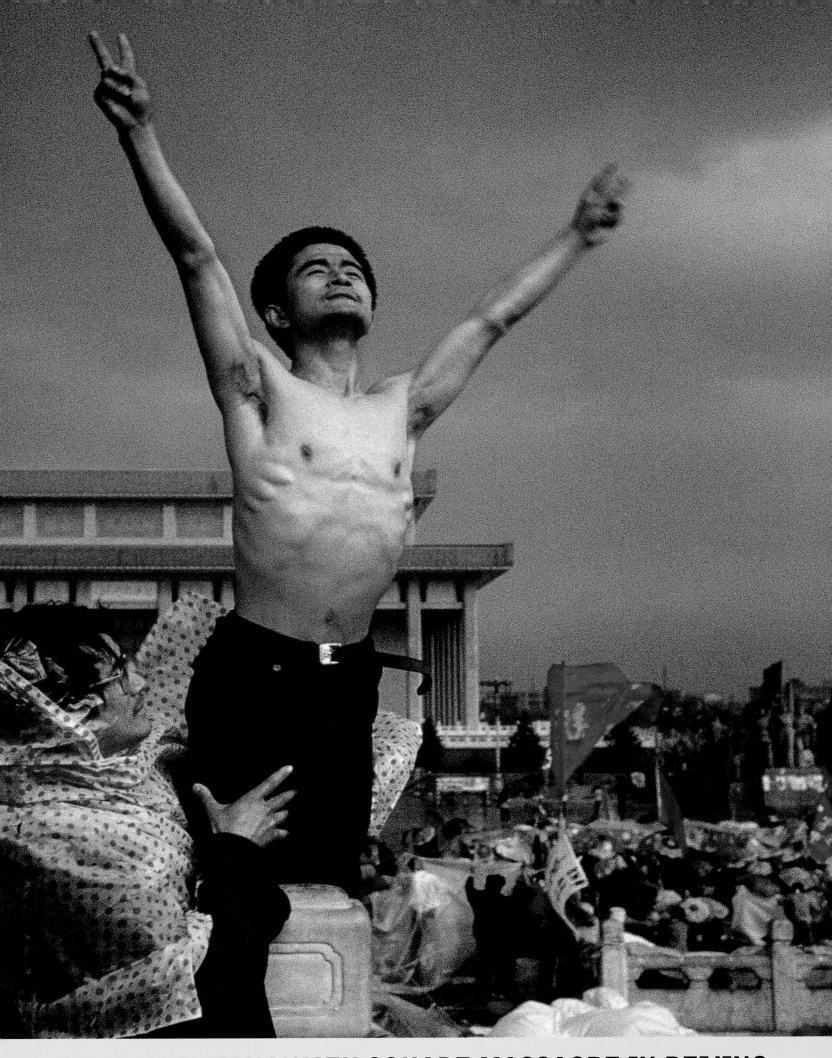

TIBET, THE TIANANMEN SQUARE MASSACRE IN BEIJING

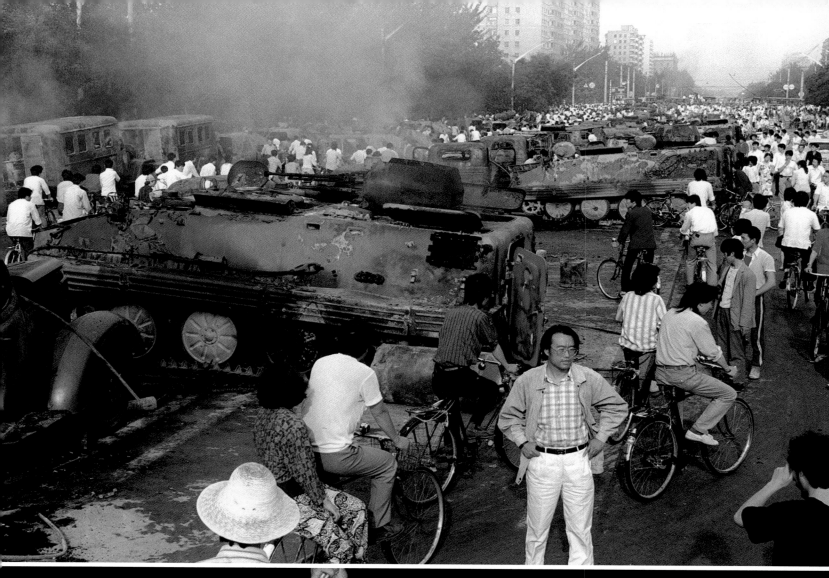

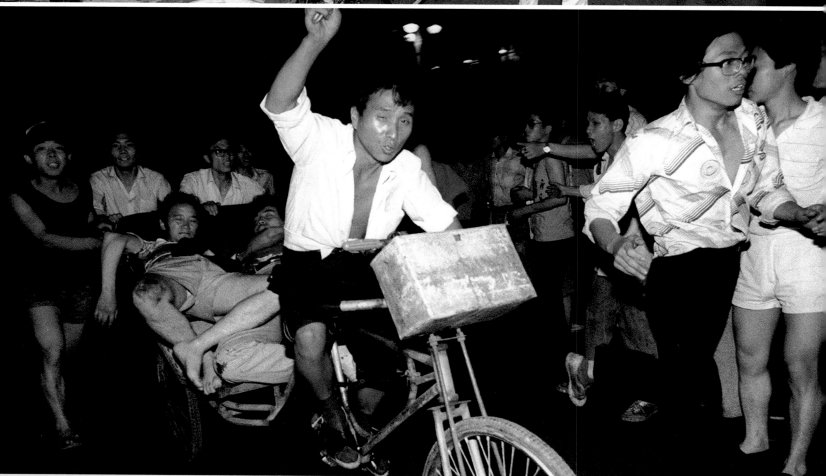

RIVETS THE WORLD'S ATTENTION. CHINESE SOLDIERS

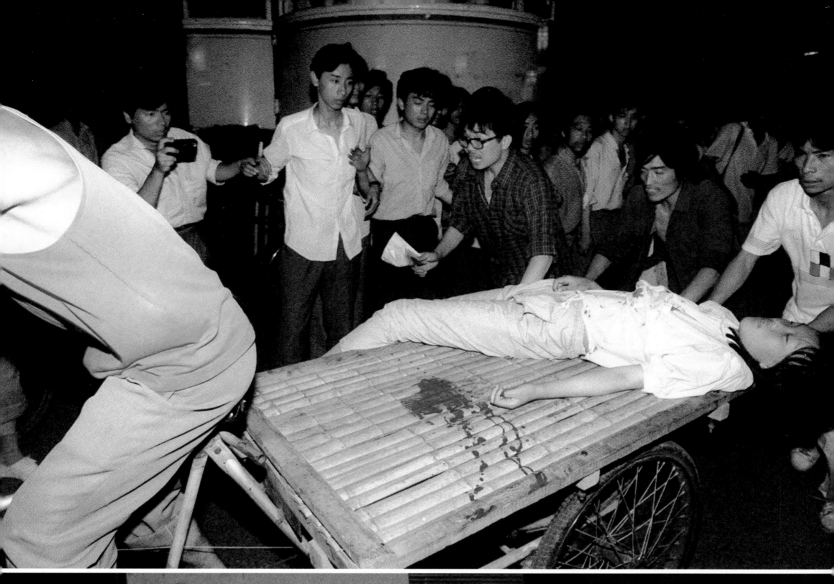

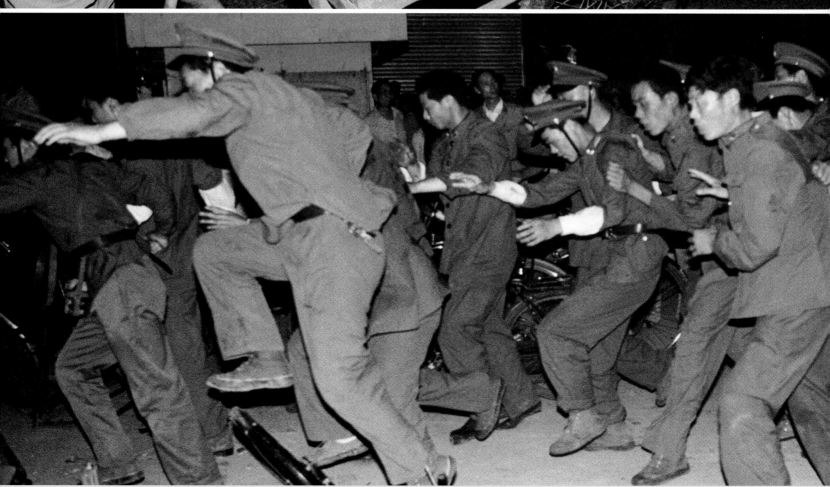

KILL AT LEAST SEVERAL HUNDRED CIVILIANS.

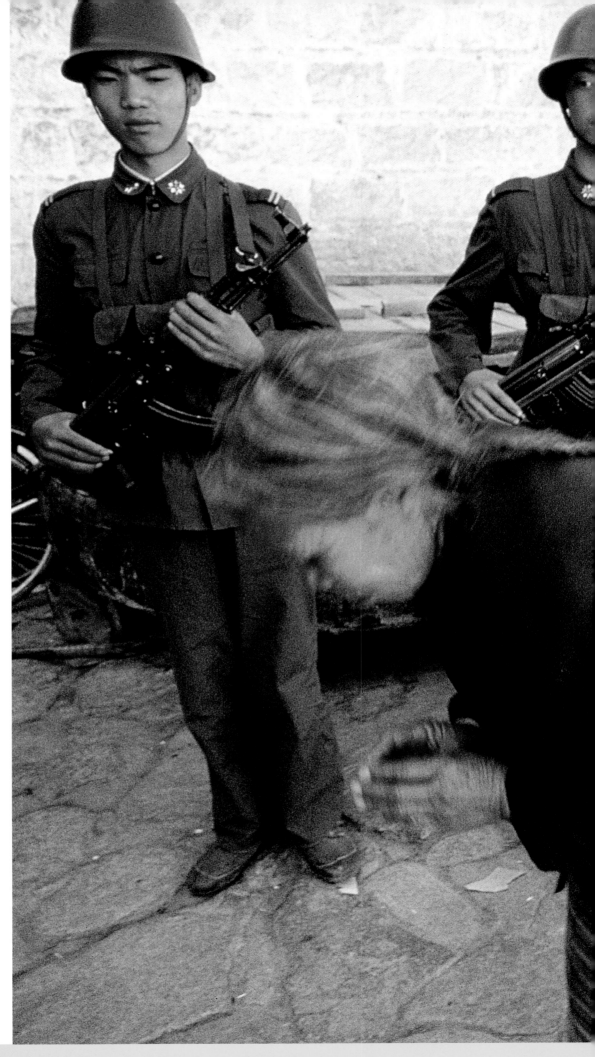

Right: Michael Springer,
Lhasa, October, 1989. At the
Barkor Bazaar, Chinese soldiers
armed with assault rifles watch
a pilgrim circumambulate
the Jokhang Temple.

80–81: Kathryn Culley,
Lhasa, 1995. On the roof
of the Potala Palace, Chinese
tourists pay a fee to dress in
Tibetan clothing.

82: Jeffrey Aaronson,
Lhasa, 1988. Three female
Chinese People's Liberation
soldiers dance at a disco in the
Lhasa Holiday Inn (detail).

83: Kathryn Culley,
Lhasa, 1995. A Chinese model
during a photo shoot at the
Jokhang Temple.

IN TIBET, CHINESE OPPRESSION

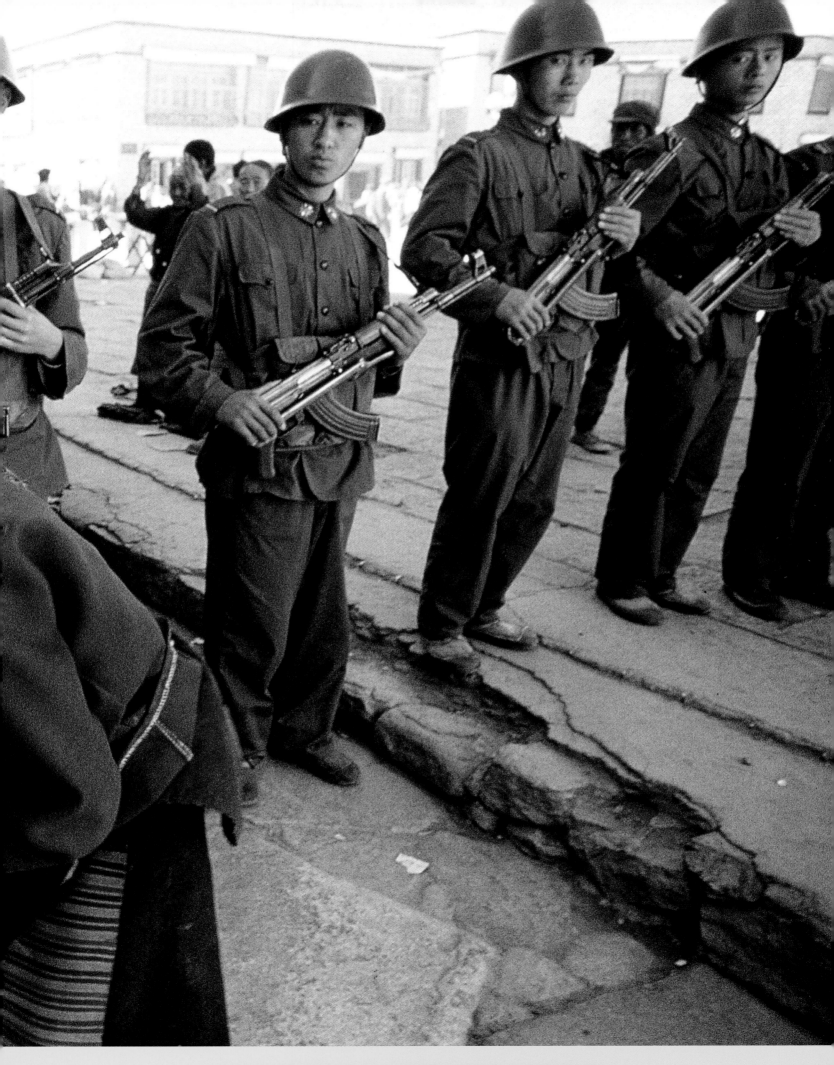

AND INTIMIDATION CONTINUE.

TIBETAN CULTURE IS CO-OPTED

AND EXPLOITED BY CHINESE INTERESTS.

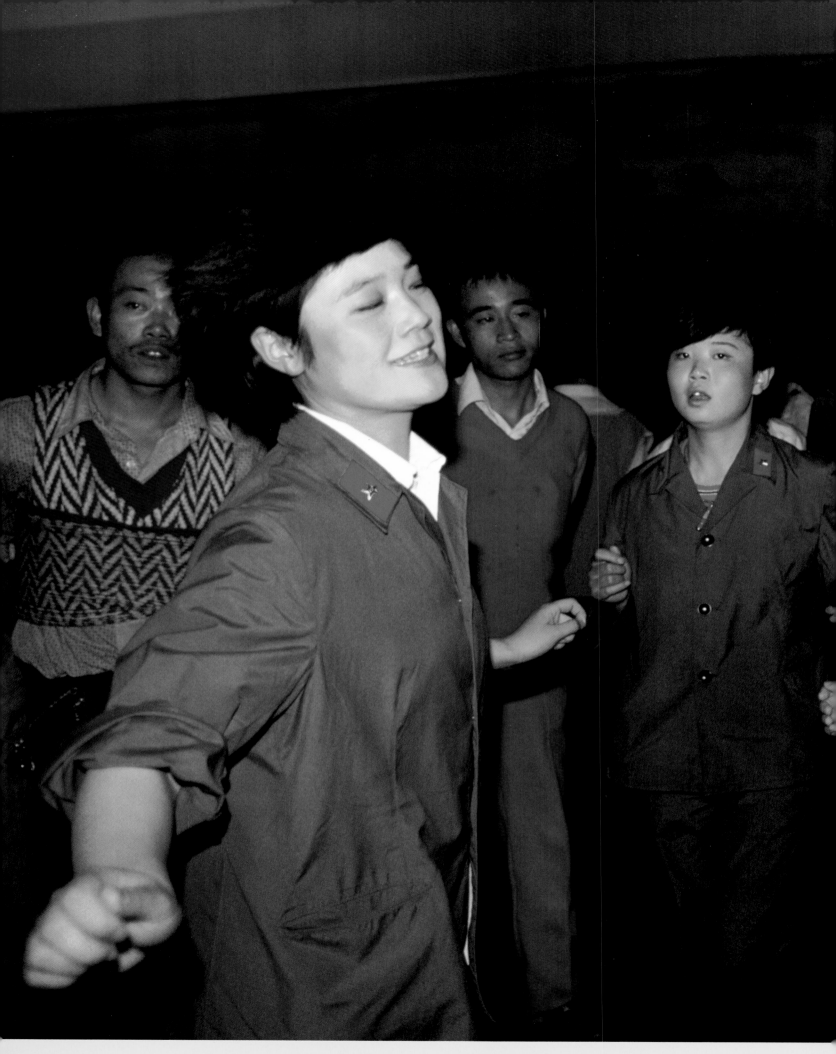

IN THE 1990s, THE CHINESE

GOVERNMENT CONTINUES ITS STRUGGLE

Chinese Document Concerning Political Thought Study During School Holidays

—January 3, 1989

To Unit Leaders and Parents of Students:

Concerning political thought study, and in order to strengthen the education of patriotic understanding and to unite the nationalities, with particular reference to the forthcoming school holidays:

1. To strengthen political and spiritual education every unit must appoint a leading cadre to be in charge of the political education of the students and to tell them the truth of the struggle so that they can recognize the characteristics of the struggle and so hold to the correct direction.

2. The school will appoint a person as Student Liaison Cadre [*lian-luo-yuan*]. Whenever anything unusual takes place, the students must not watch, gather round, support, or take part in anything. These are the rules. All units [to which the students' parents belong] must re-educate the students about the situation. If anyone is found to have done something against the rules, no matter for what reason, they will be expelled. In serious cases they will be reported to the Public Security Department for punishment. All parents of students must cooperate with their unit and with the school in order to educate their children.

3. Every unit [to which a student's parent belongs] should have a meeting with the students and the parents to study the policy of the Party, the relevant history, the relevant law, and the announcement published by the Public Security Bureau. They must often analyze what has happened in their unit and they must hold to the correct direction. If anything happens they are to inform. Student's parents must cooperate with the Student Liason Cadre and inform him of anything that happens [during the holidays]. Every unit must cooperate with the Student Liaison Cadre.

TO ERADICATE MANIFESTATIONS

Concerning activities for the students during the winter holidays:

1. The leaders of parents' units and the student cadres [*xuesheng ganbu*—students appointed as monitors over other students in their class] are to organize different kinds of sports and arts activities, and when the new term commences they will compare who has done best.

2. Concerning the organizing of social investigation [*shi-hui diao-cha*], the School's Political Study Department has already organized social investigation [tasks] for students and we demand that each student realize one task of social investigation. The main subject of their social investigation must be to eulogize the thirty years' achievement since the Peaceful Liberation of Tibet of the Communist Party's Nationality Policy and its Policy of Enriching the Nationalities [*Fu-Min*]. When the students return to school all the investigations will be checked and assessed, and compared to see which is best.

3. All students have been set some homework and parents should ensure that students complete their homework during the holidays.

We greet all the unit leaders and the parents with our best wishes.

[signed with the seal of]

[name withheld] School
[School] Party Branch
School Administration
Political Study Department

January 3, 1989

Translation of document received from Tibet Information Network, London, April 6, 1989.

86–87: Jeffrey Aaronson, Lhasa, 1998. As the Chinese national anthem plays, a crowd of mostly Tibetan schoolchildren salute the Chinese flag during a flag-raising ceremony at their elementary school.

OF TIBETAN NATIONALIST SENTIMENT.

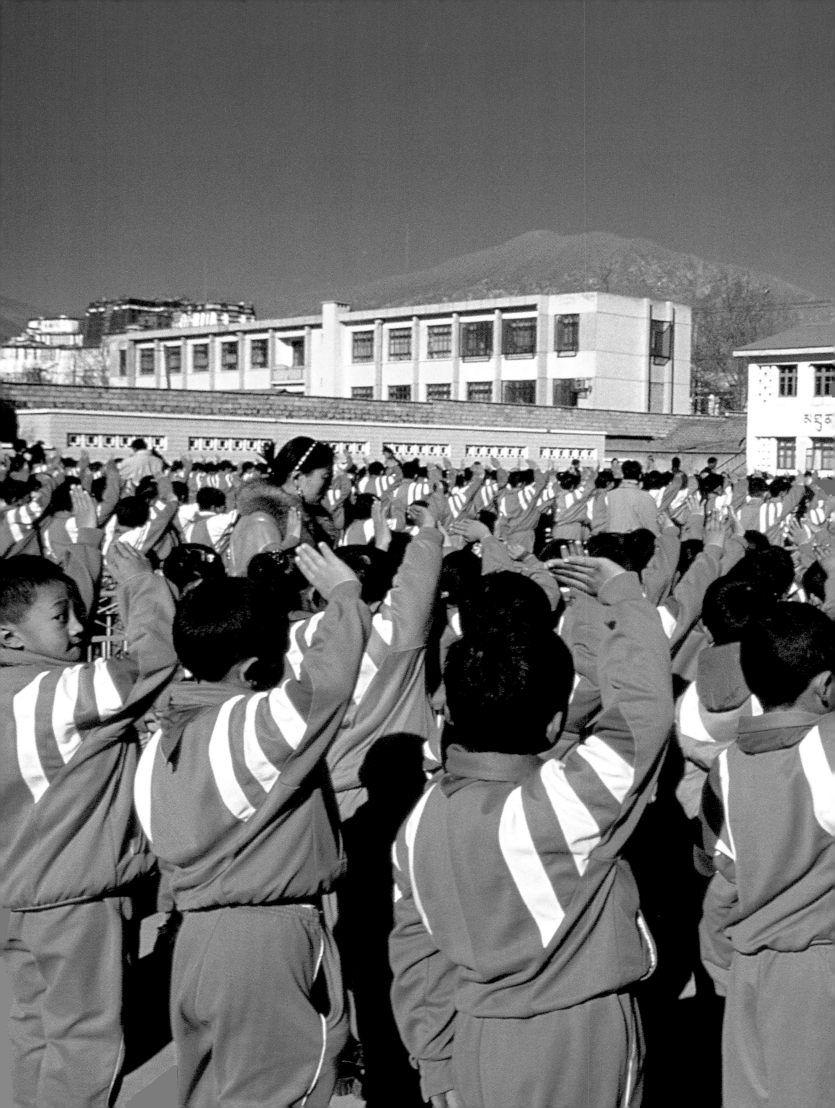

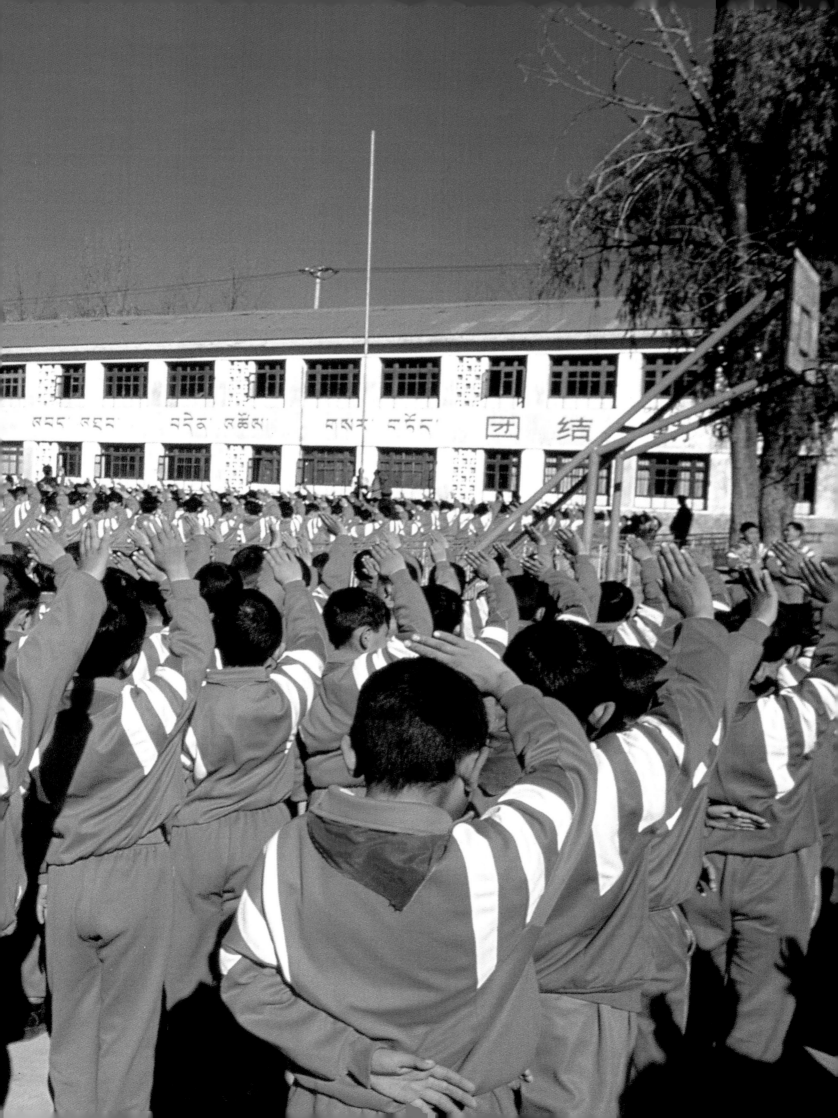

A Brief Summary of Propaganda Materials for Patriotic Education in Tibetan Buddhist Monasteries

—September 20, 1997

Lesson One: The main points concerning the propagation of patriotic education in Tibetan Buddhist monasteries and the strengthening of supervision over them in accordance with law

On the basis of the directive of the Central Committee of the CCP and the decision of the provincial party committee, the propagation of patriotic education was commenced in the second half of this year in all Tibetan Buddhist monasteries in the province with the aim of safeguarding the unity of the motherland, opposing splittism, and strengthening supervision of the monasteries. This is a primary responsibility in our province's religious work and represents a practical application of the movement of Loving the Nation and Loving Religion among Tibetan Buddhists. If this work is carried out successfully it will be of tremendous significance, not only in blocking the infiltration and destruction by foreign and domestic splittist forces, safeguarding the unity of the motherland, increasing the solidarity of nationalities, maintaining social stability, and increasing the pace of economic development, but also in leading Tibetan Buddhism into harmony with socialist society.

There are four major directions in propagating patriotic education. The first direction is education aimed at bringing unity to the Motherland and resisting nationality splittists. We need to make the broad mass of monks and nuns knowledgeable, through education, about the fact that Tibet is an integral part of China, and the roots of Tibetan nationality are found within the great family of nationalities of the Motherland, and to make them familiar with the natural historical development and progress of the Tibet region and other Tibetan areas which have occurred within the Motherland. Then the patriotic stand of the broad mass of monks and nuns will be strengthened and their willingness to safeguard the unity of the Motherland reinforced, and they will resolutely resist nationality splittists.

The second direction is education aimed at bringing religion into harmony with socialist society. We need to educate the broad mass of monks and nuns so that they know that this is the basis for the existence of religion within socialist society. If members of the clergy respect the leadership of the party and the socialist path, and continue Loving the Nation and Loving Religion and acting for unity and progress, then henceforth they may attain their legal rights and the respect of the people and achieve the status that religion needs.

The third direction is education on socialist democracy and law. We need to educate the broad mass of monks and nuns so that they are knowledgeable about our country's constitutional laws and legal practices and the need for religion to act within the constraints of specific policies and laws.

The fourth direction is education on nationality unity and nationality religious policy. We need to educate the broad mass of monks and nuns so that they know that if there is nationality unity, then social stability can be safeguarded, and there can be economic development and nationality progress. The broad mass of monks and nuns should be educated on the Party's nationality religious policy, and the broad mass of clergy members should raise their level of self-discipline in accord with policy and consciously act to safeguard nationality unity.

The majority of Tibetan Buddhist monks and nuns in our province respect the Party's leadership, respect the socialist path, support law and order, and, because their ideas are firm, have racked up diligent accomplishments in safeguarding nationality unity and the unification of the country. Generally speaking, this is very good. However, in recent years the Dalai clique has been doing whatever it can to sneak in and sabotage our country. In addition, due to our inadequate surveillance work and weak propaganda and education work, some matters requiring immediate steps have come up, even among Tibetan Buddhists in our own province.

First, the Dalai clique has been using religion to sneak in and promote splittist activities. With whatever means are at their disposal they raise the splittist cry for "Tibetan Independence," stirring up people's minds and sabotaging the unification of the Motherland and the unity of nationalities. A handful of monks and nuns have been taken in by the Dalai clique. Unable to clearly recognize some issues that have no truth to them and other important issues of basic political principles, they lack correct political direction. They even believe and follow the Dalai clique and carry out splittist activities. In some monasteries there have been instances in which the "Snow Lion" flag has been hung up and displayed.

Second, the feudal religious privilege is once more raising its head and interfering in administration and law, even to the point of dominating the basic structures in some areas. In such places people pay no heed to the basic administrative authorities and instead listen to lamas and incarnations. The mining of minerals and the harvesting of crops are all done according to what lamas and incarnations say. As a result, opportunities have sometimes been delayed and the people's production and livelihood have suffered great losses. In some places, members of the clergy have interfered in legal administration with talk of "blood money" and claims for "blood money." In some places, members of the clergy have obstructed and interfered with the local elections.

Third, the management of some monasteries has been in turmoil. Vows and rules have been lax and bad religious practices have developed. In some monasteries, the Democratic Management Committees are powerless and inattentive, and cannot exert the energy that is called for. Some members of the clergy only like expanding their monasteries and putting on large religious ceremonies, thereby increasing the heavy economic burden on the masses of religious believers. ∎

Document received from Tibet Information Network, London, February 1999.

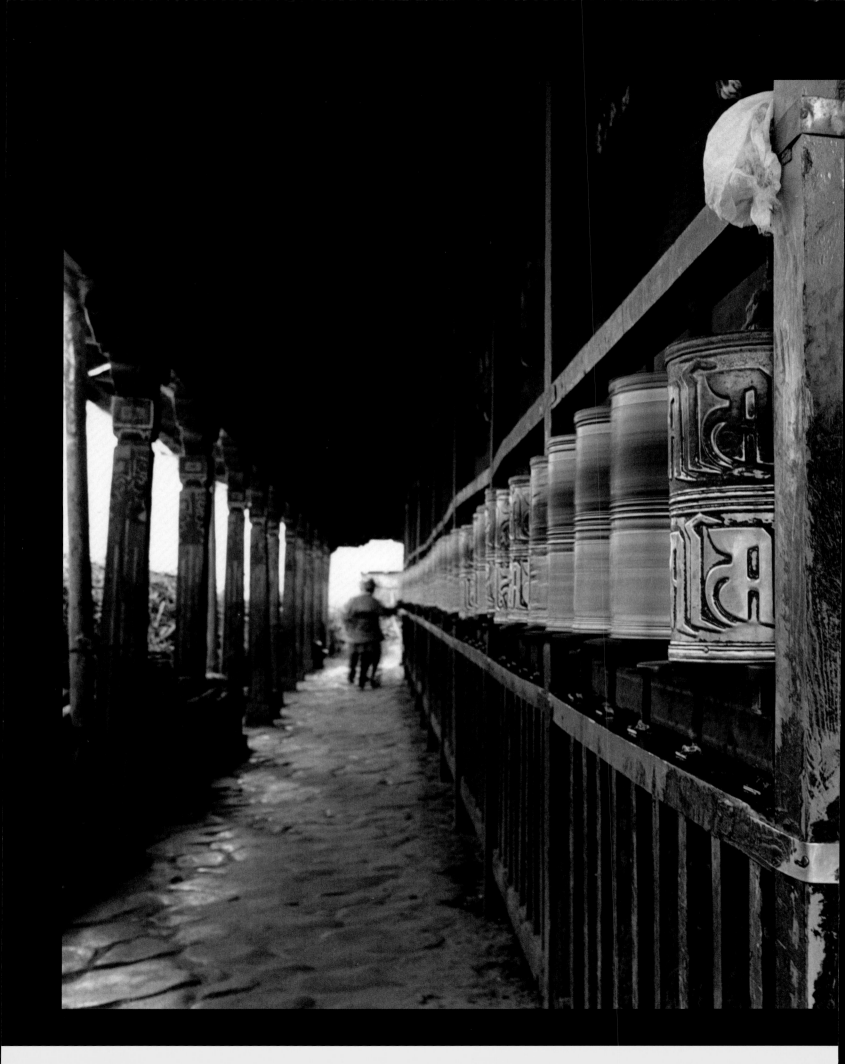

IN TIBET'S MONASTERIES, THE CHINESE GOVERNMENT

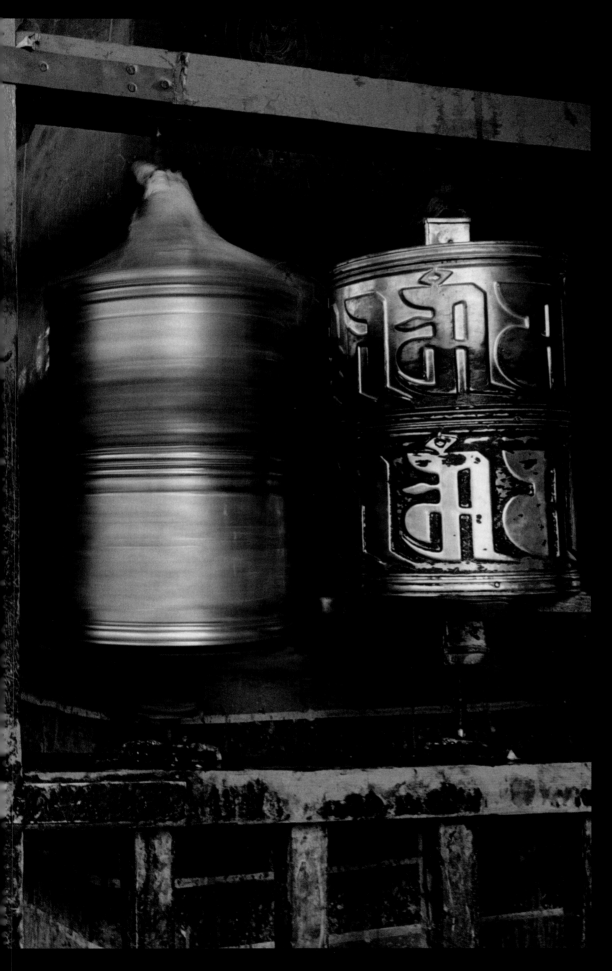

Left: Kevin Bubriski,
Lhasa, 1994. Prayer wheels
at Ramoche Monastery.

92–93: Russell Johnson,
Lhasa, 1987. As an offering of
thanks, a pilgrim tosses a hand-
ful of *tsampa* (roasted barley
flour) into the air near one of
the huge incense burners that
flank the entrance to the Temple.

94–95: Jeffrey Aaronson,
Lhasa, 1996. In the main
assembly hall of the Jokhang
Temple, monks play traditional
drums during a prayer
ceremony for Jowo Rinpoche,
Tibet's most sacred image,
located inside a chamber of
the temple.

96–97: Matthieu Ricard,
Gongla Pass, October 1998.
Prayer flags—which serve as
reminders of compassion in
meditation—inspire this wish:
"May whoever is touched by
the wind that blows upon these
flags find happiness and be
free from suffering." Gongla
is the first high pass from Nepal
to Tibet on the illegal walking
route via Nyalam.

98–99: Jeffrey Aaronson,
Near Lhasa, 1988. An image of
Buddha carved into a mountain-
side, with prayer flags on the
top of the mountain. Tibetans
come from all over to make
pilgrimages to Lhasa. When
those coming from the West
pass this Buddha, they stop to
clasp their hands and pray.

USES "DEMOCRATIC MANAGEMENT COMMITTEES"

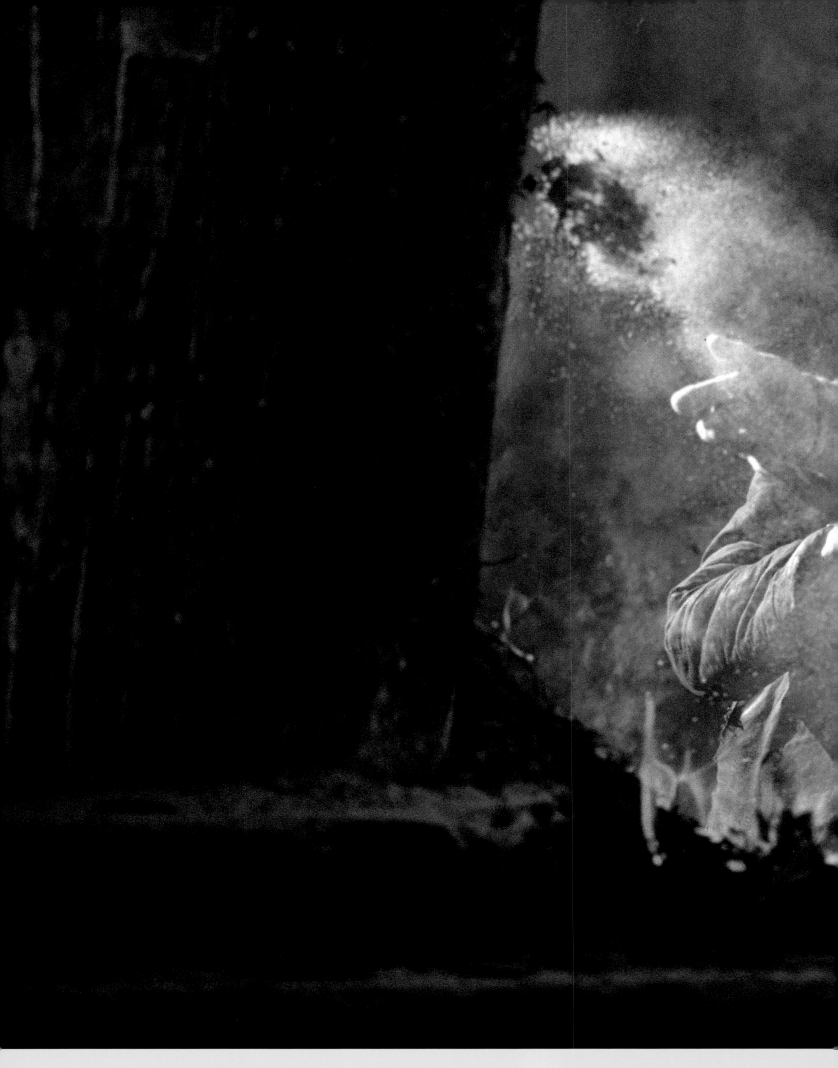

TO ENFORCE ITS AUTHORITY. YET RELIGIOUS

ACTIVITY CANNOT BE PURGED OF ITS PERCEIVED

NATIONALIST ASSOCIATIONS; GOVERNMENT

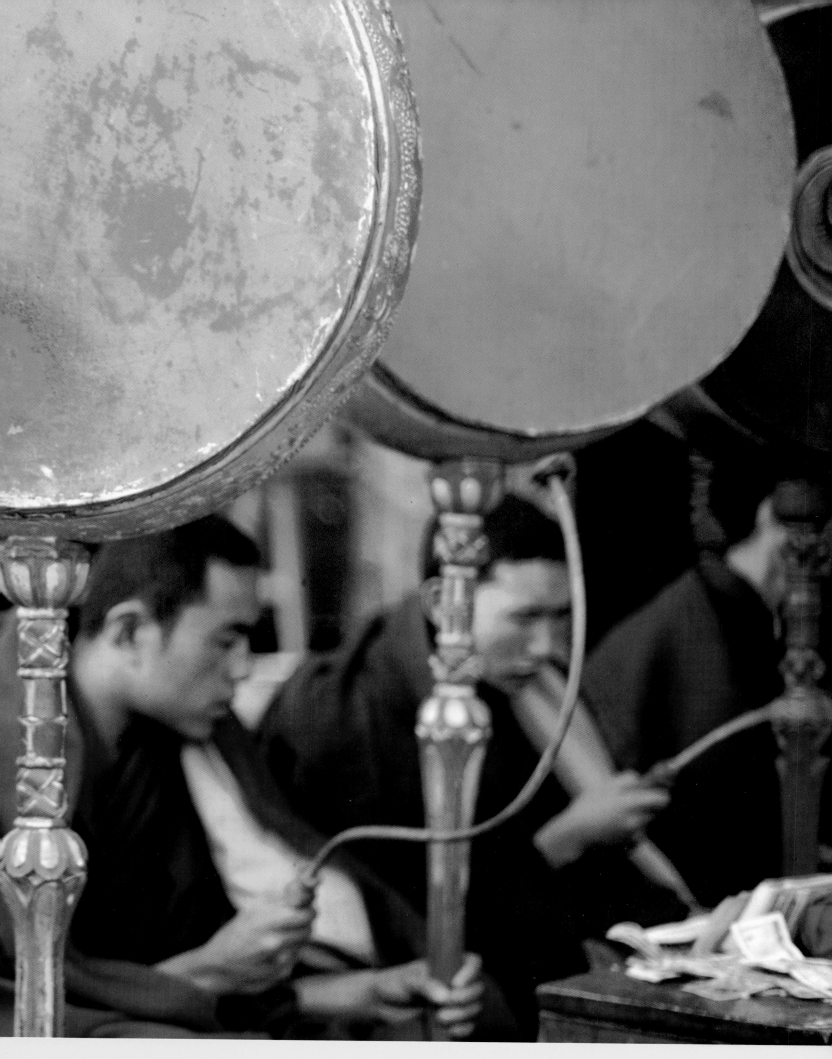

CONTROL ULTIMATELY REMAINS ELUSIVE.

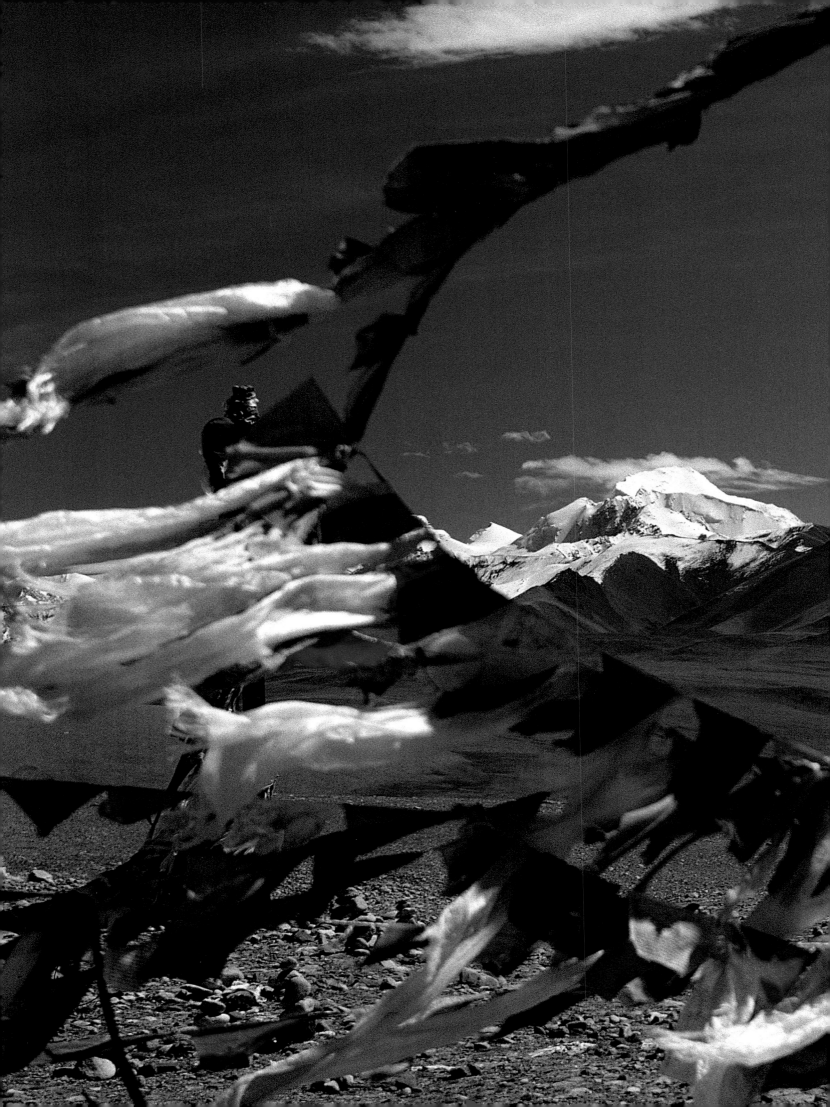

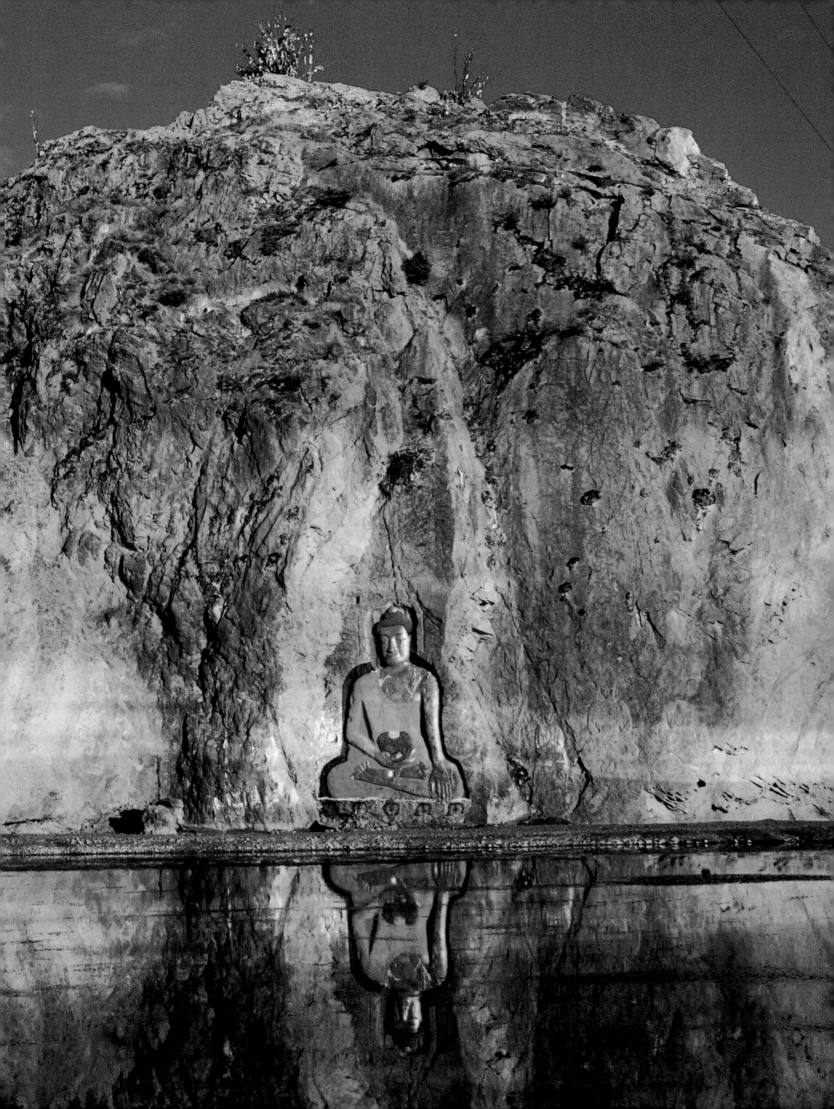

THE ECONOMIC POLICIES PURSUED ARE AIMED AT

INTEGRATING TIBET MORE RIGIDLY INTO THE PRC,

AND MARGINALIZING TIBETANS IN MAJOR

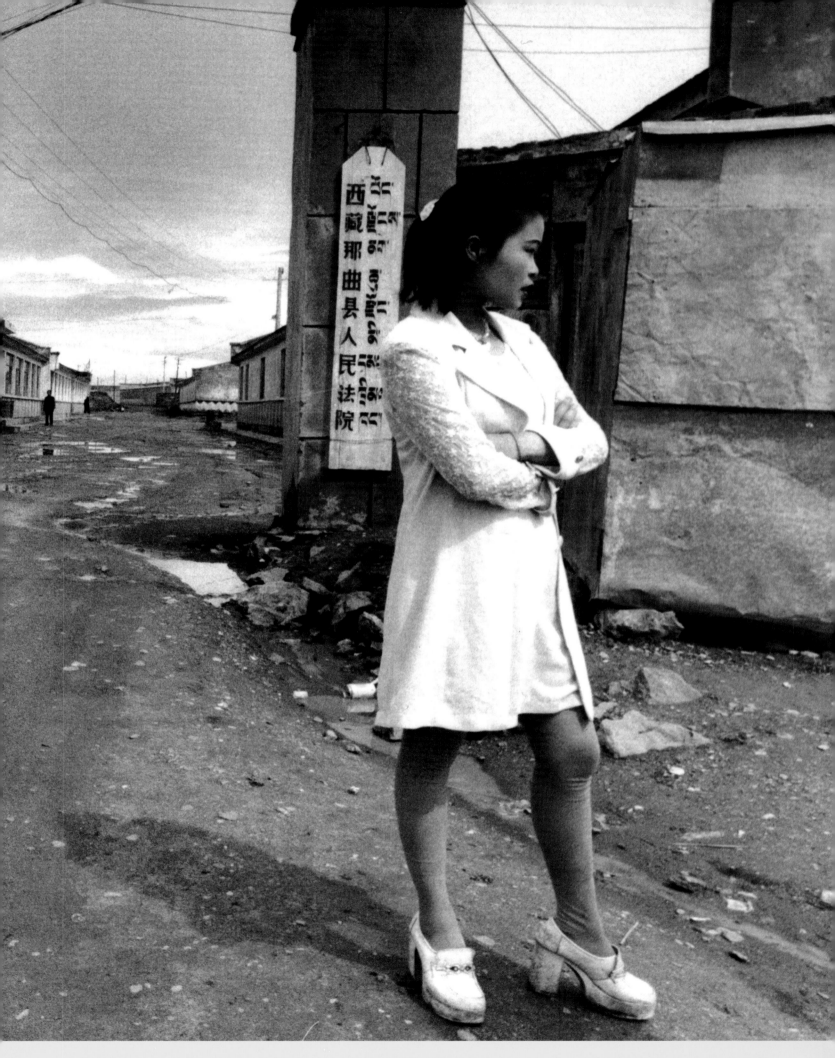

ECONOMIC CENTERS. ENTREPRENEURS AND MIGRANTS

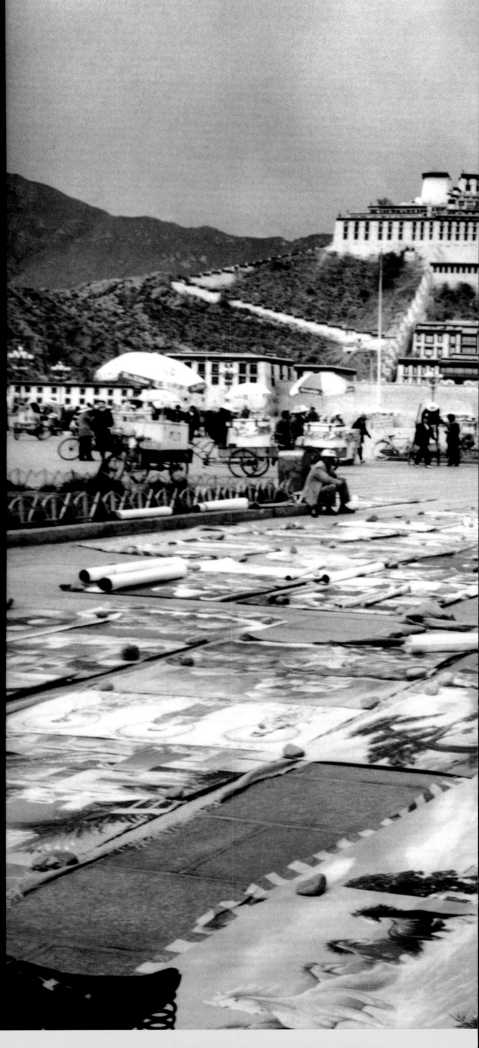

100–101: Steven Marshall,
Gepasumdo County (Hainan
Tibetan Autonomous Prefecture,
Qinghai Province), late 1995.
A Tibetan Buddhist *chorten* and
a Chinese transceiver-facility.

102–103: Alberto Giuliani,
Nakchu (Tibet), August 1998.
A Chinese prostitute.

Right: Carl de Keyzer,
Lhasa, 1998. Poster shop on
Potala Square.

**106–107: Photographer
unknown,** Qinghai Province,
1998. A Tibetan village.

FROM THE CHINESE INTERIOR IN TIBET DOMINATE

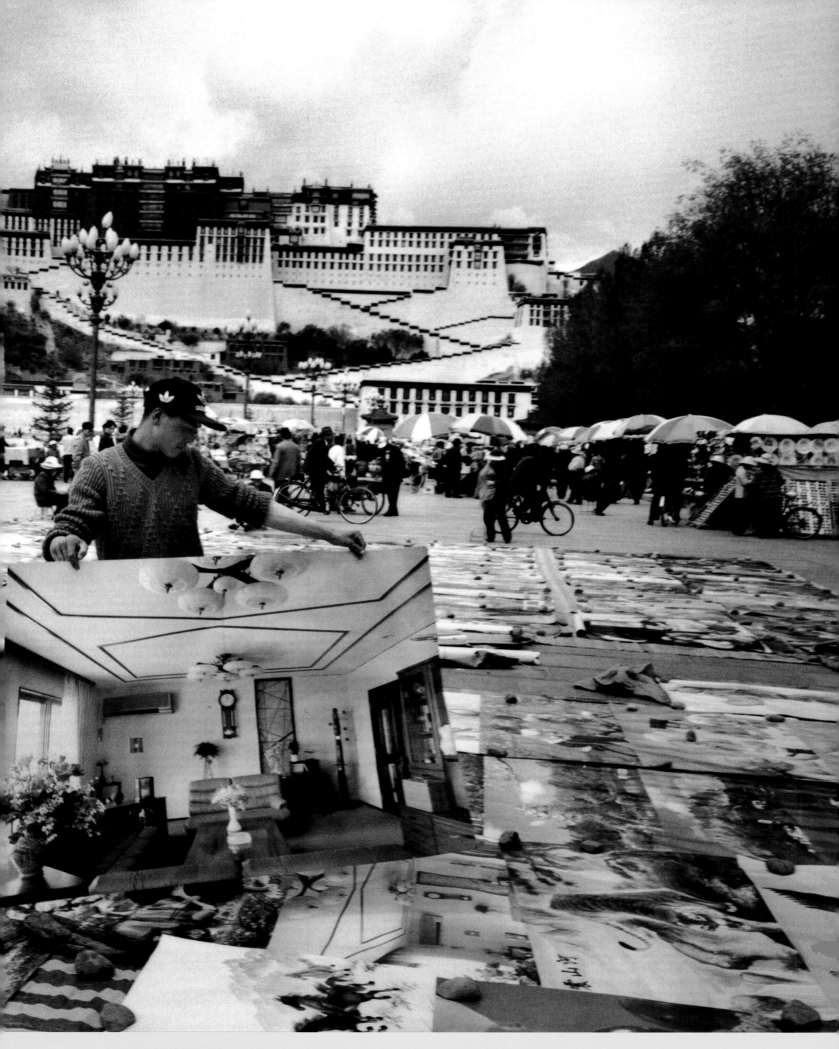

MUCH OF TIBET'S URBAN ECONOMIC ACTIVITY.

NOMADS THROUGHOUT TIBET FACE PRESSURE FROM

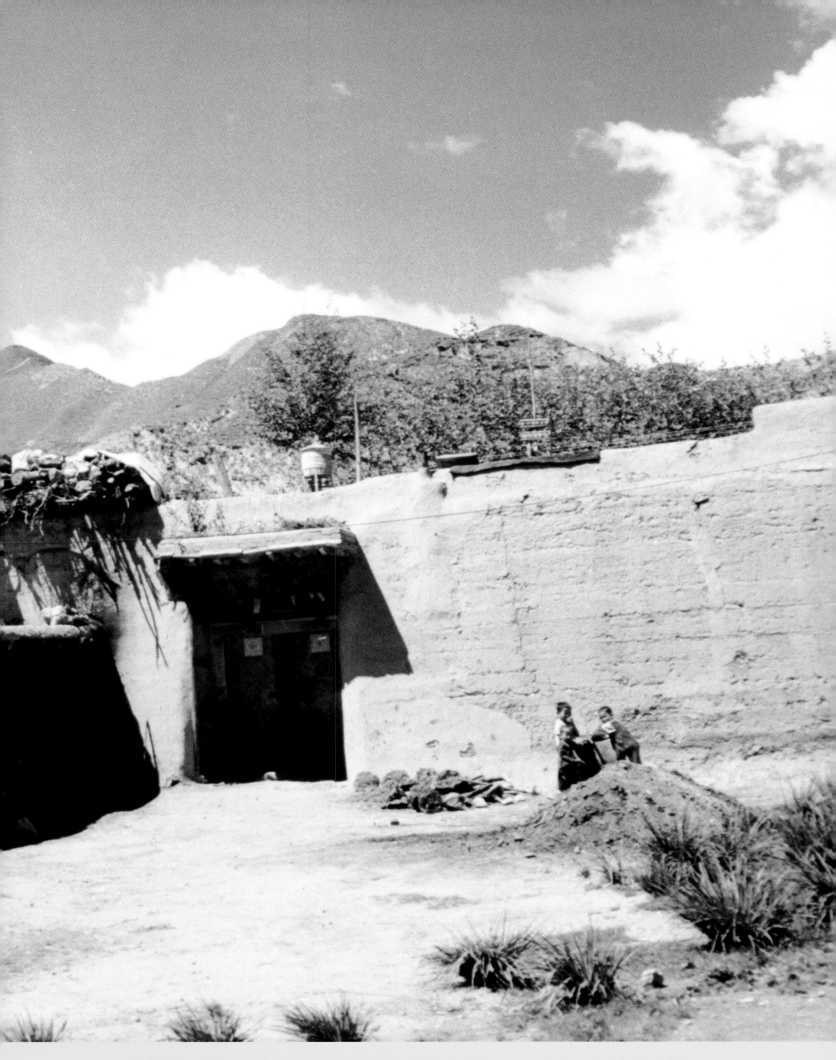

THE GOVERNMENT TO LIVE IN SETTLEMENTS.

Right: Franz Stich,
Nepal, January 1963.
Tibetan refugees.

MORE TIBETANS FLEE, RISKING IMPRISONMENT

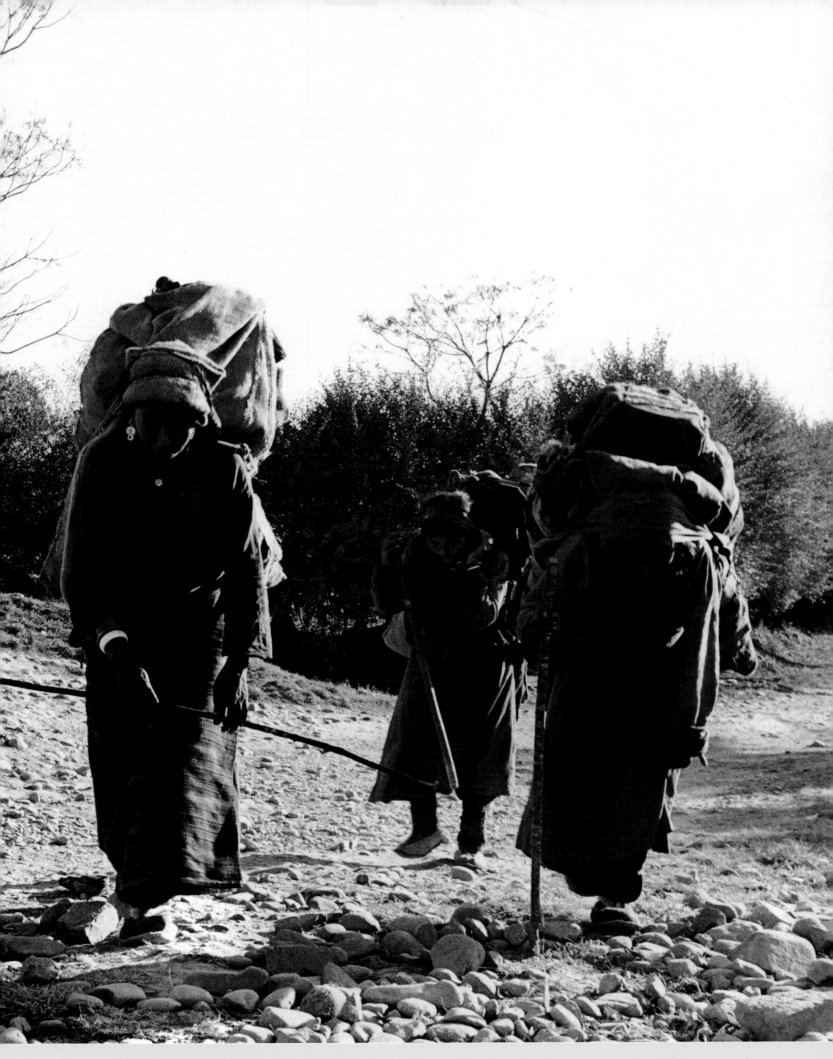

WITH OFTEN HORRIFIC CONDITIONS IF CAUGHT.

Right: Marcos Prado,
Dharamsala, 1996. Entrance
to the building where Tibetan
exiles are taken for care upon
arrival in Dharamsala.

IT IS ESTIMATED THAT EVERY YEAR ABOUT THREE

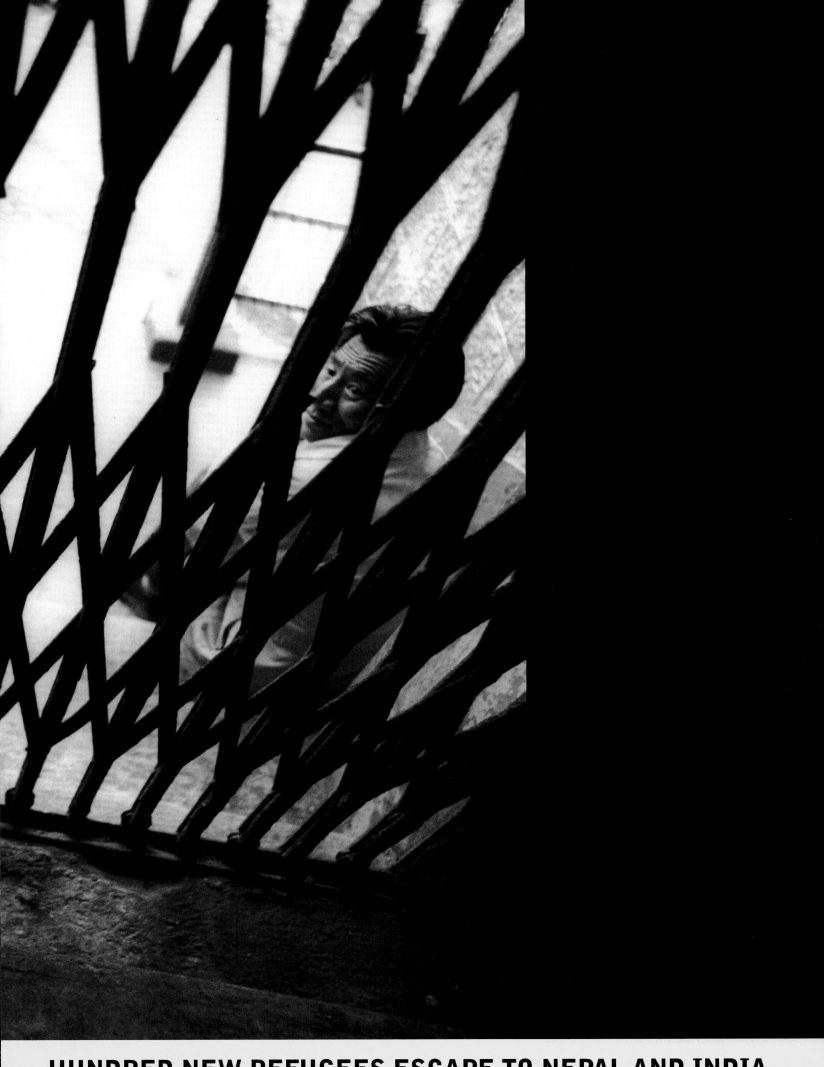

HUNDRED NEW REFUGEES ESCAPE TO NEPAL AND INDIA.

EXILE ACCOUNTS

Written and based
on interviews by
MICKEY SPIEGEL

JAMYANG DARGYE is a disillusioned Tibetan exile now in Dharamsala. He looked forward to life in India as a way of furthering his education, but none of his hopes have been fulfilled. He can't go back across the Chinese border to his home in Qinghai Province (Amdo to Tibetans), or he will be arrested for his active involvement in support of a free Tibet. When we met him in New Delhi, his future was bleak. At twenty-one, he has no full-time job and survives on handouts and odd jobs, including some translation work for Taiwanese visitors. He studies Japanese when he can and wants to go to college, but he can't afford it. He is extremely thin from tuberculosis and looks much younger than he is. Intense, feisty, often angry, sometimes depressed, Jamyang has little hope for the future.

Jamyang left Amdo for the first time in July 1993, thus missing the competitive examinations that determine acceptance to Chinese universities. He reached Dharamsala, the seat of the Tibetan government-in-exile, in January 1994, a month before his seventeenth birthday. He stayed just over a year, until April 20, 1995, then tried to go back to Amdo because he was homesick. Shortly after he crossed the border, he was picked up by police, and he spent the next year and two months in various detention centers, police stations, and prisons—five in all. He finally got back home in June 1996, but after both he and his family were severely harassed, Jamyang returned to India in August of the same year.

One of ten children—seven boys and three girls—Jamyang grew up in Taktsang, a Tibetan village in Hualong Hui Autonomous County, in Haidong prefecture. His family still lives there, growing wheat, barley, and mustard, as well as raising sheep and horses and some sixty or seventy yak. There are few opportunities for Tibetans other than farming in this poor agricultural county, and population pressure is reducing the land available for cultivation. Once predominantly Tibetan, by 1994 the county was more than 50 percent Hui Muslim, 23 percent Chinese and only 21 percent Tibetan. Foreigners must obtain special permission to visit Hualong; it is not easily granted.

Jamyang is the only member of the family to complete high school, skipping some grades along the way; in fact, he is the only one who finished elementary school while still living in Amdo. He left home because the area he is from has no facilities for furthering a Tibetan education. The lack of any meaningful opportunity for schooling in Tibetan language and culture is often cited by parents as a reason for temporarily leaving their children in India, where the Tibetan government-in-exile maintains extensive, accessible educational facilities. The Chinese-government school, although a mixed-nationalities school, was not only far away and expensive, it was not welcoming to Tibetans. "There were lots of Muslims and very few Tibetans at the school and the Han and the Muslims sometimes beat up on the Tibetans," Jamyang says. "But ever since I was little, I have never been afraid to fight."

Unlike Jamyang's two younger brothers, who went to India in April 1998 with their parents' blessing and what financial support they were able to muster, Jamyang left home without telling his family and without a passport. He actually escaped from school, telling his plans to only a few friends, who relayed the information to his parents.

It was a freezing but relatively uneventful group trip across the border into Nepal, and from there to Dharamsala. During his stay in India, Jamyang was enrolled in the Bir school, a facility where older arrivals in India could study English and Tibetan literature. At the

time he was there, most students stayed for about three years, although they could remain even longer. Jamyang estimates that all of his study time in India added up to perhaps six months. After fifteen months in India, his youth, homesickness, intermittent hospitalizations (apparently for tuberculosis), and what he perceived as his poor Tibetan—he speaks the Xining dialect—drove Jamyang to turn back home.

Jamyang's trip back to Tibet was a nightmare, marked by his arrest and detention, the callousness of his treatment, and attempts by the Chinese to recruit him as an agent.

Jamyang had decided to pretend he was Han—he speaks fluent Chinese, could pass as a Han, and had even chosen a Chinese name. He had his first run-in with the Public Security Bureau (PSB)—the Chinese police—almost as soon as he crossed the border into the Tibet Autonomous Region. At his first stop, a restaurant, four policemen (none of whom identified themselves as PSB officers) asked where he was from. "Lhasa," he said. When they asked for i.d., Jamyang said he had traveled from Lhartse in a truck and lost it on his way. At that point, he was handcuffed and transported to the PSB office in Kyirong for interrogation. Police officers there told him they knew he was not from Lhasa but had crossed the border on his way from India. When he disagreed, two officers drove him back the way he had come, stopping after about an hour at a Tibetan house. An old man answered the policeman's knock, and said that he had seen Jamyang come from the direction of the border. Jamyang shouted that the man must be mentally incompetent, and received a punch in the mouth from one of the officers. The party then returned to the Kyirong police station.

Two Chinese and two Tibetan police officers, three of whom were in uniform, took Jamyang into an office, unlocked his handcuffs, and without saying a word began to beat and kick him. They forced him to squat with his arms extended, a brick placed on each thigh, and one at the back of each knee. One of the Tibetan policemen, "a good man," Jamyang said, punched him several times, then told the others to leave him alone. But while he was still in that position, the deputy head of the Kyirong PSB, a Chinese man named Wang, entered the office and took charge. He announced in Chinese that Jamyang was very strong and he, Wang, was going to teach him a lesson. Jamyang still has scars on his back from the beating Wang administered with a piece of spoon-shaped metal—the kind you use to remove dishes from a Chinese stove. Wang told Jamyang that he knew who he was and where he was from. He repeated that Jamyang was very strong, since he still was not crying, but told him that it was better to confess everything. Jamyang replied, "If the police know who I am and where I'm from, they don't have to beat me." He was beaten nevertheless, from midnight until about 4 A.M. Finally he was taken to another room and placed in a prone position between two beds, one arm cuffed to each bed, and one policeman asleep in each bed. The cuffs were the kind that tighten with the slightest movement, and are extremely painful.

Early the following morning, Jamyang was moved to the Kyirong County Detention Center. For the next eighteen days, he was questioned about the Tibetan Youth Congress (the Tibetan exile organization most insistent on independence rather than autonomy for Tibet); the Tibetan government-in-exile and the operations of its security office in Dharamsala; his own alleged spy training, including where it had taken place, his code name, and his secret number. He was not beaten. Jamyang told us, "Chinese policemen aren't highly educated and they asked me a lot of questions about Dharamsala. I told them I didn't know anything about Dharamsala—that they probably knew more than me because they have their own agents there." Between interrogations, Jamyang managed through a system of knocks on the wall to establish communication with other detainees.

While Jamyang was in the detention center, the owner of the restaurant where he had been apprehended came to visit and bring food. Jamyang asked if he would burn some books that he had left in the trash can in the restaurant. Jamyang told the owner they were Buddhist texts, although they were actually documents carried from India, among them

Guidelines for Future Tibet's Polity and the Basic Features of its Constitution, and *My Land and My People*, the Dalai Lama's autobiography. As they were in Tibetan script, the other man couldn't read them. However, after the restaurant owner told a policeman about the books, the restaurant owner was brought to the detention center and beaten severely. Jamyang said, "When I heard him crying out in pain, I felt pity and I confessed. I shouted out in Chinese, 'I came from India. I'm a Tibetan!,' and the beating stopped."

The next stop for Jamyang, in June 1995, was the Nyari Detention Center in Shigatse, where for six months and fifteen days, along with the four others in his cell, he did little but wait and respond to interrogation handled by State Security Bureau personnel. The interrogation was low-key and polite, and the questioning centered on his alleged spying and "subversive" habits:

"You're young. You seem to know a lot. Your Chinese is very good. Where were you trained?"

"I read a lot."

"What do you read?"

"I read Wei Jingsheng's *Democratic China*."

"What is in there? What does it say?"

"It says, 'China needs democracy.'"

Three or four times, Jamyang wrote letters on the back of cigarette wrappers—a common prison substitute for paper—to the head of the Shigatse PSB, a Tibetan named Palden. Jamyang's message was simple, "If I've done something, try me; if not, immediately release me according to the law. If you don't, you're breaking your own law." No one paid any attention. Life, Jamyang says, was bad in Nyari. He had the usual food complaints. Breakfast was tea and one *mantou*, an unsweetened coarse bun; lunch, filthy rice noodles infested with insects and pebbles, and a few vegetables; supper, two *mantou* and vegetable soup. He was freezing in a long-sleeved cotton shirt and jeans with holes. "You could see my ass." Prisoners whose family members knew where they were being held could send food and clothes; Jamyang's family never knew his whereabouts. He was beaten just once at Nyari, when he protested the beating of an old monk by shouting, "You have no right to beat an old monk. You are here to guard and teach us." For this, a Tibetan named Tsering Gochen (Big Head) hit Jamyang several times on his back with a club. Jamyang was ordered to work just twice, loading vegetables that other prisoners had grown onto a truck. As far as he could tell, those held in Nyari did not have an extraordinary workload.

At Nyari and at other detention facilities, those privileged inmates who delivered meals often delivered the latest news. Jamyang learned, among other things, that Ngawang Choephel, an ethnomusicologist, later accused of spying and sentenced to an eighteen-year prison term, was also in Nyari. He also learned that on July 12 in the middle of the night, thirty-seven monks from Tashilhunpo monastery were brought to Nyari after they disrupted a meeting called by regional-level officials to denounce Chadrel Rinpoche, the monastery's abbot, for his part in the search for the reincarnation of the Panchen Lama, the second holiest figure in Tibetan Buddhism. (Chadrel Rinpoche is now serving a six-year term in a secret facility in Sichuan province.)

According to Jamyang, because he was so contentious—a trait that may have helped him cope and survive—the authorities thought he was a spy. On December 15, 1995, cuffed to the sides of a truck, he was transferred to Seitru, a state security facility in the northeastern suburbs of Lhasa for political detainees awaiting sentencing (many of them would later receive long sentences). Jamyang has few complaints about his more than four months in Seitru. He and the other prisoners, some seventeen to twenty in all, were held in individual cells. Work consisted of moving night soil to the vegetable fields, and this afforded the men an opportunity to talk, although discreetly, under the watchful eyes of the guards.

The next leg of Jamyang's journey brought him closer to home. Two officers from the Qinghai Province PSB came to Seitru, asked a few questions and then escorted him in cuffs back to his home province. On the bus to Golmud and the train from Golmud to Xining (the provincial capital), they

announced to fellow passengers that Jamyang was a murderer. At provincial headquarters, the PSB's first division, charged with political security, took over. Jamyang's handcuffs came off. He was supplied with new clothes, then taken to an upscale Muslim restaurant. Some ten or twelve officers, all high officials in Western-style clothes, according to Jamyang, were his companions. His best bet, they told him, was cooperation. "You're young; you're intelligent. You'll be able to travel to other countries." After the meal, the conversation continued as they rode out of the city in a flashy Japanese car with tinted glass. "I'm a student," Jamyang said to them. "How could I cooperate?" Remembering this exchange, Jamyang says he was laughing inside at their proposal; he knew they were trying to trick him.

At first, the car followed the route to his village, but about halfway there, it turned onto an unfamiliar road. Jamyang did not know that he was headed for Ledu county, an overwhelmingly Han area with a small Tibetan presence, just east of Xining—specifically, to the Ledu County Detention Center.

For nine days Jamyang was severely brutalized by the seventeen "ordinary criminals" who shared his cell in Ledu. "By then," he said, "I was weak and thin. I fought with them but I couldn't compete. I was sometimes beaten more than once a day. The 'cell boss' ordered the beatings when the police told him to. There were ten in the nine days. And sometimes I was ordered to bend over and the others pushed into my ass with their hands." On each of the nine days, two Xining public security officers, the same two each time (one named Qi Yude), tried to convert him. When Jamyang told them about the beatings, they replied, "This is normal; this is how it is. But if you cooperate, you'll have a house, a car."

Without warning, on the tenth day, Jamyang was taken by car, a filthy one this time, to another restaurant, this one in Ping'an, the Sinicized and industrialized capital of Haidong prefecture. During a lunch with seven or eight officers from Xining headquarters (some of whom he had eaten with before), he was told he would be going home, but with conditions attached. He could tell his family, but no one else, that he had been in India. He could tell no one, including his family, about his experiences with bureau officers and with state security agents. Nor could he contact foreigners; and he was forbidden to travel outside his home county without police permission. After a six-month probationary period, his status would be reevaluated. He received nothing in writing. In fact, during his entire ordeal, Jamyang was never given or shown any official document. He was never allowed to read what had been written during interrogation sessions, but was made to sign the transcripts.

Jamyang was driven to Bayan, Hualong's county seat. From there he made his way to his own village of Taktsang. He had borrowed five *renminbi* from the police for a ticket home, but when he met fellow villagers in Bayan, he hitched a ride on their tractor. By then his family already knew he had left India and was headed home, although they had no idea when he was arriving or that he had been caught and incarcerated. He finally arrived home in June of 1996—fourteen months after his departure from India. "When I got home, I looked like a beggar. My parents were sad to see what I looked like. And I was shocked at their appearance: they looked a lot older. My mother hardly

Jamyang Dargye,
1998

looked human, and my father looked decrepit. They told me they had made pilgrimages to monasteries and had prayed every day."

Jamyang expected to remain with his family, but a series of compromising incidents, including occasional, irregular, and very public police "visits," made him realize how difficult it was going to be for him to stay.

> I was home two days when a car with a light and a siren going arrived at my parents' house. I was taken to the Hualong County Public Security Bureau. It seems they didn't have a file on me, so I was pulled in for interrogation—the whole thing all over again. But they didn't try to turn me. They really wanted to know about India. They kept me one night.

A second incident involved an unexpected interrogation while Jamyang was in Bayan. Soon after Jamyang arrived home, his neighbors came to see him, as did many of his classmates, some from far away. A number of them gave him money. He used a portion to pay for more than twenty days of treatment and medication at the Hualong Hui Bayan County People's Hospital, and for his stay at a hotel close to the facility. "I thought I had heart problems," he said. The trouble turned out to be malnourishment. "Every time I went to the hospital, I was followed by an unmarked police car. One time, they pulled over and told me to get in. I did. They took me to a guest house." This time, officers from the Qinghai State Security Bureau interviewed him. They showed him photographs of several people—head shots, profiles, body shots—and asked if he had ever seen any of them before. He hadn't. "I still don't know who they are," he said. The officers then took his photograph, told him that if he would cooperate he would be welcome in Xining, and sent him back to where he had been staying.

The third and final incident came during a trip to a relative's house in Hainan Tibetan Autonomous Prefecture, a predominately Tibetan locale, and a day's bus ride from Jamyang's home. As required, Jamyang had reported his travel plan to the police. His first stop was the Hainan Prefecture Minorities Teacher Training Institute, where he spoke discreetly about India and Tibetan independence to some students he knew from his own schooldays. He also distributed some twenty-five pictures of Gendun Choekyi Nyima, the child recognized by the Dalai Lama as the reincarnation of the Panchen Lama. A picture of the boy had been given to Jamyang when he returned home and he had managed to duplicate it.

At midnight, state security officers from Hainan prefecture showed up at Jamyang's relative's house. "They knew me; I didn't know them. They wanted to know why I had come. They kept me about half an hour." After his relative told household members and others what had happened, Jamyang realized that staying could jeopardize his relative's relations with his *danwei*, the work or residence unit that controls most aspects of an individual's existence, including livelihood, housing, and social welfare benefits. And when he returned to his own home, he realized that his family was already, as he put it, "broken and suffering." The authorities often came unannounced to the house to ask about his activities, and he knew that if he stayed the whole situation would become "crueler." He thought about buying a gun and taking revenge on the police in Shigatse for holding him illegally, and on the police in Xining for allowing him to be brutalized, but, knowing the Dalai Lama would not welcome him if he went through with his plan, he talked himself out of it.

By the beginning of August 1996, two months after he had arrived home, Jamyang was ready to leave. He was well set up, he said. The necessary help, money, transport, and introductions had all been arranged through "ordinary" folk and through some in positions of influence. By October, Jamyang was back in Dharamsala where his weakened condition kept him in the hospital for six months.

Jamyang is restless and rootless in India. He's now too old to be a student in Dharamsala; he's already had the one chance for an education he's entitled to under Tibetan government-in-exile auspices. He's still sick, and taking medication for tuberculosis. Some days, Jamyang is ready to go home whatever the consequences. ∎

LAMA KYAP never stops moving. If he is not with his wife managing the Delek Cafe, he is on his motorcycle heading to work at Dharamsala's Amdo Community Organization, where he is general secretary, or to the language school he established for local residents. Then again, he may be elsewhere in Dharamsala, employing the teaching skills and legal knowledge he acquired in Repkong, the prefectural capital of the Huangnan Tibetan Autonomous Prefecture in Qinghai Province.

Lama Kyap is proud of his legal skills, and credits them with keeping the time he spent in detention to a minimum and reducing the extent of the brutality he experienced there. But he is also convinced that career opportunities for him in Amdo disappeared after he decided to "exert himself in the cause of Tibet." That began in 1984. Ten years later, on September 28, 1994, Lama Kyap arrived in India, four months after the arrival of his wife, Dorje Tso, and one of their two daughters.

Lama Kyap was born in October 1962 in rural Tsanmo, Repkong county, the second oldest child in a family of four brothers and three sisters. Although his father did some woodworking, the family's livelihood depended on the wheat, barley, potatoes, radishes, and greens they grew as subsistence farmers. Lama Kyap spent six years, from 1970 to 1976, studying math and Tibetan in the village before moving on to middle school. After passing an exam at the end of twelfth grade, he began to teach.

The first time Lama Kyap came to the attention of the police was on October 12, 1987 when, in response to demonstrations in Lhasa, he and two friends organized a protest of students and staff from the Repkong County Nationalities Middle School, a boarding school where he had been teaching Tibetan, math, and geography since 1982. As he recounts with a great deal of pride and pleasure:

> There was local agitation against the official family-planning policy and for Tibetan independence, so we decided to organize a similar affair. I was the main speaker. Most of the students in the eleventh and twelfth grades participated, and some from the ninth and tenth grades. The student population was 1,080, and 400 students participated. Part of the success was that I was in charge of one of the grades. We assembled at school, marched past government and Party offices, and finally rallied in front of the main government building. We were carrying banners and shouting, "Long live the Dalai Lama!" "Tibetan independence!" "Chinese out of Tibet!" The local officials called out all the security forces: public security, state security, the army, the People's Armed Police. They didn't interfere with us, but surrounded the marchers. The whole incident lasted five hours.

At the rally point, officials asked Lama Kyap and his friends to explain why they had demonstrated. As spokesperson, Lama Kyap explained that it was because of the great differences between the experiences of Chinese and Tibetans. When asked how they were different, he replied:

> We have a boarding school; you don't. You have five to six buildings: we have one very old building. You have a cement floor: we have a dirt floor that muddies up in the rain. We have a hearth only in the kitchen. In the winter, our hands and feet freeze. You have wood stoves in the classroom. We have one kitchen for one thousand students. Why are there such differences? And, why, since this is a Tibetan area, is everything in Chinese, in the offices, hospitals, markets?

Lama Kyap went on to talk with his interrogators about the official family-planning policy. "There are few Tibetans in a large area," he said. "Why do we need a family-planning policy? Besides, we have many monks and nuns." (Many Tibetans argue that the large numbers of celibate monks and nuns in Tibet make for "natural" family planning.)

Two days after the demonstration, Lama Kyap's troubles really began. For two months, he was placed under house arrest, banned from the classroom, and confined to his living quarters at the Repkong County Nationalities Middle School. Government officials and police officers questioned him daily.

> Their primary interest was in whether there was a connection between the Lhasa demonstrations in September and October 1987 and ours. One other teacher and four students also were under house arrest.

The students were given demerits and told they would be expelled if they did it again. County, prefectural, and Public Security Bureau officials—not the highest-ranking ones—came to school to talk to the teachers and staff. My friend and I were criticized at the meeting. Everyone was sitting down but the two of us. One officer said, "You were wrong; you opposed the government." I was twenty-five years old and I wasn't scared. I said, "I'm right." They told me, "If you do it again you'll wind up in prison."

From then on, state security kept Lama Kyap under surveillance.

In May 1989, following massive demonstrations earlier that year in Lhasa, there was another incident at school. This time, the protest occurred at a celebration to which students and staff were to wear their best clothes. But instead of arriving in local traditional dress, participants came in Lhasa-style dress. When government and police officials accused them of supporting the rioting in Lhasa, the organizers replied, "The Chinese leadership wears Western clothes. Do they support the West?"

Three months later, in August 1989, Lama Kyap and a friend were effectively demoted, sent off to teach at a two-hundred-pupil day school in Mepa, a poor district some thirty kilometers away. Conditions there were even worse than at Repkong County Nationalities Middle School. A year later, Lama Kyap was moved again, this time to Repkong Elementary School Number Two. "I felt they were pressuring me," he said.

In December 1990, Lama Kyap took an exam that earned him a substantial promotion, despite his history of political activity. He had prepared for it for several years by using school breaks to take courses in Chinese, Tibetan, Buddhism, and pedagogy at the Qinghai Province Education College. Of the seven who competed, he was the only successful examinee. In January 1991, Lama Kyap was assigned to the Qinghai Province Judiciary Institute, which trained people who were already procuratorate, court, and police cadres. It was located in Xining, the capital of Qinghai province and its largest city. Two other schools shared the campus, one for Tibetan students and the other for cadres studying law. In addition to his regular duties (teaching Tibetan and translating Chinese law into Tibetan for those students), Lama Kyap was able to acquire some legal training. According to him, "The authorities couldn't prevent the promotion because I hadn't broken any laws. The other teachers and students would testify that I hadn't done anything illegal."

On June 4, 1993, the fourth anniversary of the crackdown in Tiananmen Square, and two years and five months after he had moved to Xining, Lama Kyap and a friend opened a Tibetan nursery school with the goal of expanding it by one grade every year. "Actually, my friend established it and I helped. I was the headmaster and decided on the curriculum, books, and teachers. We had five or six students. The school was in Xining, and it was free of charge. The authorities didn't catch the significance of the opening date."

A month later, on July 2, 1993,

> The Qinghai security police came to where I taught. The watchman told me that someone was waiting to see me. I thought, "What's happened?" That man told me "You will go to the central translator's office" [a provincial office that handles translations of documents into several of the languages in common use in Qinghai]. I said, "But they have many translators, why me?" We walked about thirty meters and the man showed me a letter that said I had conducted counterrevolutionary activities. We went to a car, and another man suddenly came out and hustled me into the car, and then handcuffed me. I sat in the back, between two men. A driver and another man were in front. The man who showed me the letter left. I said, "I am a Chinese citizen. I have i.d. I am a law-school teacher. What you are doing is illegal." They showed me another paper from state security that said I was *fangeming*, a counterrevolutionary.
>
> They took me to the Huzhu County Detention Center [a first stop for alleged political offenders] in Haidong prefecture. I'd never been to that [non-Tibetan] area before. It's maybe fifty kilometers away. First we went to the police station. The driver and the security men remained in the car with me. One person went into the office for about half an hour. When he returned, he told the driver to continue on. When we got to the detention center, they gave me a complete body check, took my belt and shoelaces and watch and put me in a cell with a hole for a toilet—no light, no window, a peephole in the door. I was

alone. After about half an hour, two policemen came to take me to another room and left me there. All the instruments of torture were on the wall. There were five men sitting at a table. I was facing them in a straight chair with a piece of wood across the front. One of my hands was handcuffed to it.

Three men were from the provincial level Public Security Bureau . One was the second-highest-ranking officer in the prefecture's State Security Bureau, and one acted as secretary. A man named Hu, deputy chief of a PSB branch, was clearly in charge.

Lama Kyap said that despite the strange silence, he wasn't afraid. He tried using his legal knowledge and verbal skills to foil his interrogators, but with little success. From the beginning of the questioning, which lasted over two hours, Lama Kyap feigned confusion, insisting that he did not know why he was in detention and that he had done nothing to oppose the government. He insisted, "I'm a law-school teacher. I know what is legal and what is illegal. I've studied for twenty years, and I've taught for about twelve years, so I'm clear about the situation." And he added that he had a wife, a child, and parents, all with health problems, whose security he would not put in jeopardy. His interrogators let him know that despite his slyness, they would make him confess.

In a further attempt to stall, Lama Kyap asked for a translator, but the request was denied because of his knowledge of Chinese and his own work as a translator. Again he was insistent, arguing that although he had translated books, there might be questions he wouldn't understand and should he answer erroneously, he would not be able to correct himself. His interrogators accepted the argument in principle but refused to allow a translator on the grounds that the proceedings were secret.

Lama Kyap tried another tack, suggesting that his detention came about through a case of mistaken identity. The paper ordering his arrest, he said, used the wrong character for one of the characters in his name. At this point, Lama Kyap's interrogators grew impatient, ordering him to "stop his tricks." They then turned to the heart of the questioning: the people he knew. Again Lama Kyap tried to buy time, saying, "My social relationships are quite wide. I've been a teacher for ten or eleven years. I've had more than a thousand students. I know their parents, their friends, their neighbors— do you want me to tell you about all of them? Do you want me to discuss whom I know in Repkong, or whom I know in Xining?"

When his interrogators suggested he talk about Xining, Lama Kyap avoided discussing the people he knew through his clandestine Tibet support work there. Instead, since he had been careful not to mix his school responsibilities with this other work, he talked about all the Chinese, Tibetan, and Hui contacts he had at school. But his interrogators were not fooled and narrowed the focus once more, this time to the Qinghai Nationalities College.

Again, Lama Kyap went into a lengthy monologue, talking about all the people he knew at the college, naming many of them when asked. His friend with whom he had opened the Tibetan nursery school was a research student at the college and as soon as Lama Kyap mentioned his name, Samdrup Tsering, the interrogators wanted to know everything about their relationship, and if Lama Kyap knew everything Samdrup Tsering was doing. Lama Kyap told them:

We had three different relationships: teacher/student, classmates, and we're from the same county so we're friends. When I was in teacher-training school and he was in elementary school, a former Repkong monk became the cook at the school; he was a friend of my father's and he knew Samdrup Tsering's family. After school, the former monk taught us about Buddhism. As for our friendship, we have a saying in Tibetan: friends are friends, business is business. . . . You two men are asking questions; this is business. . . . But Samdrup Tsering and I are friends.

Chief Hu grew impatient and accused Lama Kyap of lying to cover up the truth, saying that the two men had formed a counterrevolutionary group. "And now," the chief said, "we stop the questions. Go back to your cell and think. And when we start again, tell us about the counterrevolutionary group." Lama Kyap countered that he had no need to think and warned Chief Hu about the

trouble he could get into for arresting an innocent person, particularly one who knew the law. Chief Hu was clearly not intimidated, and only replied, "You'd better think it over well. If you aren't honest, we are going to hand you over to someone else." Lama Kyap answered Chief Hu, "Under no circumstances can you beat or torture me. It's in Chinese law. Guilty or innocent—it's not allowed by Chinese law. If you beat me, if you torture me, one day when I get out of prison, I'll take it to court."

The second interrogation session, three days later, lasted more than two hours. Lama Kyap was prepared with a new approach. Following a strategy he and his wife had devised when they worked as a team on pro-Tibetan activities, he immediately said he was not feeling well, that his heart was bothering him and that his stomach felt bad. Should his wife get caught, she was to be sure to tell her interrogators that her husband had a bad heart and stomach. (He actually does have a mild heart disorder and a stomach problem.) To add to the story's credibility, he had consulted a doctor who gave him documentation confirming his condition, all of which had been seized when he was detained.

Once more, success eluded him. Lama Kyap's captors readily agreed to allow him one pill a week, starting immediately, and then took up the interrogation where they had left off. What was his relationship with Samdrup Tsering? What was the goal of the school the two had founded? Where had the money come from? Who else had helped them? Lama Kyap protested that he had been a Chinese Communist Party member since 1993, and was a responsible family man, conversant with the law, and not a liar. He told them:

> As to the goal, there are no facilities in Xining from elementary school through college that are all in Tibetan. In Xining we have Tibetans who don't know the language and don't know Tibetan script because they have to study in Chinese. We wanted to have English, Tibetan, Japanese, and Chinese classes. There is no other goal. The money came from Tibetan associations in different areas in Qinghai. The school is legal. The Qinghai Education Ministry gave formal documents.

His interrogators came up with a different scenario, accusing him of trying to foment counterrevolution with money from the Dalai Lama clique. When Lama Kyap vehemently denied any such intention, he was told bluntly, "You are not telling the truth. What happens to you when you don't tell the truth is not our business."

That night, three young men from the People's Armed Police (PAP) came to Lama Kyap's cell. They handcuffed him with one arm extended over his shoulder and down his back and the other behind him extended upward; to this day he still experiences pain in that shoulder. They punched him in the stomach so that he had trouble breathing, and announced, "You're a counterrevolutionary; you're a liar; if you don't tell the truth, we'll beat you." And they did, with a club. He still has scars from the beatings, from near his ankles up past his knees. He thought the beating lasted more than an hour. When Lama Kyap lost consciousness, his torturers threw water on him. Then the process was repeated, again and again. After a third round, the handcuffs were taken off and the PAP officers left him alone. Lama Kyap's pants were wet with blood, and he hurt all over. The worst pain was in his knee, and he couldn't move his shoulder.

During the next four or five days, PAP officers "visited" him three times. In addition to being beaten and hit on the head, he was shocked with electric cattle prods and held in an airtight room sprayed with insecticide.

Once the beatings were over, the series of interrogations resumed. Lama Kyap immediately showed his scars and protested his beatings. His interrogators not only professed ignorance—saying they had been away at Xining during the abuse—but even denied he had been beaten. They offered to investigate "and deal with the matter seriously." When Lama Kyap argued that he was in danger of dying from being hit in the two places he was most vulnerable—his heart and stomach—he was given a pill and told, "If you want to get out of here quickly, tell the truth."

At his next interrogation, when Lama Kyap asked if they had investigated his beating, the reply was terse. "You weren't beaten severely. The wounds were not caused by the PAP. You passed out and fell. We complained to the PAP, but they said they didn't beat you and we told them not to—it's not allowed."

They then began to ask him about his views of the Dalai Lama. He understood that they knew he had a copy of the Dalai Lama's autobiography, because when he first arrived at the Huzhu County Detention Center, officers there had confiscated everything he was carrying, including his keys. He knew they had searched his room at school and had opened his locker. So he replied:

I have two views: I am a member of the Chinese Communist Party and I must hold the views of the Party. The Dalai Lama says Tibet is independent. The Communist Party says Tibet is an inalienable part of China. I must uphold that view. My mother and father are Buddhists; I've been much impressed with Buddhism and a faith was born in me. After the Dalai Lama won the Nobel Peace Prize, I read *My Land and My People*.

He says that his interrogators became furious.

For some three weeks the sessions continued with little change in tenor. During that time, Lama Kyap's wife, Dorje Tso, was trying to locate him. At the time of his arrest, she had been away from her teaching post at Repkong County Nationalities Middle School making plans for an upcoming summer vacation in Beijing. When she could neither find her husband nor get answers from his friends, Dorje Tso went to the director of Lama Kyap's school, who told her Lama Kyap had gone to Sichuan "for a school job." She knew then that something was amiss and finally managed to get reluctant friends to tell her what had happened. It took Dorje Tso twenty days to find out that much.

Lama Kyap's ordeal ended almost as abruptly as it began, when prison authorities moved him to a traditional Tibetan hospital where he remained under the eyes of security officers. He had been told he would not be allowed

Lama Kyap (right) and a customer, 1998

to return to his home town, but Lama Kyap was surprised when he received permission to return to teaching, and even more surprised to find that the school had paid his hospital bill. But once back at work, Lama Kyap learned quickly that his career in Amdo was over. School authorities told him his attitude was bad; security followed him everywhere. He began to form an escape plan for himself and his wife and daughters.

By February 1994, six months after Lama Kyap left the Huzhu County Detention Center and while he was still at the Qinghai Province Judiciary Institute in Xining, Dorje Tso began to tell her Tibetan and Chinese friends, acquaintances, and colleagues at the Repkong County Nationalities Middle School that her husband was a bad person. And Lama Kyap began to tell his own friends that he was having problems with his wife. Word began to spread that the couple would get a divorce. The husband and wife even drafted a letter saying, "We don't get along, we live in two different places. . . . We have two daughters: you take one, and I'll take one." Dorje Tso alone signed the letter and sent it registered mail to Lama Kyap from a third location. If Dorje Tso were to escape, he had the letter saying their relationship was over. He took the oldest child; she kept the

five-month-old baby with her. Then, in March, she told school authorities she wasn't feeling well and was going to Xining for a couple of months for medical treatment.

Dorje Tso, the baby, and Lama Kyap's sister managed the journey to India with a great deal of help and very little difficulty. When they were jailed in Nepal for three days, the offices of the United Nations High Commissioner for Refugees and of the Tibetan government-in-exile managed to have them released. When she finally arrived in India in May 1994, Dorje Tso, taking no chances, told everyone but the Tibetan government-in-exile's security office that she had left her husband. Once word reached Lama Kyap in Xining that the three were safe, he put the rest of the plan into action.

The staff at the Qinghai Province Judiciary Institute was routinely monitored. Fortunately, Lama Kyap was friendly with the school's resident spy and devised a way to use that relationship to further his escape plan. First, he arranged for a friend in Repkong to send a fax saying that his grandmother had died on June 20. The story sounded true since she was in fact seriously ill and his school colleagues knew that. Lama Kyap left the fax where the security person couldn't possibly miss seeing it. Then he told school authorities that he would have to take a leave after final exams.

At 8:30 A.M. on July 7, 1994, a year after his detention, Lama Kyap arrived at the bus station with his belongings and bought a ticket to Repkong. Although he had arranged with still another friend to buy him a railroad ticket from Xining to Golmud, about six hundred kilometers away, he actually boarded the bus, but stayed on only until the next stop, which is a major crossroads in Xining. As arranged, Lama Kyap went into a restaurant divided into dark individual rooms, where he cut his hair, shaved his beard, changed into clothes provided by a friend, and put on sunglasses. The train was to leave at 5 P.M. At 4:30, his friend hailed a taxi to take Lama Kyap to the station. Lama Kyap knew that he would not have to show any i.d. to board the train, only his ticket. He was also aware that if he went to a registered guest house in Golmud, he would have to show some form of i.d., but in the more disreputable guest houses, no one would bother to check. And he knew where to find a private bus to Lhasa that used two drivers alternately, did not stop, and required no i.d. The trip took two days. Once in Lhasa, in possession of a fake i.d. and a fake pass to Dram, a Tibetan-Nepali border town on the Tibetan side, Lama Kyap became "Sonam Tashi," a garlic worker.

The next phase of the trip took Lama Kyap—now Sonam Tashi—to Shigatse, where he paid for a place in a car going all the way to Dram. At the border, he presented his phony papers. A Nepali Tibetan arranged for a guide, obtained Nepali clothes for him, and finalized details of a 40,000 *renminbi* payment (approximately U.S.$5,700), half to be paid to the driver when he arrived back in Dram, and half to be paid when it became known that Lama Kyap had arrived safely in Nepal.

As a result of a dispute about trade in garlic over the Tibetan-Nepali border, motor traffic in that area had been blocked for a month. The delay forced Lama Kyap and the five or six others in his group to wait until the beginning of September, when his friend's garlic supply, which was Lama Kyap's ticket across the border, could proceed to Nepal. Because the businessmen and military at the checkpoint were well acquainted, i.d.'s sometimes were not checked. Lama Kyap was advised not to show his false i.d. unless specifically asked to.

At the customs and immigration post, which is about nine kilometers from the actual border by way of a twisting road, the group—dressed like workers in rubber sandals and T-shirts—were asked if they had papers. They replied they were only transporting the garlic as far as the border and would be back in half an hour. Allowed to pass, they delivered the garlic to a storage house and left it in the care of a Nepali merchant. Their Nepali guide arrived at 8:30 P.M., and told them to wait in the garlic house, saying that he would come back at exactly 10 P.M., when they would have two minutes free of any patrolling Chinese soldiers. (In fact, the soldiers had been bribed and told to take their time changing shifts.)

Just before 10 P.M., four of the "workers" walked to the Friendship Bridge, which spans the border. Fortunately, there was a dispute among the waiting truck drivers and consequently a major traffic pileup. The four crossed the bridge and, to avoid a Nepali police station, followed the guide down a dangerous and steep slope to a path along the river. In Tatopani, five kilometers into Nepal, they

waited for twenty-four hours until their driver arrived with a truckload of garlic. The escapees hid in the garlic all the way to Kathmandu. Lama Kyap waited twenty days in Kathmandu before finally proceeding to India and reuniting with his family.

Samdrup Tsering, the man who established the Tibetan nursery with Lama Kyap's assistance, did not fare as well. Detained at the same time and initially held in the same place as Lama Kyap, he was formally arrested five months later on charges of counterrevolutionary propaganda and incitement, and tried in camera in Huzhu county. On July 2, 1998, he completed his five-year sentence at Qinghai Provincial Prison Number Two. ■

LUKHAR JAM In 1995, Lukhar Jam's options were stark: seventeen years in prison, or escape to exile in Dharamsala. Then twenty-six, he chose exile. When we interviewed him, a year after he had left home and eight months after reaching India, most of his energy was still focused on coming to terms with making a permanent home away from his family in Amdo. In telling his story, this tall, imposing young man was sometimes quite animated; at other times, he was lethargic and removed, or despairing, as though he were reliving his ordeal. It was obvious that he had endured a terrible trauma.

Lukhar Jam was born in February 1969, one of seven brothers and sisters in the semi-nomadic area around Chabcha, the high-elevation capital of Hainan Tibetan Autonomous Prefecture in Qinghai Province (Amdo). As he was growing up in that area, with a mostly Chinese population, he came to realize that there was a marked difference between Tibetans and Chinese.

> I didn't like being under Chinese pressure. I personally didn't like the Chinese Communist system and their hypocritical activities. I knew Tibet was an independent country, and that China occupied it with the use of force and slaughtered many people. Tibetans are . . . totally different from Chinese. So I didn't like the policy of China being over Tibet. Tibetans will always be Tibetans, but the Chinese use their policies to divide Tibetans. They place them in separate administrative areas—in Gansu province, in Yunnan, Sichuan, and Qinghai, and in the Tibet Autonomous Region.

Lukhar Jam completed both primary and lower-middle school in Tsigorthang, an area of Xinghai county, a basically pastoral and overwhelmingly Tibetan county in Hainan. He then trained as a farm-machinery mechanic at a technical school, but never worked at that trade. Instead, in October 1991, he left for India, traveling by bus to Lhasa, then Shigatse and Sakya, and on foot to India via Solo Khumbu in Nepal. Other than being short of money and sometimes of food, he had a relatively trouble-free journey. Lukhar Jam stayed in Dharamsala eighteen months where he studied Tibetan literature and English. Then he returned home.

The return trip, however, proved to be much more stressful than the original journey for Lukhar Jam, both physically and mentally. He was carrying copies of the Dalai Lama's *My Land and My People*, a videotape of a speech the Dalai Lama made when he accepted the Nobel Peace Prize in 1989, and human rights documents including some sixty copies of the Universal Declaration of Human Rights, and he therefore made a detour across the mountains instead of heading directly for the official border.

> I carried the books and videotape home because people, especially older people, wanted to see the Dalai Lama. They often prayed they would see him in Tibet. I knew the books and tape would bring happiness to them. Tibetans don't know about the Universal Declaration, and I thought that if I distributed copies it might help them to understand.

Lukhar Jam arrived home on December 15, 1992. Once there, he and some of his intimate friends, both men and women, organized a "dare-to-die" youth group of activists willing to play a

front-line role and take sometimes inordinate risks for their beliefs. As Lukhar Jam had anticipated, people were very pleased with the materials from India, so much so that sixty copies were not nearly enough. He and his friends managed to buy a mimeograph machine and distribute copies directly to people and by mail to monasteries and schools in regions of Qinghai other than Chabcha. But almost from the start, the organization faced two problems: finances, and the danger to group members from public and state security branches. Lukhar Jam managed to alleviate the money worries by selling some of his family's domestic animals. "I was the behind-the-scenes operator," he said, "and even though I had no work, I acted like a businessman. My parents really loved me and were very kind to me and didn't stop me from doing what I wanted. They gave me money, but I never told them what I was up to."

About two months after Lukhar Jam arrived home, he concluded that the project was a failure, and without telling his family he set off again for India. On February 25, 1993, at night, Lukhar Jam and ten others left Shigatse and headed for Dingri County in the Tibet Autonomous Region. After one member of the group became ill, all eleven stopped at a lodge run by the Dingri County administration. But just before dawn, when they were about to leave, they found themselves surrounded by six or seven armed border-patrol soldiers and public-security officials, who immediately began to frisk them and to search their belongings.

Lukhar Jam, now 1,200 kilometers from home, with only 50 more to go before he reached the Chinese border, knew he was in trouble. Although some of the documents and books he was carrying were available in local bookstores in Amdo, the Chinese government had labeled them *neibu* (internal). The most sensitive document, which he had procured from another source, was a Chinese map dating from before 1950. It was a planning document issued by the Lanzhou area command's military headquarters showing entrance points for an invasion of Tibet, along with local population figures in the affected areas. According to Lukhar Jam, such numbers made it relatively easy to calculate the critical differences between the pre- and post-invasion population. The other documents, regional gazettes on the national economy, the tax structure, education, and family planning, were the kind, he said, "that give information government officials don't want people to know, although there are no current secrets in them."

Even more critical—not only for Lukhar Jam's own safety, but also for that of two of his friends—were petitions with photographs of them attached; he was carrying these papers to the Dalai Lama. Both men were still in Amdo. One, named Tsegon Gyal, was a former policeman in Tianjun County who had been detained for a month in 1989; the other, Namlo Yak, was an education official in Tsigorthang, the county where Lukhar Jam had gone to school. Namlo Yak had been interrogated in 1990. The details of the two men's ordeals were spelled out in the petitions, as was information about the persecution of Tibetans in Tibet. (As a result of the seizure of these documents, Tsegon Gyal and Namlo Yak were, in fact, detained in May 1993.)

Lukhar Jam was detained in the Dingri County Detention Center; the others were released. Some may have reached India: word of Lukhar Jam's capture reached Dharamsala quickly. State Security Bureau officials in Dingri conducted some perfunctory interrogations during the week or two when Lukhar Jam was there. But his case was considered serious enough for him to be sent back to Shigatse where higher-level officials could take over. Lukhar Jam's objective during interrogation was to buy time to get a message to the friends whose petitions he had been carrying, urging them to flee. To that end, he lied about where he had procured the *neibu* books and documents, telling his interrogators that a friend in Lhasa had offered to pay his travel expenses if he took the books to Nepal. The friend, Lukhar Jam told them, was already in Nepal on a travel pass.

Lukhar Jam describes his prison experience in detail:

The prison regimen is the same for political and criminal prisoners all over China. In Dingri, I was not beaten or tortured. But Shigatse was another story. I was on my knees, my hands were cuffed together with one arm over my shoulder and the other behind my back. My shoulder became dislocated. I was not allowed to sleep for two days and nights and they didn't give me much food. I fell asleep and fell over

and hit my head. . . . I was interrogated for five or six hours a day and when I fell asleep they poured water on me. When they weren't interrogating me, they tied me up, but even then when I fell asleep, they poured water on me to wake me. . . . This all happened in the prison office and many Public Security Bureau officers were involved. Then I was taken to a cell. My torture increased because I was not cooperating. For about a week more, I was beaten and tortured with every kind of technique. They used cattle prods. My body swelled so much that my pants tore when I tried to put them on, but they didn't give me new ones.

He points out the lumps on his wrists, a scar near his hairline, and a swelling on his shoulder as evidence of his treatment. Lukhar Jam also recalls other kinds of intimidation and attempted persuasion:

Once, the head of the region's Public Security Bureau told me, "We are all very grateful to the country and the Party because they provide us with everything . . . so how shameful you are if you act against the country and the Party. And your shameless action is against the law of karma" [the Buddhist principle of cause and effect]. I told him, "I grew up under the care of my parents. My parents worked with their hands and feet and lived their lives to take care of their children, and the government and the country haven't done anything for me. So why should I be grateful to them?" So he got angry and yanked at my clothes, saying, "These clothes are a product of the Party and the country." I told him that they were from India. Then I was beaten severely, and my hands were cuffed and they kicked my body.

After less than a month in Shigatse, security-bureau officers took Lukhar Jam to Seitru, the state-security detention facility in the northeastern suburbs of Lhasa, where he was asked the same questions and gave the same answers, but was not ill-treated. By April 7, 1993, he had been taken back to Qinghai Province, to a detention center in Tsongkhakhar (Ping'an), the primarily Chinese capital of Haidong prefecture. There, in early July (although there are discrepancies among dates in official documents related to this case), he was formally arrested and moved to a special isolated and very secure detention center in Delinkha, the capital of Haixi Mongolian and Tibetan Autonomous Prefecture. Haixi is the site of military bases, and access to it is highly restricted.

Lukhar Jam objected on several counts to the more than four-month interval between his detention and formal arrest, saying it exceeded the legal limits. He also objected to the officials' failure to notify his family that he was being held. Furthermore, he said, "When my elder brother came to find me in Tsongkhakhar, the officials lied and told him I wasn't there anymore. It's a day's travel by bus from home to Xining, and another day by train to Tsongkhakhar."

Interrogation by state security, procurators, and court officials continued for close to another year, until May 22, 1994. During that time, Lukhar Jam was consistently angered by the anti-Tibetan bias of many of his interrogators. He recalled, "When Mr. Shu, a Chinese official from state security, was interviewing me, he got very angry when I answered his questions in Tibetan. He said, 'In China, everyone should use Chinese. It is unnecessary to speak Tibetan, and no one uses it. If you want to live in this country, you must use our national language.'"

According to court papers dated July 28, 1994, the Haixi Intermediate People's Court sentenced Lukhar Jam to an eight-year term for "espionage" and ten more years for "organizing and leading a counterrevolutionary clique." If he "showed a good attitude," according to Lukhar Jam, "they'd take a year off my sentence." Indeed, his sentence was commuted to seventeen years.

According to the Haixi Procuratorate, he and his alleged co-conspirators, Tsegon Gyal and Namlo Yak, had "delivered four items of unlawful correspondence" out of the fourteen Lukhar Jam had brought back from India, and "purchased and collected over thirty volumes of books and materials, such as surveys of eight autonomous prefectures or counties" in Qinghai Province and eight pieces of "classified or top-secret documents and data." Evidence presented to the court by the procuratorate consisted of two statistical volumes, one about the national economy and the other about the educational system. In addition, Lukhar Jam was accused of having been sent to Qinghai by an "external espionage organization" (i.e. the Tibetan government-in-exile), to "deliver correspon-

dence and gather intelligence." "On numerous occasions," the document continued, "he disseminated reactionary opinions concerning such subjects as Tibetan independence."

Tsegon Gyal and Namlo Yak received prison terms of sixteen and twelve years respectively for their petitions to the Dalai Lama, and for helping to collect confidential information. In addition, the formation of the "dare-to-die" group had, according to the verdict, "incited . . . splittism and endangered national security." Although the three denied the charges of spying and promoting independence, and pointed out that many of the books they had were available in local stores, their arguments were labeled "false and in contradiction with the law." A fourth detainee, Shawo Dondrup, who was less than eighteen years old when detained, reportedly was released by the procuracy after nine months in detention. It took until November 1997 for the details of the trials and the harsh sentences to reach humanitarian organizations. By then, two months had passed since the Qinghai Higher People's Court had concluded that the sentences imposed on Namlo Yak and Tsegon Gyal went beyond the allowable punishments. Their terms were reduced to four and six years respectively, and on November 14, 1997, Namlo Yak was released. He arrived in Dharamsala in March 1999.

As far as Lukhar Jam is concerned, the legal system in China is a travesty. There were, he said, three problems with his interrogation and trial:

> It was not public; I was not given the right to hire a lawyer—the Chinese didn't follow their own laws. About two months before the trial started, I was interrogated by procuracy officials. Then they gave me a paper explaining the charges and told me to prepare for the trial. I told them I didn't know the system and asked for a lawyer. Officials from the procuracy and from the court denied that I had the right to have a lawyer. For another month, court officials questioned me. Then the judges and officials came and gave me another paper. Even on the day of the trial I was asking for a lawyer.
>
> The third problem was that the Chinese kept me in prison over a year before they tried me. After the trial I stayed in the same cell in the detention center for another two years. My friends didn't leave their cells for years. When I left Amdo, they were still in the detention center. We all should have been moved to a prison after we were sentenced.

Lukhar Jam's description of the trial and appeal process provided evidence of other violations of Chinese law:

> During the trial, they took off our handcuffs, but two soldiers held each of us. There were three Qinghai Province Public Security Bureau officials present, four court officers from Haixi prefecture, and three from the procuracy. One person was a Muslim; all the rest were Chinese. All the documents were in Chinese. There were two or three journalists. They never published anything about the trial. They just cursed us [in print]; this proves they are not independent. They do whatever the government tells them. After the charges were read out by the procuracy, the chief judge asked if we agreed. That was our chance to speak. The judges listened to us, then took a ten- or twenty-minute break. It was late in the day when they told us the sentence, but they didn't give us the papers for ten days. The chief judge had come to see me about a week before the trial and told me I would get the heaviest sentence—so I know they decided the sentences before the trial.
>
> We all refused to accept the verdict. I wrote a letter in Tibetan—I do know Chinese, but I know Tibetan better so I wrote it in Tibetan. I didn't have anyone to help me. I wrote that I came to Tibet to meet my parents and family and that I never came to spy and that I was never the head of a counterrevolutionary group. I said that the books they said were state secrets could be found everywhere. It took over two years for the high court to decide the appeal. That's against the law, too.
>
> The trial was videotaped but not to show to the public. Sometimes when I was interrogated, they videotaped me and they took pictures of me in detention. They interviewed me after the trial. They said, "You got the heaviest sentence among the prisoners in Amdo. Do you still think Tibet will get freedom?" I told them I didn't feel like answering and it was useless for me to answer, but then I told them, "Freedom for Tibet is the right of the Tibetans and historically there is no right for China to rule Tibet.

. . . Without freedom, our great religion and culture have been declining and Tibet's environment has been badly damaged."

By the time of the trial, in July 1994, Lukhar Jam—who had entered prison healthy—was seriously ill. In Shigatse the beatings and poor food had taken their toll, but it was not until his transfer to Delinkha that the deterioration accelerated. On April 29, 1995, when he was finally released on medical parole, his weight was down to thirty-nine kilograms (approximately eighty-seven pounds). He was still thin when we interviewed him in August 1998. His abdomen had become painfully distended, diagnosed initially as resulting from a liver ailment, and he had developed *feifushui*, a lung disorder. When Lukhar Jam left prison, he could not stand, much less walk, unaided.

Detention-center officials had ignored Lukhar Jam's many requests for medical treatment and had even placed his friend Namlo Yak in leg irons for a week for writing several letters of complaint to prison authorities. But nothing changed until a routine inspection of the facility by high-ranking provincial officials. During cell inspection, prisoners were required to line up by twos. When Lukhar Jam did not respond to the demand, one official removed his quilt and blanket. "He was shocked at how thin my legs were. I think that the higher officials talked to the prison officials, because they started to treat me right away."

Lukhar Jam's condition steadily worsened over the next five to six months, and officials moved to release him, fearing he might die in prison. The process of obtaining his release degenerated into a bureaucratic nightmare. The chief of the detention center, who announced that he would refuse to take responsibility if Lukhar Jam died in prison, asked the prefecture to approve the release. At the same time, the chief, with the assistance of the center's health committee, forwarded to the Haixi prefecture hospital and the Tibetan-Mongolian hospital the agreement he obtained from the provincial high court to underwrite medical expenses. After prefectural hospital personnel put Lukhar Jam through a battery of tests, they told the high court that Lukhar Jam was beyond help. The medical advisors to the court, upon evaluating the hospital's report, concurred. Lukhar Jam said he later heard that the thinking was that even if he went to the best hospital and the government spent 20–40,000 *renminbi* (ca. U.S.$2,850–5,700), there was no hope.

Despite that conclusion, during the month before he was released, cadres and soldiers at the detention center began to take Lukhar Jam to the hospital for day treatment. While there, he was shackled to the bed by one hand while he received intravenous glucose in the other arm. At night, even though he was thought to be infectious, he was returned to the overcrowded cell he shared with five or six others. Finally, the head of the high court, representatives from the intermediate court, and procuracy officials all decided that he had to be released.

Once the decision was made, Lukhar Jam was asked if family members would act as guarantors. When he replied yes, they were notified that he was ill and that they should come to the center and bring money to cover his medical expenses. According to Lukhar Jam, "Relatives came and went. Mostly they cried. And they wouldn't bring my mother. They were afraid of what my appearance might do to her." His older brother and his uncle, however, stayed a month, buying him food he could digest, meeting his medical-related expenses, and eventually arranging for a few face-to-face visits. Initially, Lukhar Jam had only been able to see them from a distance, on his way to or from the hospital.

Finally, Lukhar Jam felt he was improving and told his relatives to tell the detention center they had run out of money and were going home. In fact, at that point all they had left was 900 *renminbi* (U.S.$125), barely enough to cover another two or three days of treatment. They had already spent some 18,000 *renminbi* (U.S.$2,570). For two weeks, Lukhar Jam pretended to get worse. But the detention center refused to cover his expenses, treatment was terminated, and his condition again actually deteriorated. At that point, his family was notified to come and take him home. Two uncles agreed to post 6,000 *renminbi* (U.S.$950) and to sign and thumbprint a six-point agreement. Lukhar Jam remembered four of the points:

- Should he die, the family will accept his death and tell others that it had to do with the illness itself and not the treatment he received in prison.
- Should he recover, the family will hand him over to prison authorities when so ordered.
- Should a guarantor die, his heirs (probably his children) will be responsible for upholding the agreement. Therefore, before he can be released, each guarantor must provide to the authorities a complete list of family assets.
- The family will pay all medical expenses.

Lukhar Jam also had to sign and thumbprint a second six-point agreement of which he recalled three requirements:

- to inform the authorities of any contacts with the Tibetan government-in-exile;
- in case of recovery, to come on time if ordered to appear by the court, the Public Security Bureau or the detention center;
- should he have to go to any hospital in any place, to report the incident to the PSB.

Within a week after Lukhar Jam arrived home in April 1995, he started treatment at Chabcha People's Hospital. But after two to three months, when his condition was rediagnosed as an intestinal blockage, and not a liver ailment, he opted for traditional treatment at Hainan Prefecture Tibetan Hospital, which was, according to Lukhar Jam, "the best in Chabcha, and was famous all over Qinghai."

> The staff was very friendly. They had to send reports to the Chabcha security department because it was responsible for me. I was still appealing my sentence, so the security department sent the reports to the high court and to the State Security Bureau. After about a year, I was almost recovered, but the staff never mentioned that I didn't have a problem or that I was being treated as an outpatient. They always said my health was not good, and they kept a bed for me even when I wasn't there. I was a patient almost to the day I left Amdo. The hospital reduced the charges so we only had to pay 4,000–5,000 *renminbi* (U.S.$570–710).

Once out of the detention center, Lukhar Jam used other subterfuge methods to keep his condition from detention-center officials. From almost the moment he returned home, he had had to report his thoughts to the PSB on a weekly basis, and he was questioned whenever something concerning Tibet occurred in Qinghai. "It was a big problem," Lukhar Jam said.

> At first an officer came to the hospital. Later on, when I went to the PSB station, I didn't even wash my face. I wanted to look ill. They asked about Tibetan independence and putting up posters and about whether I knew this or that person. They suggested I work with them. I had to say something to please them, so I said I would contact them when I knew something. I was frightened; I didn't want to go back to the detention center; I was sure I would die if I did. And there was no way my family could pay 70,000–80,000 *renminbi* (U.S.$1,000–1,425) again. A lot of people from where I lived—high lamas, rich people, officials—had given money because they knew I was a political prisoner and because of the feeling of being Tibetan. So I knew I had to be careful about how I answered.

Time was beginning to run out, and Lukhar Jam knew it. By midsummer 1997, word had leaked that he had regained his health. Furthermore, his appeal still had not been heard. (He found out later that it was heard in absentia on August 13, 1997 and turned down.) In June 1997, three years after sentencing, his two friends found guarantors and were released temporarily:

> They were under surveillance and I was under even heavier surveillance, but for a month we managed to do some business together. . . . Then in August, much to their surprise, they were re-arrested. They had come to believe they would not have to go back to prison. They even had expected to get their jobs back and they had relaxed their guard. They thought at worst they would be called to court for an appeal hearing. I was convinced they would be returned to prison but would only have to serve half their terms.

While Lukhar Jam was in Xining, prepared to flee if necessary, he telephoned his friends, only to hear that they been arrested and that they had been beaten for not telling where he was hiding. As soon as he heard the news, Lukhar Jam put his carefully worked-out plan into action. He had been staying in a guest house owned by a friend. On August 20, Lukhar Jam told the friend that he was leaving for Lanzhou for medical treatment and would be back soon. As evidence of his intentions, Lukhar Jam left most of his belongings at the guest house but managed to carry with him documents related to his case. When Hainan and Qinghai security came to arrest him in Xining, his friend repeated the story. The officers waited a few days in Xining and then headed for Lanzhou.

By that time, Lukhar Jam had already reached Golmud, the largest city in western Qinghai, and from there traveled to Lhasa by bus. He reached Lhasa in forty-eight hours. In both Golmud and Lhasa, Lukhar Jam did not dare stay in hotels; instead he stayed with friends. The police later caught up with many of those who had helped him; and his uncles, as guarantors, were interrogated and fined heavily.

According to Lukhar Jam, the physical hardships of his flight and the need to beg money from friends in preparation for the winter trek across the Himalayas were not his biggest problems. It was the threat of being caught again. "That was on my mind. If I was caught, two years would be added to my sentence. I might even be executed because I was carrying all the documents related to my case."

He arrived back in Dharamsala on November 20, 1997. When we interviewed him in August 1998, he was struggling to find a way to earn a living, make new friends, and advance his education, and also with how he could contribute to the Tibetan cause. It is clear that he could no longer even attempt to go back across the border. He had already decided that one solution might be to use his personal experience to focus international attention on how China's government circumvents its own laws in order to solidify its political control. ■

Lukhar Jam, 1998

RINCHEN DORJE still plans to be a writer, even though it was his writing that got him into trouble with Chinese authorities. He only began to advocate actively for free speech for Tibetans in 1991 as a student at Qinghai Institute for Nationalities in Xining, but his involvement with Tibetan political struggles is rooted in an event that preceded his birth: his maternal grandfather's arrest during the Chinese Cultural Revolution (1966–76). Almost twenty years later, in 1994, Rinchen fled to Dharamsala. By then, he had come to recognize that the Chinese government used literature solely as a tool for political propaganda purposes. The contrast between pictures of a confi-

dent, poised, clearly happy Rinchen with his college friends and the man we met in 1998 who could never quite manage a smile is a reminder of what Rinchen lost through his commitment to human-rights principles.

Rinchen lived from the time he was five until he was twelve with his maternal grandfather. Before being sent off to prison, his grandfather had been a local government secretary in Tianzhu Tibetan Autonomous County in the Wuwei region of Gansu province. He was also a high lama in one of the major sects of Tibetan Buddhism, the Nyingma. (Nyingma monks have permission to marry, among other privileges.) The combination was enough for Chinese authorities to humiliate him by subjecting him to public ridicule and physical indignities before he was sentenced. According to Rinchen, "The Chinese said lamas sucked blood from the public."

Although his grandfather was eventually "rehabilitated" and offered his old job back, he refused. When Alak Shardong Rinpoche, a high lama well-known locally, invited Rinchen's grandfather to return to his old religious activities at Kapuk, the family's small ancestral monastery in Chentsa, Huangnan Tibetan Autonomous Prefecture, many members of Rinchen's mother's family made the move. Chentsa is one of the richest agricultural regions in Qinghai. It has a long history of Tibetan settlement (at least one extant Tibetan Buddhist site there dates back to the ninth century), and in 1994, 58 percent of the population was still Tibetan.

In 1976, when Rinchen was five and his parents divorced, he, his mother, and his younger sister joined the rest of the family in Chentsa. His mother and sister lived with his grandmother. Rinchen lived in the monastery. For some four years after his mother remarried and moved again, this time to Yulgan, a Mongolian Autonomous County in Huangnan where there are few Tibetans, he remained at his studies in the monastery. From his grandfather and his grandfather's students, Rinchen learned to read and write Tibetan.

In 1983, when he was twelve, Rinchen joined his mother, sister, and stepfather in Yulgan and began his secular studies, completing primary school and lower-middle school in three years instead of the usual five. Back in Chentsa after his stepfather (a teacher of Tibetan) was transferred there, Rinchen continued on into upper-middle school. Upon graduation in 1990, he was admitted to a five-year program at Qinghai Institute for Nationalities, Department of Minority Nationalities Languages and Literature, Tibetan section. There were 280 students all told in his department. Forty Tibetans were admitted every year and forty Mongolians every two years.

Rinchen entered the Institute not long after the 1989 crackdown on the prodemocracy movement that had started in Tiananmen Square and had spread throughout China. He reports:

> All the rules and regulations had been changed. We had to go for seven weeks of military training and for one year we all had daily two-hour *dang de sixiang jiaoyu* (Party thought education) meetings. It was a kind of reeducation. The Tibetan section had a lot of other changes, big ones. Before, Tibetan history, religious history, classical grammar, and logic were taught in Tibetan. That stopped, and the student magazine, called *Lagya* (*Self-Respect*), stopped publishing. There was so much reeducation going on it was difficult to study well. After about one year, in March or April 1991, I was finally able to start learning in that institute.

But the Tibetan courses still had not been reinstated. Rinchen said:

> [Instead] we had to study politics, a philosophy based on Marxism, aesthetics, modern Chinese language, history of the Chinese Communist Party, and modern Chinese history. There were two courses about Tibet: Tibetan literature—taught in Chinese—and Tibetan language. For the latter, the only one taught in Tibetan by Tibetan teachers, we used a three-book set that had some grammar, some poetics, and some general Tibetan history.

Early in 1991, Rinchen and many of his friends petitioned school authorities for reinstatement of the discontinued courses. When two or three student representatives delivered the appeal to the chairman of the Minority Nationalities Languages and Literature department, he was willing to

accept it but told the delegation that school authorities would have to research the matter. Several days later, when the students returned to his office, the chair told them that the petition had gone to the office of the Institute's president and that he, the chair, did not have the authority to decide. The students replied by asking the chairman to return the petition, then going themselves to see the president, who told them that the issue would be decided after proper discussion and research by the Institute's Party Committee. (Schools, like other organizations, have party committees at every level.)

After repeated visits to the president, the students realized they would never get another answer and their effort to reverse all the changes had failed. They decided on another tactic. They would petition only for the reinstatement of the publication *Self-Respect*. In June 1992, the school authorities granted the request but with a string of conditions attached: First, anything that remotely resembled a political discussion could not be published. Second, school authorities would appoint three advisors, one a Tibetan and the other two Han Chinese—and at least one would be a Communist Party member. All articles were to be vetted by the advisors before publication. Students would have minimal leeway, both in criticizing the school and in voicing opinions. On very rare occasions, they might try to have their political poems or articles published, usually unsuccessfully.

Interested students openly chose twelve of their number as an editorial board, which they called the Youth Literature Committee. Six of the twelve worked together as editors and in rotation as editor-in-chief. Rinchen was one of the six. The renamed magazine, *Babchu* (Torrent), and the editorial board's official title memorialized Dhondup Gyal, a tragic young Amdo intellectual who committed suicide in 1985 and has since become an icon for a younger generation of Tibetans.

The plan, to publish two editions a year starting in 1992, began smoothly enough. Then, at the beginning of 1994, Rinchen became editor-in-chief. By that time, student complaints had multiplied. "Many good articles were submitted but they never got published," Rinchen noted. "So I made some changes. I removed the names of the advisors from the magazine and planned the next edition without consulting them." Rinchen also contributed an article, "*Ruming*" (Clan Names), which ostensibly had to do with the relationship between Tibetan clan names and clan spirits. "What the article was really about, though," Rinchen said, "is that a Tibetan can't be more than a deputy head; he can't have a full position. I said in the article that when a Chinese person sees a Tibetan name, he immediately thinks '*fu*'; that's Chinese for 'deputy' or 'second.'"

Rinchen continues,

Two or three days after I took the proofs to the printer in Xining, the Party Committee called me and scolded me and asked questions about whether I'd written the clan-name article. I said yes. And they wanted to know about the other articles, too. Someone from the school went to Xining to bring back the proofs. Then I was interrogated. They wanted to know what my motives were, and they wanted to know what I was thinking when I wrote the article. They wanted to know why I didn't consult the advisors, and they reminded me that not consulting them violated school regulations. Then they told me to write a detailed letter of apology to the school president. I had to give a clear explanation of my personal background. I had to tell them what made me write the article. And I had to tell them why I didn't consult the advisors. They warned me not to go to class and not to leave the school compound. . . .

I was very upset. For four or five days, I didn't do anything but think. I didn't believe I'd made any mistakes, so how could I apologize? And that's when I came to realize that the government wanted literature as a means of political propaganda.

In his unhappiness, Rinchen went home without asking school authorities for permission, a move that could have further impeded his academic career. During the two weeks he was there, he made his decision to flee, made his preparations, and one June night left for India.

Traveling by bus, Rinchen went first to Lhasa, where he spent two and a half weeks locating a guide and meeting some monks headed in the same direction. After paying 500 *renminbi* (then approximately U.S.$70), he traveled in a group of twelve to Saga in the Shigatse region and from

there on foot at night to Solo Khumbu in Nepal, a route that took them over some of the highest mountain passes in the world. According to Rinchen, the biggest problem for him was his poor eyesight, which made night travel over a seventeen-day period very difficult.

The group had no serious difficulties until they reached Pema Thang where local residents and Nepali police robbed them of all their belongings and beat them up. He reported: "They beat some of the group with guns and sticks—some seriously, some were hit on the head. Then they told us to move on—but we didn't want to. So the police beat some of us again and threatened to hand us over to the Chinese. So we moved on a little way and finally were able to go to sleep."

Some Tibetan-speaking Nepalese people guided the group members to a police station where they hoped they might find help retrieving their belongings. The officers there took them back to the place where they had been caught. "We didn't get our money back, but we got everything else back," Rinchen reports, "And the police promised they would bring us to Kathmandu." For two days the twelve group members waited in prisonlike conditions until the officers escorted them to the next police station. The officers at the second station then took over, accompanying the group to the next police station, and so on. But each leg of the trip took a long time because, for safety's sake, the route was never direct. In Pokhara, the group was held up for five days before being sent on to Kathmandu by bus.

Rinchen Dorje, 1998

But their troubles weren't over. Rinchen and the others arrived in Kathmandu on a Saturday when the United Nations High Commissioner for Refugees (UNHCR) office was closed. "We were held in cells until Monday," he said. "The place looked like a prison. The Reception Center (a Tibetan government-in-exile agency) paid 500 Nepali rupees [approximately U.S.$7.40] each so we could be released."

In August 1994, Rinchen arrived safely in Dharamsala, where he now works for a Tibetan freedom movement.

■

Three Rongpo Monks

From 1994 to 1997, monks at the Rongpo Monastery in "eastern Tibet" were deeply involved in political activities, distributing leaflets, putting up posters, and using lay and religious festivals to get their independence message out. The window didn't last long. By mid 1995, Rongpo monks

were in serious trouble, and their troubles escalated over the next two years. This is the story of three of the Rongpo monks, all now in exile in Dharamsala.

TENZIN NYIMA As an activist monk, Tenzin Nyima (now twenty-nine years old), conceived and executed a plan to hang two Tibetan flags in prominent sites in Repkong, the prefectural capital of Huangnan Tibetan Autonomous Prefecture, in Qinghai Province, where the Rongpo monastery is located. Chinese authorities, aware of the symbolic importance of the Tibetan flag, ban its ownership and display. The repercussions went on for most of 1997. Some monks fled, many others were questioned extensively, and several were arrested, Tenzin Nyima among them. But he engineered a daring escape, as he had two years previously when he was captured at the Tibet-Nepal border on his way home from India.

Today in Dharamsala, Tenzin Nyima spends much of his time studying English with two other Rongpo monks, Lobsang Tenzin and Lobsang Lungtok. Their experiences, similar in some respects and very different in others, broaden understanding of monastic life in Amdo, the campaign for Tibetan independence in Rongpo monastery, and Chinese government attempts to cleanse it of all so-called splittist influences. The monastery complex, whose beginnings reputedly go back more than six hundred years, is a major Tibetan Buddhist center and a prime tourist attraction. Despite sustaining devastating damage during the 1958–59 Tibetan uprising and the 1966–76 Cultural Revolution, Rongpo still has an extensive collection of Buddhist art housed in beautifully restored buildings.

Repkong town, originally centered on Rongpo, was still 69 percent Tibetan in 1994, and today Tibetans still dominate much of the surrounding high grassland area, where Tenzin Nyima and his nine brothers and sisters grew up. They all helped grow barley, wheat, and rapeseed and care for the family's sheep and yaks in Sakor, a small village of some thirty families seven kilometers from the town itself. All ten children attended the village primary school; none continued to middle school. Tenzin Nyima started when he was nine, completed fifth grade at the age of fourteen, and in the same year entered Rongpo monastery. There, he studied poetry, grammar, astrology, and dialectics, and committed Buddhist prayers to memory at one of the monastery's three "colleges"—or units—each with its own curricular emphasis. One of Tenzin Nyima's younger brothers later joined him at Rongpo.

In March 1994, Tenzin Nyima and another monk from Rongpo, Lobsang Gyatso, went on a pilgrimage to India to meet the Dalai Lama and to visit Buddhist holy places. They had no trouble reaching Dharamsala, but in late spring 1995 on the way home, they were caught in the city of Dram near the Tibetan border. Tenzin Nyima says that he had to carry wood and the soldiers beat him frequently. But because it was considered extremely difficult to escape from Dram, Chinese PSB officers there were sometimes lax about monitoring the prisoners. Tenzin Nyima and Lobsang Gyatso observed their negligence, and after six days in Dram they managed to escape. They were recaptured almost immediately in Nyelam (some four hours from Dram by car) and spent another six days there.

Tenzin Nyima blames his "damaged memory" on the treatment he received in Nyelam. During his interrogation, he was not only badly beaten but given electric shocks, twice on his hands and four times on the front of his head.

It became dark in my head. And later, when I tried to speak, I wasn't able to speak clearly. They treated me so harshly because of how I answered their questions. When they asked me, "Why did you go to India? Why did you go to meet the Dalai Lama? How did you know the Dalai Lama was in India?" I said, "I became a monk at a young age and I knew that the Dalai Lama was Tibet's lama. I wished to meet him."

After six days in Nyelam, Tenzin Nyima was finally free to continue his journey home. Back in Repkong, Huangnan prefecture PSB officers questioned him for only a few days, but he remained under surveillance even after he rejoined his monastery. As he explained it, "A friend had warned me that someone was watching me. Sometimes this person wore a PSB uniform; sometimes not. But I didn't know for sure that I was always watched until I was arrested [in June 1997]."

During the intervening two years, Tenzin Nyima concentrated on his studies, but not to the exclusion of his political interests. ■

LOBSANG TENZIN In June of 1995, not long after he returned to Rongpo from India, Tenzin Nyima's two Dharamsala friends, Lobsang Tenzin and Lobsang Lungtok, were arrested just hours apart for "political crimes." At that time, the two were not yet friends, but neighbors; they had never coordinated their independence activities, and their subsequent histories differed in many respects. Lobsang Tenzin was never sentenced; Lobsang Lungtok, after a full-blown trial, was sentenced to an eighteen-month term for "counterrevolution propaganda with intent to sabotage the unity of the nationalities."

Like Tenzin Nyima, Lobsang Tenzin came from a farm family in a village near Repkong. In 1987, at the age of fourteen, when his days at a village primary school were finished, he entered a small monastery called Geutang, near his home. But by the time he was nineteen, he had left for the greater study opportunities available at Rongpo. Like many other monks, Lobsang Tenzin lived in the monastery compound in a house built for him by his family. Lobsang Tenzin described his first arrest, on June 5, 1995 at around 2 A.M.:

> While I was asleep, more than ten policeman jumped from the walls of the monastery into the courtyard of my house. I didn't know they were there or how long they had been there until they switched on the light. About ten were in the house, and several more were outside. None had on uniforms, but the policemen and I knew one another, because the monastery and the prefecture headquarters of the Public Security Bureau are both at Repkong. I don't know if they were armed or not. They didn't show me any documents.
>
> Because I knew they were policemen, I didn't say anything and pretended to be asleep. They said, "We know all about you, and we have to search your house." They searched all my books and took those they needed. Then they said, "Now wake up and put on your clothes. You have to come with us to the office. We have some questions." They closed the door, locked it, and kept the key. One of the policemen asked if he should turn off the light, but the head of the county PSB said I would be back soon.
>
> We drove with the red light on top of the car on but without the siren. First we stopped at the prefecture PSB office for me to sign a paper. Then I was taken to the Repkong County Detention Center.

From 1995 through 1997, independence posters surfaced periodically in Rongpo, and books and pamphlets—some from Dharamsala—were circulated. Lobsang Tenzin had his share and copied extracts from them onto 8-by-14-inch paper. After adding his own ideas about what he considered to be an ongoing campaign to eradicate Tibetan culture and the Tibetan people, he photocopied the results at a shop on a main road in Repkong. But Lobsang Tenzin's plan for posting and distributing the posters was never realized. All copies were seized in a police raid on his house, along with eight notebooks in which he had written essays about Tibetan independence and human rights. Rongpo monks had regularly patronized this photocopy shop, and the shop's owner had been routinely supplying the PSB with copies of independence materials processed there.

During his interrogation the next day and the following week, Lobsang Tenzin answered all questions according to whether he thought the police already had proof of the activities they were

asking about or whether they were trying to trap him into confessing to something they weren't sure he had done. They asked about the posters and notebooks; but much of the interrogation was an attempt to uncover his confederates. Lobsang Tenzin says his interrogators kept telling him:

> We know all about you: your crime is not that big. We are investigating where the documents about Tibetan independence and human rights came from. We will forgive your crime and give you a reward if you will tell us, and also tell us the names of the people who are spreading the campaign.

Throughout this first week of interrogation and during additional questioning some three months later, Lobsang Tenzin was never beaten. He said he thought this was because his interrogators were Buddhists. He did admit to being frightened but was still willing to speak out about his belief in Tibetan independence and in the Dalai Lama, and about the farmers' and nomads' tax burdens. After his interrogators instructed him to write down all he had said, the questions stopped.

Seven months after his detention, on January 6, 1996, Lobsang Tenzin was temporarily released on the conditions that he appear when called and request permission if he intended to leave the area. Although he was permitted to return to Rongpo, life there became very difficult. He explains:

> The police would constantly come near the walls of my house and climb on the roof to watch and listen. Many times when I wasn't home, the police searched my house. They came inside like thieves, but without stealing anything. They left a lot of footprints. My family would notice this when they came to visit, and it became their wish that I go to India. They had been told, "If policies become slightly more strict, your son will be in real trouble." And my friends told me, "Don't do this kind of work again. If it causes problems for you, that's okay, you are a single person. But after you are arrested, it will cause problems for many people."

More than two years after his release, on March 11, 1998, and a year after a major eruption at Rongpo monastery, Lobsang Tenzin left home, arriving in Lhasa four days later. From there he traveled to Dram on a business pass. By March 25, he was in Kathmandu and by April 1 in Dharamsala. His family sold the Rongpo house they had built for him. ■

LOBSANG LUNGTOK Lobsang Lungtok's early history is similar to those of his friends. Together with eight brothers and sisters, he grew up in a small farming village near Repkong, attended school until the age of fifteen and then, in 1990 or 1991, entered Rongpo monastery. He describes parts of the initiation process:

> The first thing is a haircutting ceremony. After that you go to the highest lama and get permission to enter. And the third thing is to go to the head monk, called the *geko* [the disciplinarian in charge of enforcing the monastic rules and regulations], and try to get permission from him. The Chinese government says there should be a limit on the number of monks in the monastery, so the committee that runs the monastery says so, too. But in practice, if anyone wants to be a monk, he can be a monk. It is not necessary to seek permission from the Chinese authorities. But before anyone is admitted, he must sit for the exam given by the Religious Affairs Bureau. The Chinese say, "If anyone is admitted without sitting for exams, he is not a qualified monk." [If you pass], you get a certificate stating that you are qualified to be a monk.

Lobsang Lungtok explained that a high percentage of Rongpo monks had not taken the exam, but during his years in the monastery they faced no special problems. The one difficulty he was aware of applied to those whose homes were outside Repkong. Although technically they could not be admitted to Rongpo, many did manage to obtain the necessary special permission from the abbot. A second reported difficulty involved monks younger than seventeen. They were forbidden to sit for certification.

Lobsang Lungtok recalls his middle school years:

I didn't participate in protests against the Chinese, but a sense of nationalism: being a Tibetan, loving Tibet, grew in my mind. My older brother, Gendun Gyaltsen, was already a monk in Rongpo monastery. He was arrested without any reason by the Chinese, and I was very upset. It was said that he pasted up posters. I was a school kid, and one day I went to his room in the monastery and four Public Security Bureau officers were searching it. They found the "master letter" [from which the others were copied]. . . . One officer frightened me and searched the bag I was carrying. There was a love song written in one of my notebooks. When he saw that, he asked, "Are you a student or not?" They told me I was very bad. My brother was detained for five or six months. In 1991, after he was released, he went to India. When he returned, he was held for ten or fifteen days in the county detention center.

After my brother and I were in prison, my mother said, "Our family does too much work for Tibet. Now stop it. What use is it to us?" Earlier, my father and his brother had come up with a letter that spoke out for the death of all Chinese; they faced many problems.

"In March 1995," Lobsang Lungtok continues, "the Tibetans in India said a peace march was coming from Dharamsala to Tibet. So I started putting up posters in support of the march and accusing the Chinese of destroying Tibetan culture. The Chinese found out about it, and they arrested me."

Altogether, Lobsang Lungtok hung five large posters on the walls of the monastery, at the middle school, and at a teacher-training college housed in a large, modern complex. He explained that his posters were somewhat out of the ordinary. "Usually, when Tibetans put up posters they use only simple words that say 'Tibet is independent.' But I wrote a poem about the meaning of independence."

As in Lobsang Tenzin's case, the posters had been photocopied in town. Lobsang Lungtok is certain that the shop owner betrayed him to the police.

Lobsang Lungtok's arrest came close to three months after the poster incident. On June 5, as he was on his way to buy vegetables in the market in Repkong, ten PSB officers, on bikes and in a jeep, caught up with him. In the detention center, set amid agricultural fields on the border between the township and the county in the northeast portion of Repkong, State Security Bureau personnel interrogated him for some ten days, particularly about who had helped put up posters and who was working behind the scenes and advising him politically. Lobsang Lungtok confessed to what was already known to the interrogating officers, that is, that he had composed and hung the posters, but he insisted that he had acted alone, and added that even if he had had guidance, he would never reveal the source. He contended that he had not broken the law.

They asked him what he was doing on the fifteenth of some month in 1993, and other questions about his daily movements. Lobsang Lungtok says that he answered truthfully whenever he could remember. The questions were sometimes harsh, sometimes polite, and sometimes his interrogators just "chatted" in an effort to "educate" him. There were the usual entreaties to confess and work with the security forces in lieu of a harsh sentence, and there were the usual threats that if he didn't, he might never leave prison.

Lobsang Lungtok reports that he had a difficult time in detention primarily at the hands of PAP guards who tortured and beat the prisoners without any reason. Such beatings often came during monthly checks of prisoners' cells. Months after Lobsang Lungtok's release, safe in Dharamsala, the memories are still fresh and painful. He acknowledges that he often thought about and dreamed about his experiences. He describes one incident:

In the first courtyard, a few prisoners had tried to escape by digging a hole. Then after two days, a lot of soldiers came inside our prison and started to beat us. I was in courtyard Number Two. I don't know exactly how many people were in our courtyard, because they made us stand with our faces to the wall. We were not allowed to look, otherwise they would hit our faces. So they beat us from behind. They didn't use any tools. They kicked me at the right of my back and in my ass where the hole is. This was all very painful, and I fell down. Then they shouted, "Stand up!" and beat me with their fists. They started twisting every part of

my body—hard twists—mostly just below my chest. I was in monk's dress. One soldier pulled on the belt and untied my robe, and I looked behind me. The Chinese soldiers said, "What are you looking for?" They kicked more. Two soldiers held my head; another punched me on the back. I had a lot of dark-blue bruises. I lay on my bed for a few days. I couldn't walk properly. The soldiers laughed when they saw me walking like that—with my legs apart. I couldn't urinate properly, and it was very painful when I did.

That evening we told them we wouldn't eat. They told us it would harm us if we wouldn't eat, and that we would be able to stop eating for two days, but that then we would ask for food.

Two or three days after that, high officials from the prefecture came. We still had bruises on our backs. They took videos of our bodies and asked us what happened. They told us they would tell the soldiers that something like this shouldn't happen in the future.

Sometimes we were beaten with no reason at all. Sometimes, they would just slap. It's routine in prison to get beaten or slapped.

Like Lobsang Tenzin, Lobsang Lungtok blames his poor memory on prison-related conditions. He, however, attributes it not to the beatings, but to nosebleeds related to a "very bad cold" that started on the first day of his imprisonment. The twelve pills per day he had to take for one week did nothing to stop the bleeding. He also experienced a rapid heartbeat, headaches accompanied by dizziness, and severe pain in all the joints of his hands and feet. The prison doctor visited twice and told him he wasn't sick. After five months of growing progressively weaker, Lobsang Lungtok was shipped to the prefectural Chinese hospital in Repkong for a checkup. The herbal medicine prescribed by the doctor there did not stop the nosebleeds, nor did an injection administered by PSB officers.

Suddenly and unexpectedly, the PSB sent Lobsang Lungtok back to the monastery, perhaps, he thinks, because the authorities did not want to bear the expense of medical treatment. For his part, he hoped to "neutralize" his condition through nutritious food.

He remembers some of his first experiences after getting out of detention:

Someone brought my mother; she slept in my room that night. I couldn't sleep—maybe it was out of joy; maybe because of the change. I did go to my village, but I didn't like to stay there because some of the villagers would scold me for not thinking of my family, my mother. Some of my aunts and uncles were very angry at me for causing trouble for my family. They said, "You can't lift the sky with one finger." My elder brother, Jamyang Lodro, became very angry at them and said, "Even if our finger is broken, we should try to lift up the sky."

He was arrested after I came to India. Now that I am here [in Dharamsala], many people don't want to tell me what happened because they are afraid to tell me bad news regarding my family. He was a teacher in the school in Rongpo. He was detained for about fifteen days in 1997. He had explained the Dalai Lama's speeches to the students. He was a bit strange; he was very outspoken. He used to learn the Dalai Lama's speeches by heart. He always said, "Whenever you wake up, you always have to think, 'Today I will be kind to others.'"

At the monastery, Lobsang Lungtok was far from free. "The security bureau often visited," he explains. "When I was staying with my family, they gave written notice to village offices stating that I was not allowed to go anywhere outside the village, and that if I did, I would be arrested."

By April 20, 1996, Lobsang Lungtok was deemed cured and returned to prison. Five days later, he was formally indicted. In August 1996, he stood trial on charges of counterrevolution. He describes his trial as secret.

There was no one there to watch, just three judges, two procurators, a secretary, my lawyer, and me. The lawyer was paid for by the people from my village. He was supposed to help me but it was just a game to show that I had a lawyer. The trial took three or four hours.

I was standing just below the raised platform between wooden bars as if in a cage with a door. The judge in the middle read out the details of my offense, and the procurators added that I should get a heavy sentence. My lawyer said, "Putting up posters on walls is not a serious activity and should not merit a

heavy sentence." The procurator spoke for about an hour and a half, mentioning "splittism." The lawyer spoke half an hour. [Then] the judges began asking me whether I had anything to say about the charges of counterrevolution. I said I didn't feel that I had done anything against the law which could be charged as a counterrevolutionary offense.

Two or three days later, I was called back to court again and they showed me an official paper with "Guilty" written on it.

He received an eighteen-month sentence and two subsequent years' deprivation of political rights, which limited his right to speak freely and to associate with whom he chose.

Lobsang Lungtok decided against an appeal, as the process could take longer than the four months he still had to serve and, according to Chinese law, could result in a longer sentence. His lawyer gave him no advice on the issue. In fact, according to Lobsang Lungtok, "He was like an actor in a movie. . . . He kept insisting that if I confessed honestly, I would get a lighter sentence." Lobsang Lungtok said some of his lawyer's courtroom tactics made him suspect that his lawyer actually was trying to help the prosecution identify other "splittists." Lobsang also believes that he was the first person from his area who actually had a court trial; everyone else had been directly imprisoned.

From the time of his release on December 5, 1996, until he was warned that he might again be arrested, Lobsang Lungtok studied, read in his room in Rongpo monastery, and went to teachings. ■

CRACKDOWN IN RONGPO MONASTERY Events in Rongpo came to a head on March 22, 1997, when Tenzin Nyima carried out his plan to raise two Tibetan flags in prominent places in the town of Repkong. After purchasing sufficient white cloth to make the flags, he asked a friend, Rigdrol, to draw two snow lions, a nationalist symbol representing the victory of the combined secular and religious authority of the Tibetan government. When the drawings were complete, Tenzin added the words "The Tibetan snow lion will tear out the bloody heart of China." With the help of Lodroe, a monk from his own village, Tenzin Nyima hung one flag from a telephone pole at a highway crossing in the center of Repkong, then cut the rope supporting the Chinese flag in front of the Huangnan Nationalities Teacher Training Institute, climbed the pole, and attached the other Tibetan flag. It was 2:00 A.M. on a Sunday when the flags went up, but it took until 9:30 the next morning for the army to remove them. According to Lobsang Lungtok, once the flags were discovered, the sirens started up and sounded all day.

Tenzin Nyima had chosen the date to coincide with a visit of the Dalai Lama to Taiwan, a trip he had learned about from a Voice of America (VOA) broadcast.

A concerted poster and leafleting campaign in February during Monlam (a prayer festival following the Tibetan New Year) had preceded the flag raisings. Rongpo was clogged with visitors, and posters were everywhere in Repkong, many denouncing the Chinese government's interference in determining which boy was the reincarnation of the Panchen Lama (the second most important figure in Tibetan Buddhism), and demanding that the Dalai Lama's choice be released from "protective custody." Other posters featured a collection of statements by the Dalai Lama, and still others held translations of information from VOA broadcasts. The leaflets were folded and thrown in all the rooms in the monastery. Others were put under each door at night.

Following Monlam, the Rongpo monks were busy, as they are every year, with monastic and collegial gatherings, debates, and prayers, culminating in an examination and promotion to a higher class. In 1997, these activities didn't end until March 19, just three days before the flags went up.

The crackdown in Rongpo began almost immediately after the flags were discovered, and lasted well into April. Most of the forty or fifty monks from Rongpo hauled in for questioning were released in a matter of days, if not hours. The detentions were secret. Each monk was told, "When you leave, you are not permitted to tell anyone that you were detained. If you talk to anyone, you will regret it the next time you are imprisoned." For the most part, the monks took the warning seriously. No one was allowed to leave the monastery and even within the monastery walls, the monks' movements were restricted. "Whenever we did go out," Lobsang Lungtok says, "there were police in and out of uniform walking up and down and they wanted to know where we were going."

Several monks were arrested, some solely for possession of Tibetan flags. One layman, Menba Dorje—a practitioner of traditional Tibetan medicine who often stayed in the monastery, and who was suspected of having photocopied many leaflets and books and of supporting the Tibetan cause—received an eighteen-month sentence. Aware that he would be among those arrested even though he had done nothing untoward since his release, Lobsang Lungtok fled, leaving home on April 12, crossing the border into Nepal with twenty-four others on May 21, and arriving in India in June 1997.

Sometime after midnight on April 22, 1997, almost a month after Tenzin Nyima had hung the Tibetan flags, six officers from the state and public security bureaus jumped into the courtyard of his house on the monastery grounds and took him in for several hours of questioning. Rigdrol and Lodroe were not caught until June, when the evidence against them was corroborated.

On April 27, the arrival of a work team composed of public and state security forces and Religious Affairs Bureau cadres signaled the start of a full-scale reeducation campaign in Rongpo, one that was to last seven months. On the first day, all monks were ordered to a central meeting place on pain of expulsion for nonattendance. Work-team members asked that monks "voluntarily" hand over all photos of the Dalai Lama and all video- and audiotapes and other materials from the Tibetan government-in-exile. According to Tenzin Nyima's account:

> They announced this over a loudspeaker and threatened to punish us without mercy or regard for age if they later came to know we had any in our possession. No monks, young or old, handed over any items. The main speaker was the secretary of our prefecture. He was the campaign chairman. He talked about the five main points in the two books he had: oppose the splittist movement; uphold the unity of the motherland; accept the Chinese-chosen Panchen Lama; accept that Tibet is not independent; accept that the Dalai Lama is trying to destroy the country.
>
> He threatened that all the monks who were not from the Repkong region would be sent back. But, at that time at least, the officials were unable to implement such a policy. The work team did close down temporarily a monastery-financed school for monks under fifteen, forcing them to return to their homes. The policy affected some one hundred novice monks.

By the second day of the campaign, forty team members out of the fifty who came were stationed in the three colleges. Each monk was given a letter. The team questioned all the monks one by one but didn't search their rooms. They planted informers to find out who had raised the flag. There were study meetings every day. Each class in each college of the monastery had study books.

On June 18, long before the end of the reeducation campaign in October, security officers again invaded Tenzin Nyima's courtyard in the middle of the night. Twelve officers searched his house, confiscated a copy of the Dalai Lama's autobiography, five VOA tapes, and other compromising material, then brought him in handcuffs to the prefecture-level detention center in Repkong, only minutes away from the monastery. The very next day, Tenzin Nyima was transferred to a prison in Henan Mongolian Autonomous County for six days of questioning. He assumed the transfer had to do with keeping word of mouth about his detention to a minimum.

Once in Henan, Tenzin Nyima quickly came to know that Lodroe and Rigdrol, the monks who had helped with the flags, had also been seized. The knowledge affected his decision to confess after

four days of questioning. "It would create more problems for my two friends if I didn't accept my 'crime,'" he says. "I was the head of the work so I had to take responsibility if there was a problem."

Almost immediately following his confession, arrangements were made for Tenzin Nyima and the two others to be returned to Repkong in a two-jeep convoy. As he recounts:

> When we were going to Repkong, I was thinking, "If I reach Repkong, I will be taken to court and given a very long sentence. I might be able to escape. But maybe they will shoot and kill me. But if I have to face many difficulties in prison for many years, I will not resent dying."

> I kept looking for a good place to escape. And when we reached a forest, I told them I had to pee. The driver and one of the PSB officers got out, and the person in charge of my case told me to go with them. But I didn't. [Instead,] when he had his zipper open, I ran downhill—but I fell down and hurt my leg badly. They shot at me. I forced myself to go on and hid in an isolated spot among tangled shrub, while the officers went straight into the forest [trying to find me].

Tenzin Nyima, 1998

Tenzin Nyima managed to hide out for three months, time enough for his leg to heal. Some nomad families were willing to help him with food, clothes, and medicine; others turned him away, some out of fear and some because the PSB had spread word that a horse thief was in the area. Finally, Tenzin Nyima knew that he had to flee Tibet.

> I received a secret message that I had to move quickly, because the Chinese were going to look for me in the place where I was hiding; I had to leave the region. I traveled to Xining, Lhasa, Dram, and on to Nepal. I heard later that the forest where I hid was sealed off by soldiers and searched for four days. The PSB had distributed about seven hundred pictures of me. They even looked for me in Lhasa. My family's and my relatives' houses were searched at night without warning. They even told people I had a gun and a radio with me.

Tenzin Nyima left his "home country" in September 1997, and arrived in Dharamsala in late autumn.

During the time Tenzin Nyima was in hiding and arranging his escape, security officials were pressuring his two confederates, Rigdrol and Lodroe, for evidence. The outcomes were different. Rigdrol, who had drawn the snow lions on the white material but was told nothing about the plan to make and raise the flags, spent four months in detention before being released on the guarantees of his family and fellow villagers. But Lodroe, who had helped to hoist the flags, was severely beaten during the detention phase of his imprisonment. Later, he was in such pain from an untreated stomach ulcer that on at least two occasions he banged his head against a wall until he lost consciousness. He finally served either one year or eighteen months (exiled monks from Rongpo who knew Lodroe do not agree

about the length of his sentence). And there was one last humiliation left for both men. At the October 20 meeting that ended the reeducation campaign in Rongpo, armed soldiers escorted Rigdrol (who was already out on bail) and Lodroe before the assembled monks, lamas, and senior prefecture officials. After they were ceremoniously handcuffed and denounced as "splittists," their sentences were read out. At the same time, the expulsions of eighteen monks, who were deemed not to have been reeducated, were announced. The whole procedure was videotaped and eventually shown on Qinghai television. The meeting itself was described as terrifying, with armed soldiers surrounding the gathering. Having been told that the soldiers had orders to shoot if there were any disturbances, monks didn't dare say a word to each other.

According to available information, no monks from Rongpo have been overtly engaged in independence activities, and none have been arrested since the 1997 reeducation campaign ended in October.

Since coming to Dharamsala, the three friends, Lobsang Lungtok, Tenzin Nyima and Lobsang Tenzin, have made different adjustments to life in exile. Lobsang Lungtok's time in India has not been free of problems. On January 4, 1998, after five months in the Bir school (a government-in-exile facility where adults can study English), and a month of study on his own, he was jailed for a month and a half for lack of valid residence papers. (India gives shelter to Tibetan refugees, but is not a signatory to the UN Refugee Convention. Tibetans are technically stateless; they do not have explicit refugee status. Recent arrivals are not even issued residence permits.) It took twenty days for his friends to find out where he was and to be permitted to visit. Government-in-exile officials, preoccupied with security matters, spoke directly with the detainees, but did not request their release until they had satisfied themselves that the detainees presented no danger to the exile community. Lobsang Lungtok had taken part in a hunger strike during his detention, and was apprehensive that he would be returned to China and would face further persecution there. It took more than another year and a half for him to finally find what he considers meaningful and enjoyable work. Until he, too, found work in early 1999, Lobsang Tenzin spent his time studying by himself. Tenzin Nyima's future seems even less secure than his friends'. At the end of 1998, he was still spending much of his time in study on his own. In Dharamsala, "studying" is often a euphemism for marking time. ∎

Lobsang Lungtok (right) and Lobsang Tenzin, 1998

Editors' Note: In the preceding texts, Chinese terms and names appear in a standardized Pinyan romanization. Tibetan words are phoneticized to make pronounciation easier for English-speaking readers. For cross-referencing, refer to the Appendix on page 182.

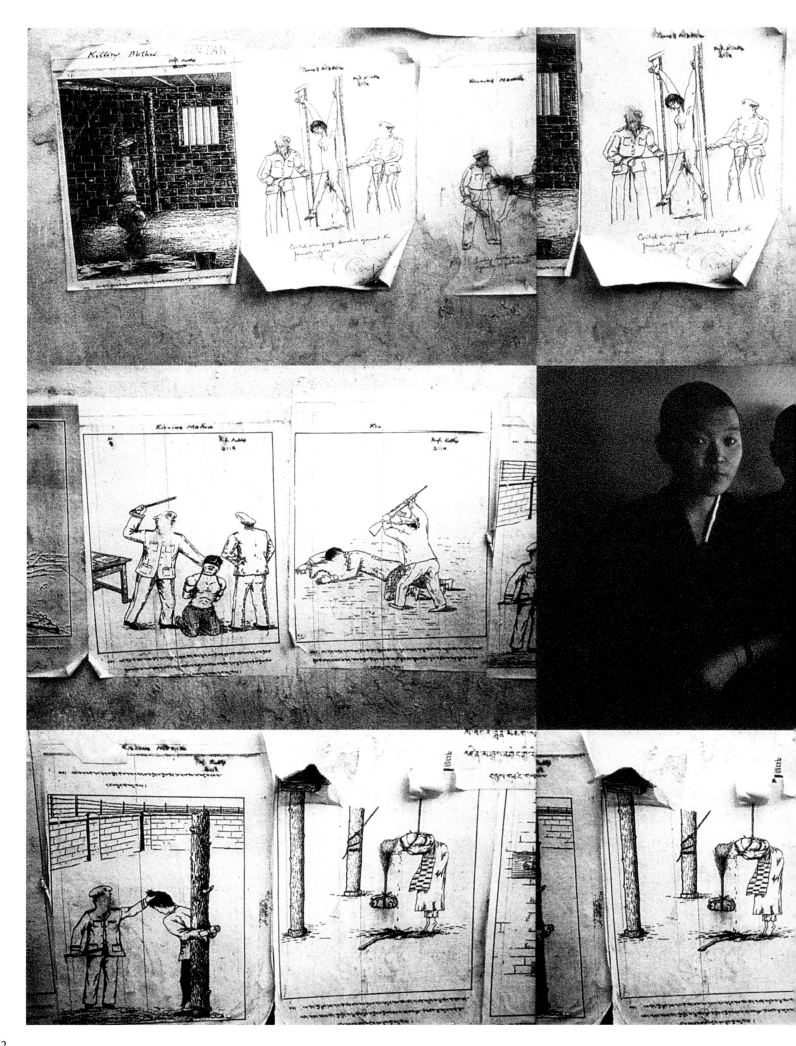

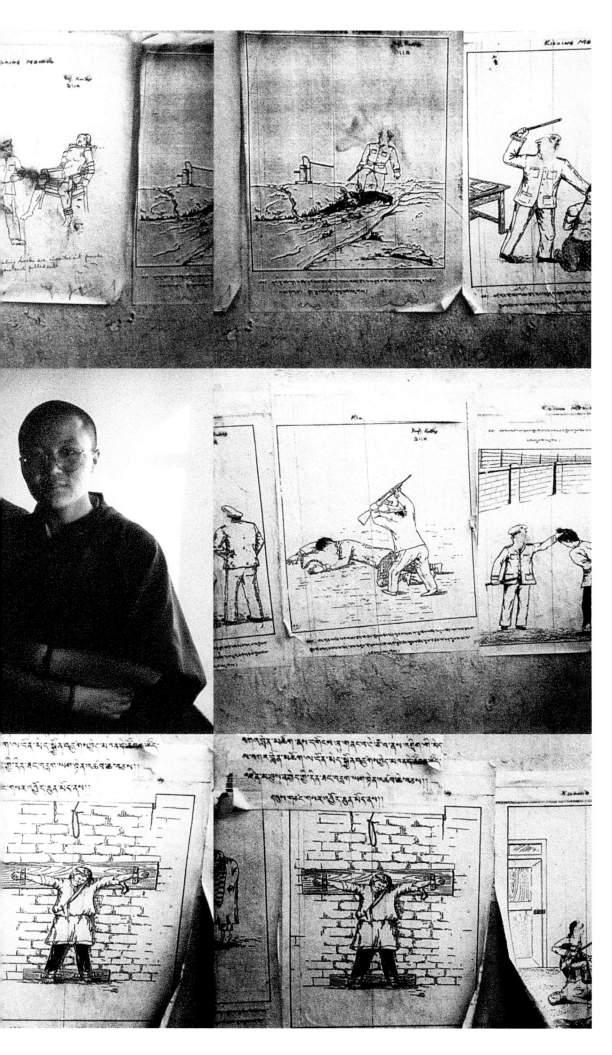

Richard Gere,
Methods of Killing, India, 1993 and 1996.

"I was in India for teachings given by the Dalai Lama. On a wall near the main temple, there were these drawings of torture methods used by the Chinese. They were exactly the same horrors described by people I had met in Tibet. An hour after I photographed these drawings, a rain obliterated them. Three years later I photographed these nuns, who had recently escaped from Tibet after suffering the same tortures." —Richard Gere

(Excerpted from Gere's book, *Pilgrim.*)

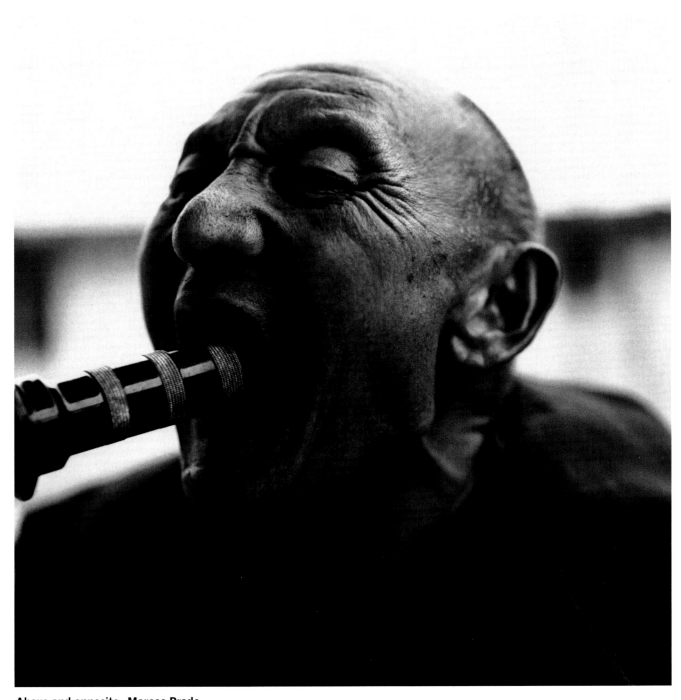

Above and opposite: Marcos Prado,
Dharamsala, 1996. Palden Gyatso, a
senior monk, was imprisoned for more
than thirty years. He now travels the
world demonstrating how these Chinese
torture devices, which he stole upon his
escape, were used on his body.

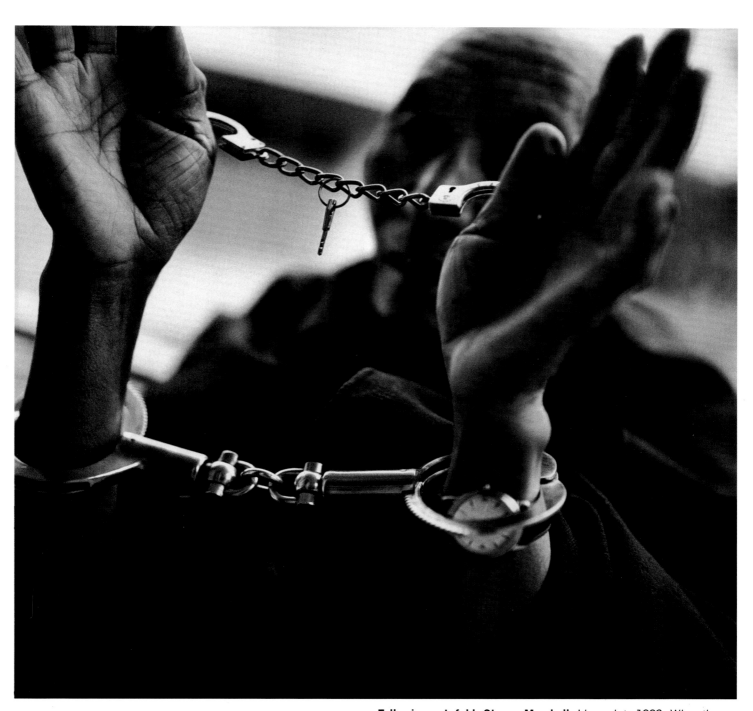

Following gatefold: Steven Marshall, Lhasa, late 1993. When the Dalai Lama fled Tibet in 1959, Lhasa covered little more than one square mile and had a population of less than 30,000. "New Lhasa" occupies more than thirty square miles. Its population is estimated at more than 200,000. The area of the city center (pictured on the front flaps of the gatefold) begins at the Potala Palace and ends with the Barkor, the chief remnant of "Old Lhasa," now largely reconstructed. At the Barkor's center is the Jokhang Temple, the spiritual heart of Tibet. Drapchi prison is located a mile north of the temple. Since this photo was taken, a three-story cellblock considerably enlarged its capacity. Some inmates from Drapchi work at a cement factory located behind the prison. Construction of the factory began after Lhasa was designated a Special Economic Zone in 1992. Utritu prison and Sitru Detention Center are also close to the Jokhang. Two new prisons, one completed in 1997, the other in 1999, stand opposite Utritu.

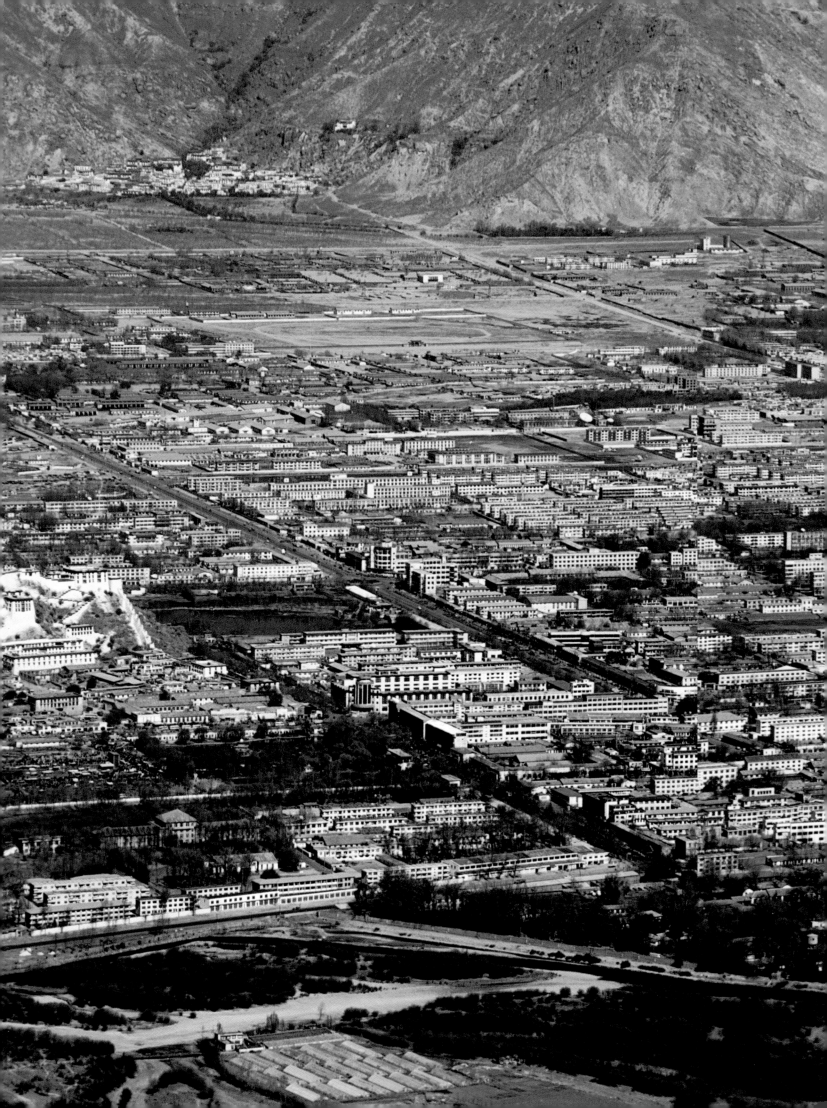

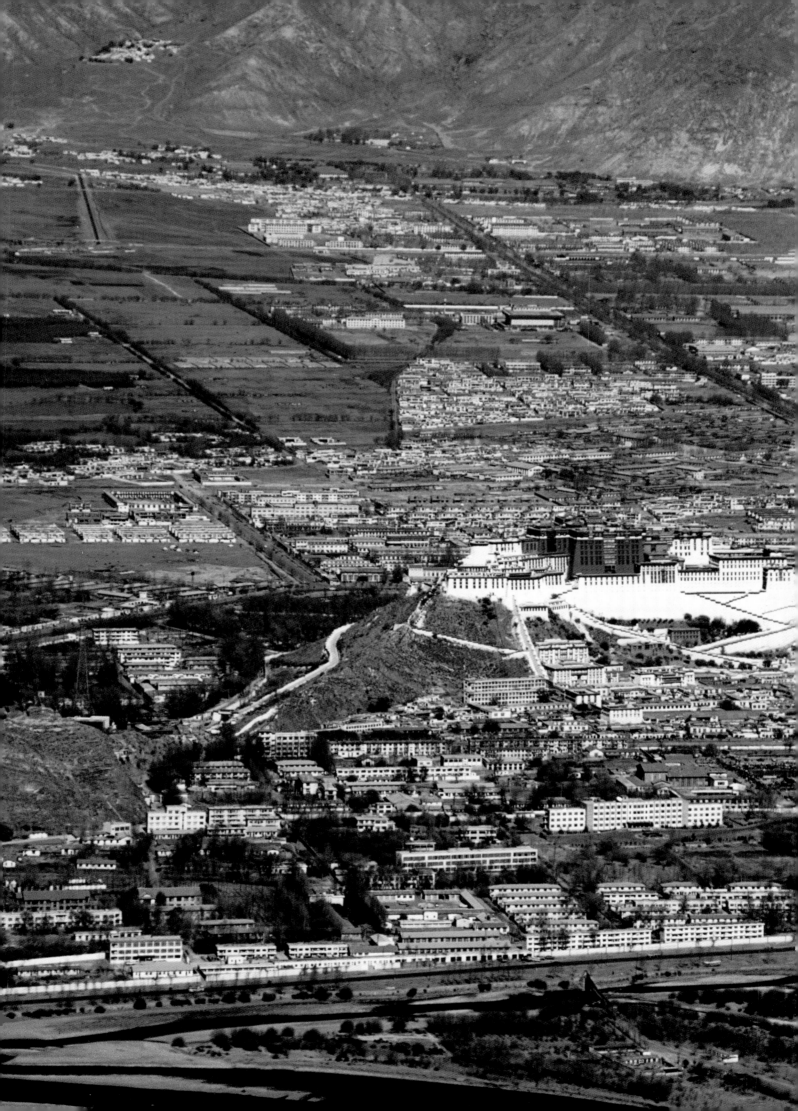

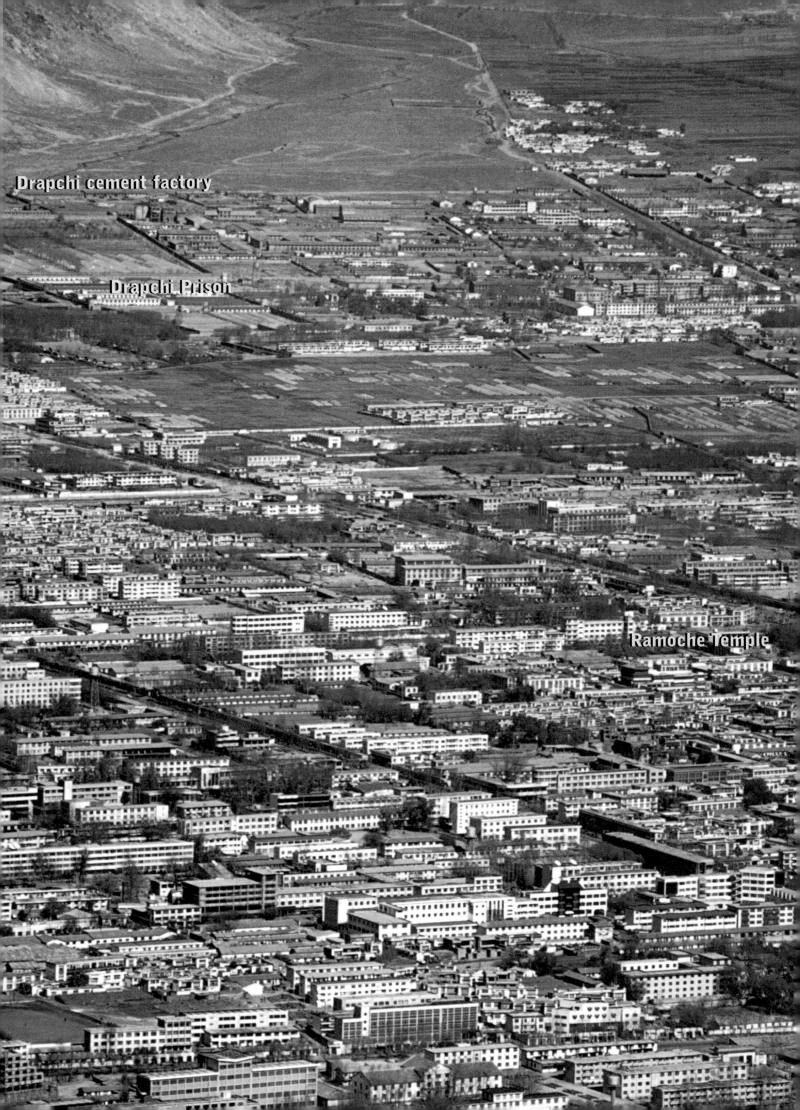

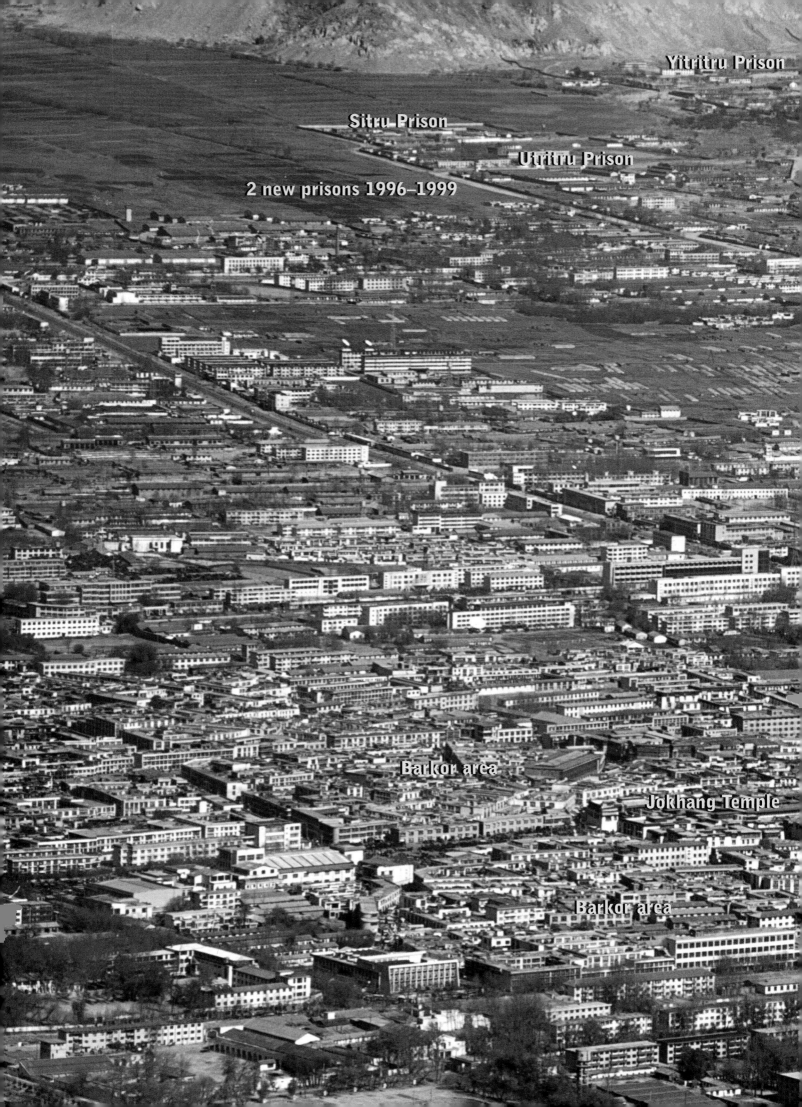

Yitritru Prison

Sitru Prison

Utritru Prison

2 new prisons 1996–1999

Barkor area

Jokhang Temple

Barkor area

PRISONS IN TIBET

STEVEN MARSHALL

Some five to six hundred Tibetans are believed to be detained for the nonviolent expression of their political or religious beliefs. Most are from the Tibet Autonomous Region (TAR), but some are residents of Tibetan autonomous prefectures and counties in the Chinese provinces of Qinghai, Sichuan, Gansu, and Yunnan. It is impossible to know the true number because China allows no outside organizations to visit its prisons on a regular or systematic basis, and its statistics on prisoners are singularly unrevealing. As far as we know, the government does not publish statistics on prisoners broken down by ethnicity, and even if it did, there would be no way of knowing how many Tibetans had been charged with common crimes for what in reality was nonviolent political activity. The scant information available leaks out primarily through political prisoners and often arrives well after the fact, sometimes years later.

The Chinese government maintains that it holds no political prisoners, because political offenses are not identified as such in Chinese law. Instead, nonviolent political activity inconsistent with official ideology can be labeled "subversion," "endangering state security," "plotting the overthrow of the state," or merely "disturbing public order." Until October 1, 1997, when statutes on "counterrevolution" were formally abolished, such activity could also be labeled "counterrevolutionary propaganda and incitement," and many Tibetans are serving sentences under this charge. From 1987 until the present, the vast majority of Tibetan prisoners have been arrested for participating in political demonstrations, putting up political posters, or distributing political leaflets.

The average sentence for political prisoners detained at the end of 1998 was just over seven years, but some Tibetans arrested for peaceful protests were serving much harsher sentences.[1] Years in prison is not all they face. Many Tibetan detainees face torture, beating, and degrading treatment during interrogation; unfair trials and sometimes detention without any trial whatsoever; punishment in prison, including long periods in isolation or years added to their sentences, especially if they try to protest the treatment of other prisoners; and illness and sometimes death from poor treatment and substandard prison conditions.

From the time Tibetans are taken into custody until their eventual release, they may be held in a wide variety of institutions: police lockups, municipal or county detention centers, labor camps, and prisons, to name a few. Detainees and prisoners are often transferred among these institutions, so it is often not until a prisoner is released that his or her places of detention become known. Every county in Tibetan autonomous areas outside the TAR is believed to have a detention center run by the Public Security Bureau—the police—where most detainees are held for initial interrogation. Most prefectures, the next-highest administrative division, have at least one formally designated prison and often several labor camps, mostly for production of agricultural goods, for sentenced prisoners. Each province, with the exception of Qinghai, has several "reeducation through labor" centers, where people may be held for up to three years by administrative order, without any trial. Qinghai has only one.

The TAR has at least two provincial prisons. Prison No. 1 is called Drapchi, after its location, about a mile from the center of Lhasa, Tibet's capital. Prison No. 2, known as Powo Tramo, lies four hundred miles east of Lhasa. Seitru (Unit No. 4), in Sangyip, is the provincial detention center. It appears to be the facility where detainees suspected of serious political crimes—such as passing information between Dharamsala and Tibet—are interrogated. A second unit, apparently serving the same function, opened in the Sangyip complex in late 1998. Trisam, a provincial-level labor reeducation facility, is tucked away in Lhasa's western suburbs. The city of Lhasa has its own detention center, Gutsa, located about four miles east

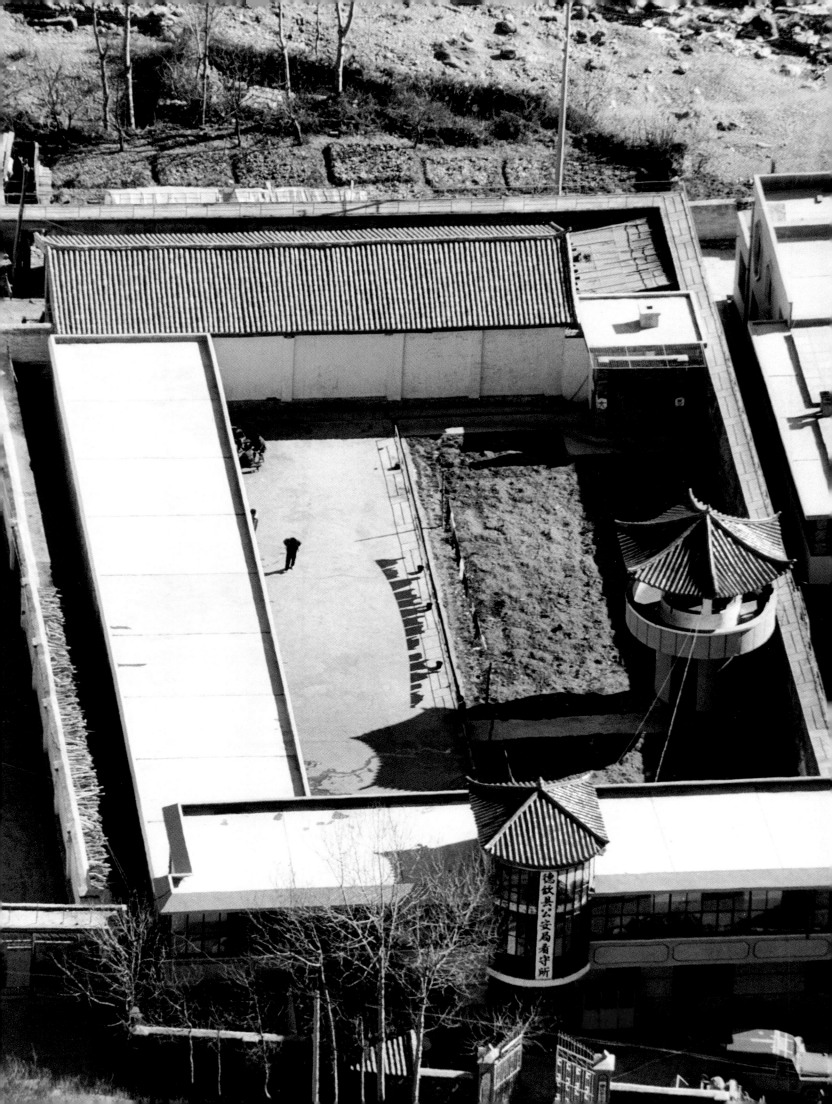

of Lhasa's Barkor, the path that loops around the central Jokhang Temple. It has a particularly bad reputation for torture. A facility known as Utritu (Unit No. 5), in the Sangyip complex in Lhasa's northeastern suburbs, is also called Lhasa Prison and serves Lhasa and its seven counties. There are detention and reeducation centers in each of the TAR's six prefectures, in addition to many county-level facilities.

Many detainees never reach a courtroom or learn why they were jailed. China's Criminal Procedure Law permits police to detain and hold a suspect for months while an "investigation" is carried out. The objective of many such investigations is to obtain information on the suspect's contacts and to force a "confession." A study by the Tibet Information Network found that 41 percent of Tibetan political prisoners arrested between 1987 and 1997 were held for several months without charge and without access to defense, before finally being released.[2]

There is no presumption of innocence in Chinese law and verdicts in political cases are usually predetermined. Police often employ harsh methods during investigation to induce "confession," including beatings, electric shocks, painful binding of limbs, suspension from a ceiling or out a window, and protracted periods of standing, kneeling, hunger, thirst, sleeplessness, heat, cold, and conditions of dark-only or light-only. In 1997, China's National People's Congress passed a new Criminal Procedure Law that included a ban on torture and other coercive means of securing confessions, but there is little evidence of its implementation in Tibet, and the law still allows the use of material obtained through illegal means.

The inherent cruelty of the prison system in Tibet, from gratuitous slaps and kicks to life-threatening beatings, is applied equally to men and to women. The harshest treatment appears to be reserved for those viewed as "troublemakers." These prisoners, including young nuns, are those who refuse to be cowed or recant their views, but instead continue to campaign for Tibetan independence, demand better prison conditions, or protest the treatment meted out to fellow inmates.

Prisons and protests

Most repression in Tibet took place out of the public eye until a series of major protests erupted in Lhasa in September and October 1987, in March 1988, and in March 1989. The 1987 protests started with a pro-independence protest timed to coincide with a visit by the Dalai Lama to Washington, and ended with more than a dozen killed and as many as four hundred detained. The March 1988 protest started as a demonstration for the release of Yulo Dawa Tsering, a senior monk and pro-independence leader arrested several months earlier. It was fueled by the resentment of monks from Lhasa's main monasteries at having to participate in carefully stage-managed ceremonies intended to give the impression of happy Tibetans free to practice their religion as they chose. The protests in March 1989 started as a small rally on the anniversary of the violence in Lhasa the year before and led to two days of clashes. By the evening of March 7, troops were entrenched in the Tibetan quarter of the city; by midnight martial law, which was to last fourteen months, had gone into effect. The arrests that followed the 1987, 1988, and 1989 demonstrations had the effect of dramatically increasing the number of Tibetan political prisoners, particularly those in Drapchi prison. That increase led to the use of prison protests as a tool of political expression.

Since 1987 there have been ten major protests in Drapchi and at least one each in Trisam and the Sangyip complex. Two involved a single individual, Tanak Jigme Sangpo, but by and large, protests have been coordinated affairs involving large numbers of prisoners and focused on particular grievances. They have taken the form of joint hunger strikes, shouting campaigns on behalf of prisoners in particular trouble, collective refusal to meet visitors, letters detailing prison conditions, and straightforward support for Tibetan independence.

The earliest protests were organized by male prisoners, but by 1992, the women of Drapchi, primarily young nuns, were organizing their own protests. From then until the last known protest, in May 1998, women figured prominently.

The first of the important protests in Drapchi occurred in 1990 when a twenty-year-old prisoner, Lhakpa Tsering, was denied medical treatment after he had been severely beaten. Although prison officials eventually provided some minimal treatment in response to demands from other inmates, he died on December 15, 1990. Some ninety prisoners responded by writing "We mourn Lhakpa Tsering's death" on a bedsheet and displaying it to prison officials. Veiled threats and blandishments succeeded in silencing the prisoners and no repercussions followed.

Two major protests occurred the following year, 1991. In each instance, prisoners attempted to involve visiting diplomats, and each time prison authorities responded harshly. On March 31, James Lilley, then U.S. ambassador to China, visited Drapchi. Despite prison authorities' attempts to keep him away from political inmates, two of them managed to hand him a letter detailing their grievances, but the letter was immediately snatched from his hands by his interpreter. The prisoners involved were severely beaten and put in isolation cells. When other inmates protested both that treatment and the prisoners' subsequent transfer from Drapchi, the People's Armed Police (PAP) were called in. Reprisals against the protesting prisoners were swift and severe.

On December 6, 1991, Tanak Jigme Sangpo, already punished for an earlier protest, staged a second one, shouting pro-independence slogans during a visit to Drapchi prison by a Swiss delegation which included the Swiss ambassador to China. In addition to being beaten and transferred to isolation, his sentence, then nineteen years, was increased to twenty-eight. (If he survives, he will be eighty-five years old when his term is up in 2011.)

By 1992, the women of Drapchi had organized. That year, the first day of the Tibetan New Year, called Losar, fell on March 5, the anniversary of the demonstrations in 1988 and 1989. Many Lhasa residents had decided to acknowledge the coincidence of Tibetan New Year and March 5 not by *doing*, but by *not doing*. Contrary to tradition, tattered window-awnings, dirty door-hangings and faded whitewash remained untouched, greeting the New Year with utter cheerlessness. In Drapchi, the women chose another form of protest: non-cooperation. Twenty-three of them, nearly all nuns, followed Tibetan tradition by donning items of Tibetan clothing brought by visitors. Prison officials, angered by the display of respect for Tibetan ways, ordered the women to remove the clothing and wear new Chinese prison uniforms. The women refused; PAP troops were summoned. They proceeded to beat prisoners for the three full days of the Losar holiday. When the PAP troops finished kicking them, punching them, battering them with iron bars, and shocking them with electric batons, the women were confined to isolation cells.

The 1992 protest drew little international attention, but the nuns persisted. In June 1993, fourteen imprisoned nuns, half of whom had been punished for the Losar incident in 1992, managed secretly to record independence songs. Each participant was able to contribute an individual passage using symbolic language to declare love for her land and religion and her devotion to the Dalai Lama. The cassette was smuggled out of the prison. When copies were circulated and guards realized what had happened, the nuns were again beaten and placed in solitary confinement. Court-imposed sentence extensions ranged from five to nine years.

By April 1996, every woman political prisoner in Drapchi was willing to be involved in a protest that initially took the form of a hunger strike. The incident began after prisoners refused to comply with the demands of a "patriotic education" campaign. As part of that

campaign, inmates were ordered to denounce the Dalai Lama, and to reject the boy he had recognized as the reincarnation of the Panchen Lama, and each was to declare support for the boy approved by China's State Council—none of whose members were Tibetan. When prisoners refused, officials threatened daily cell inspections by PAP troops. Three leaders of the women prisoners, Ngawang Sangdrol (who had been a leader in the 1992 protest), Norzin Wangmo, and Phunstog Pema, were beaten and placed in solitary confinement. When PAP officers began the inspections, nuns were accused, apparently arbitrarily, of having wrinkled bedding or improperly folded quilts. They were thoroughly thrashed. They responded with a hunger strike that lasted five days, until prison officials threatened forced intravenous feeding. The officials denounced the nuns for "attempting to harm the national reputation."

The women were not cowed. In February 1997, again during Losar, nuns in Drapchi again vented their frustrations. This time, after officials assembled the women to listen to a performance by two "well-reformed" prisoners singing praises of Mao Zedong, two of the nuns responded loudly, drowning out the socialist tunes with "patriotic" Tibetan songs. Guards beat both women and transferred them to isolation cells. The remaining women went on a hunger strike the following morning, demanding that their comrades be released. Again the strike was broken after five days, this time after guards promised they would try to seek release of the nuns. (It is not clear that they ever intended to make good on that pledge.) After the women resumed eating, they were told that the sentences of the two singers would not be extended, but the two would serve out their terms in isolation.

Five months later, in July 1997, nuns protested again, after one woman was put in solitary confinement for her pro-independence protest timed to coincide with the return of Hong Kong to China.

A protest in Drapchi in October 1997, during a visit by the U.N. Working Group on Arbitrary Detention, again drew international attention. Three prisoners, imprisoned for ordinary criminal offenses, apparently feared that the visitors would be fooled by the extensive preparations that prison authorities had made to impress them. They decided to mount a protest during the U.N. officials' visit. One of the men began shouting "Long live the Dalai Lama." The delegation secured a promise from prison authorities not to punish the man, but the authorities broke the promise. The following day, after the prisoner had been taken to an isolation cell, two other men organized a meeting to protest his treatment. They, too, were put in solitary confinement. All three were beaten, reportedly beyond recognition, and later sentenced to additional years in prison. Chinese authorities refused to give detailed information about the cases to the U.N. and insisted that the longer sentences were imposed as punishment for additional offenses.

The most severe crackdown on prison protests took place after demonstrations in Drapchi occurred on May 1, 1998, International Labor Day, and May 4, International Youth Day. On both occasions officials had gathered hundreds of prisoners in an outdoor courtyard for a flag-raising ceremony in preparation for a visit by a delegation from the European Union (E.U.). Political prisoners and "common criminals," normally separated, were brought together. It appears that officials planned to videotape this assembly of well-behaved prisoners celebrating socialist achievements in Tibet. When the May 1 ceremony began, two common criminals, apparently aware of the impending visit, began shouting political slogans and were promptly joined by many of the assembled prisoners. Guards and PAP troops terminated the demonstration with gunfire, clubs, and electric batons. Officials tried to restage the event three days later, on May 4, the day of the E.U. visit. The consequences were almost identical. This time, Gyaltsen Drolkar, a nun who had participated in the 1992, 1993, and 1996 prison protests and whose sentence had already been extended from four years to twelve, initiated the protest. Again officers used deadly force to halt the noisy melee. The E.U. visitors were unaware that anything unusual had happened.

Authorities implemented extraordinary measures to prevent reports of death and injury from leaking out, and queries by foreign governments were initially dismissed by Chinese officials. Drapchi's governor told a Danish delegation who visited that August that nothing had happened. The vice-governor, however, admitted to another member of the same group that something had indeed occurred. Later that month officials in Lhasa's Justice Department told a European Democratic Union delegation that shots had been fired, but only into the air and only because police were "frightened." Officials have consistently denied that anyone died as a result of the protest. But over the following months, information leaked out and by late summer 1998, the death toll was known to be at least eleven, including six nuns, four monks, and one of the lay convicts who sparked the first protest. Others were severely injured. Some participants, including political prisoners, disappeared—they are believed to have been shifted to isolation facilities in nearby prisons after severe beatings. Most disturbing were reports that the six nuns all committed suicide on June 7, one month after the incident, at the time they reportedly were still in solitary confinement. At least one of the most active nuns, twenty-three-year-old Ngawang Sangdrol, who by then had had her original three-year sentence extended to seventeen years, protested again about a month after the May incidents. In October 1998, the Lhasa Intermediate Municipal Court added four more years to her sentence.

Prisoners have no illusions about penalties for arousing official displeasure. As has been demonstrated, bodily harm, long periods in isolation, and extended sentences are a near certainty. For some the results have been permanent injury, or even death. Traditional Tibetan funerals, called "sky burials," which entail dismemberment, provide opportunities to discover fractured skulls, swollen brains, broken ribs, punctured lungs, and damaged kidneys. One of Tibet's most respected political prisoners, Jampal Khedrub, a Drepung monk, sentenced to an eighteen-year term after his arrest in 1989, was summoned to a meeting with Paljor, a Drapchi prison official, in July 1996. He left the meeting unconscious and died the next day. Funeral preparation revealed a crushed testicle. Two months earlier, a monk, Sangye Tenphel, died in Drapchi after a beating by the same official. Funeral masters found broken ribs and lung damage. None of the bodies of the nuns who died in the aftermath of the May 1998 demonstrations were returned to families. After relatives were permitted, from a distance, a brief look at part of their faces, the bodies were cremated, thereby destroying any evidence of abuse they might have revealed.

In China, as in most countries, imprisonment has two goals: punishment and reform. But even in prison it is hard to reform beliefs. When crimes are expressions of ideas, it is minds, not actions, that must be altered. Initially, prison authorities in Tibet tried to dilute the solidarity shared by political prisoners by dispersing them among ordinary convicts. This, in itself, was heightened punishment for persons who did not consider themselves criminals. But jailers found that banned beliefs spread easily, even to murderers and rapists, and in January 1990, while Lhasa was under martial law, separate divisions were created for Drapchi's political prisoners.

As the "patriotic education" and anti–Dalai Lama campaigns have intensified in Tibet, so have the consequences for prisoners. Those who refuse to disavow their beliefs face prolonged beating, light deprivation, and solitary confinement. When one of their comrades is beaten, put into isolation or killed, they protest in a unified voice. The collision between political prisoners and jailers highlights the failure of a system which has proven its capacity to punish, but not to reform. More importantly, it illuminates why prisoners risk so much when so little can be won. When a Tibetan prisoner dies rather than capitulate, Chinese authorities can issue denials, try to cut off the information flow, or destroy the evidence. But minds remain unreformed. ∎

1. Steven D. Marshall, *Hostile Elements* (Tibet Information Network, London, 1999) pp. 56–57.
2. Ibid, pp. 53–54.

Right: Steven Marshall, Bamei labor camp, Tawu County (Ganzi Tibetan Autonomous Prefecture, Sichuan Province), spring 1995. Along the only road through Garthar is one of a network of labor camps that are spread throughout Tawu and Dartsedo counties in Ganzi TAP. Some of the inmates are forced to mine gold. A local trader, Tsering Dorje, who had been sentenced to twelve years' imprisonment, feared that he would not survive the sentence and managed to escape into exile. He described a prison regimen in which prisoners had to fulfill daily excavation quotas despite poor nutrition and little rest. Some prisoners are alleged to have committed suicide in preference to being beaten, starved, or worked to death; others have injured or mutilated themselves to avoid the grueling labor. According to Tsering Dorje, any attempt at escape from Bamei was punished by flogging, followed by lengthy isolation in a small, darkened cell, the door of which would not be reopened until the confinement period was completed.

152 top: Steven Marshall, Drapchi Prison, central Lhasa, 1996. As of 1998, the Tibet Information Network had documented some 270 Tibetan political prisoners in Drapchi Prison. The actual number is believed to be higher, probably between 300 and 350. The frequency of politically motivated demonstrations within Drapchi has risen in recent years, paralleled by a jump in the rate of deaths from abuse. The same TIN report lists nineteen political prisoners who died of abuse in Drapchi from 1990 through 1998. Prisoners have suffered serious illness from harsh labor conditions, including high temperatures and excessive exposure to insecticides in prison greenhouses where tomatoes are grown for sale in local markets.

152 bottom: Steven Marshall, Lithang County Public Security Bureau Detention Center (Ganzi Tibetan Autonomous Prefecture, Sichuan Province), 1996. At 15,400 feet (4,700 meters), Lithang is one of the world's highest towns. The principal monastery, Chamchen Choekhorling, has contributed to the number of Tibetan monks who have either escaped the country or remained behind to protest. Twenty-six-year-old Lhadar was one of four monks held in the Lithang detention center in August 1993, accused of putting up anti-Chinese posters. He died in custody after only six days, reportedly as a result of severe abuse. Police claim that he committed suicide. The jail's watchtower, conspicuously tall for the size of the prison compound, was constructed so that police or army would have a firing platform with a vantage across the entire town.

153 top and bottom: Steven Marshall, Sangchu County Public Security Bureau Detention Center (Gannan Tibetan Autonomous Prefecture, Gansu Province), 1995. The monks of the Labrang Tashikhyil Monastery have staged protest activities over the past decade, most actively in 1995. One of the monks jailed that year, Jigme Gyatso, was beaten savagely with a wooden bat, and forced to remain standing for extended periods over a ten day period. Months later, in extremely poor condition, he was released to his family's care after a sum of money was paid. Police reportedly feared that he would otherwise die in custody.

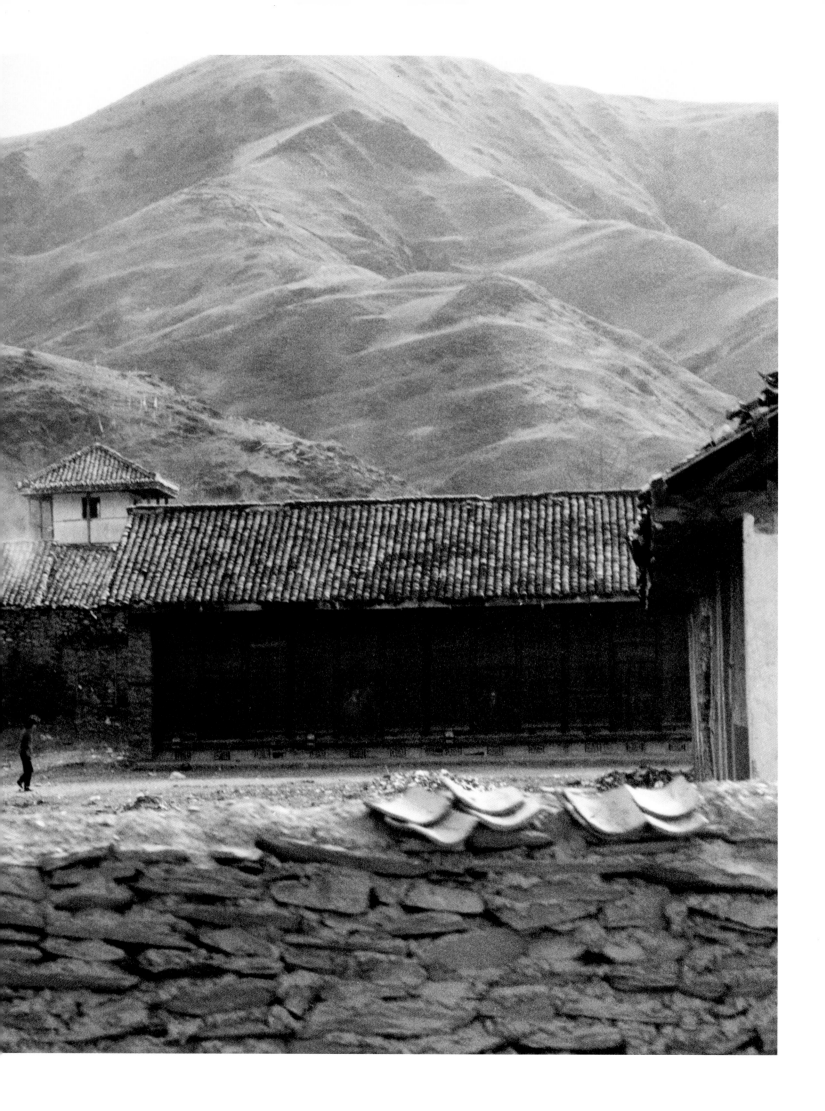

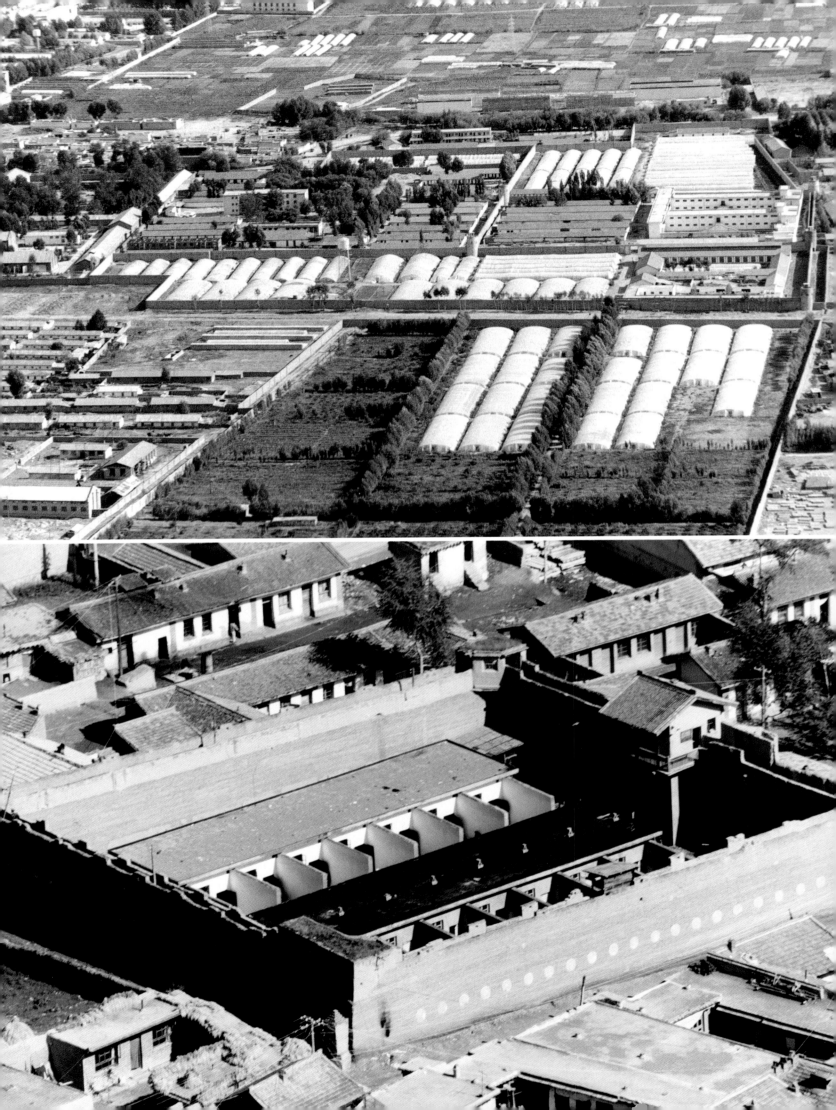

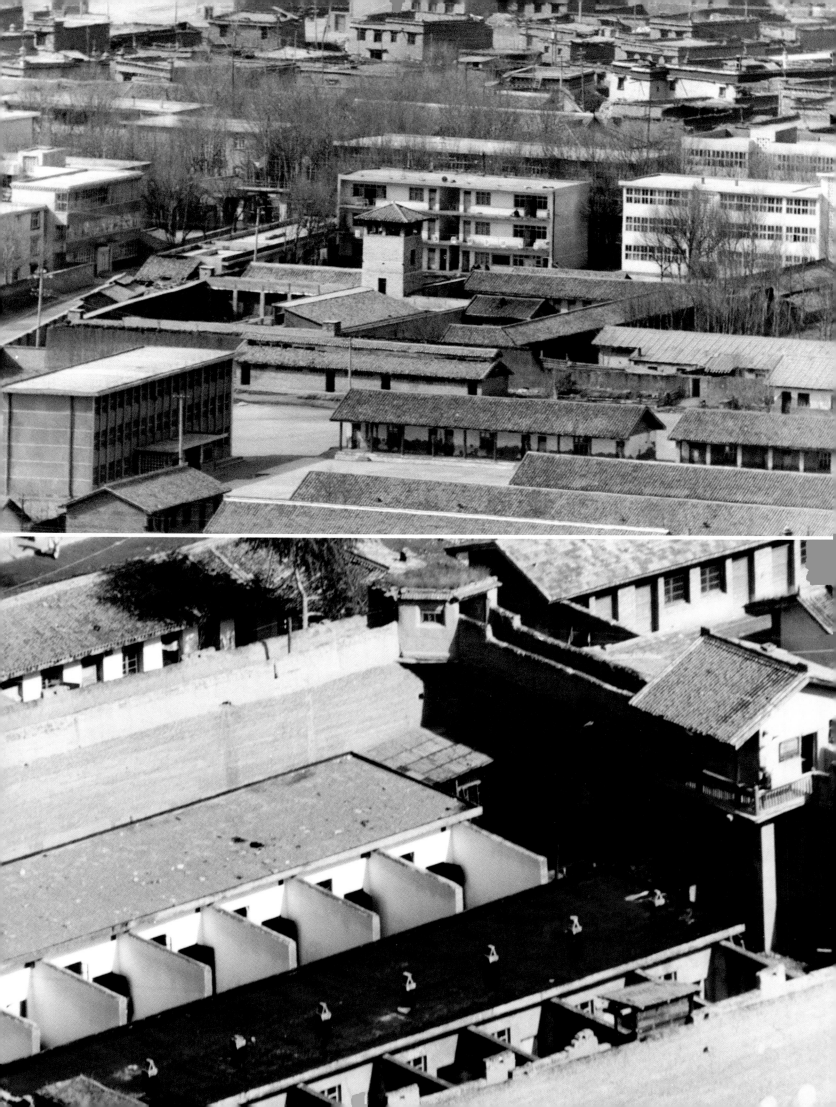

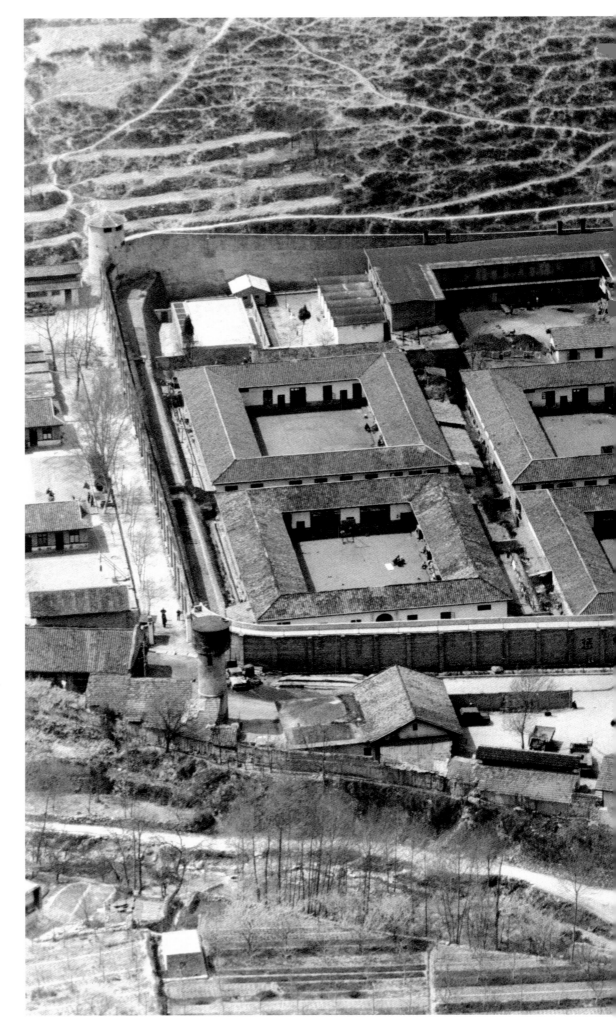

Steven Marshall, Maowun Prison (Maowun county, Aba Tibetan and Qiang Autonomous Prefecture, Sichuan Province), 1996. A self-contained production enclave, this is the main prefectural prison in Aba T&QAP. Information about the facility's inmate population and its role in regional political imprisonment is only beginning to emerge. Ngaba county, the prefecture's most politically turbulent, is the birthplace of seven of the political prisoners who were held at Maowun. Three are monks from Kirti Monastery. One, Lobsang Sherab, was detained in 1998 and reportedly beaten and tortured while held at a detention center in the prefectural capital Barkham. After receiving a three-year sentence, he was transferred to Maowun. Another locally renowned political prisoner, Garchoe, was imprisoned in Maowun in 1993 and reportedly was shot dead the following year when attempting to escape from an agricultural work gang.

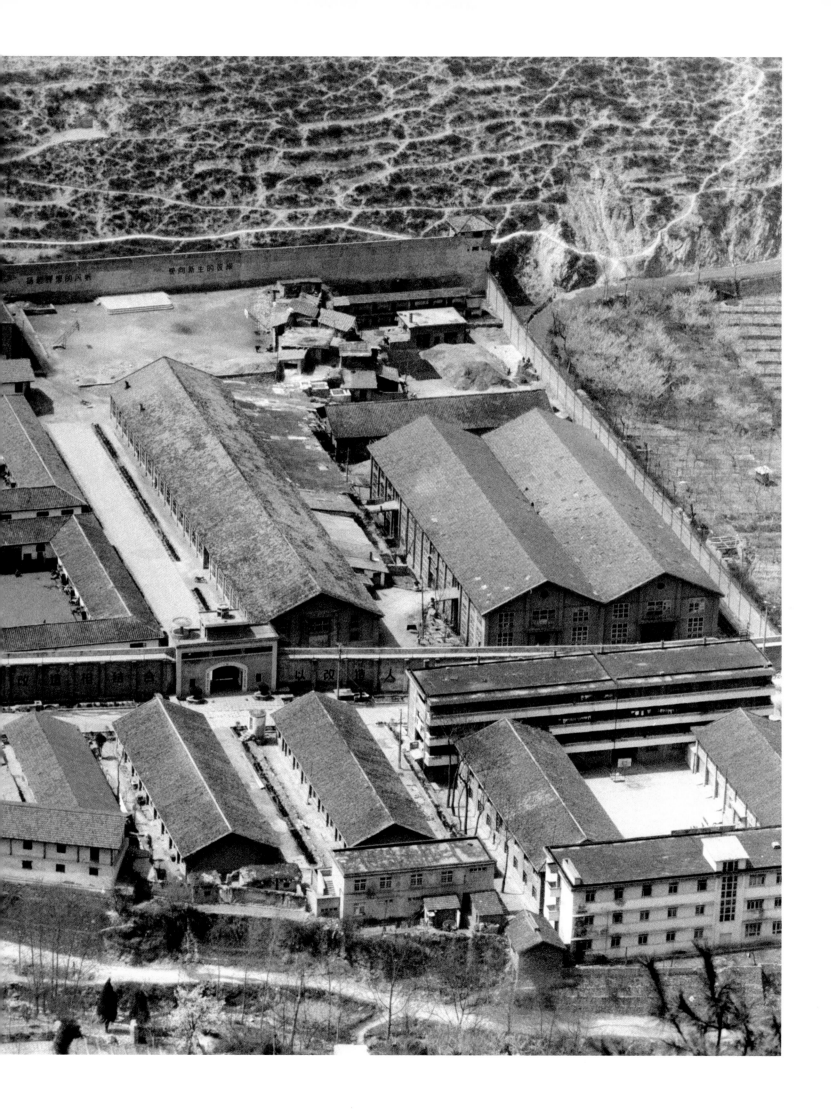

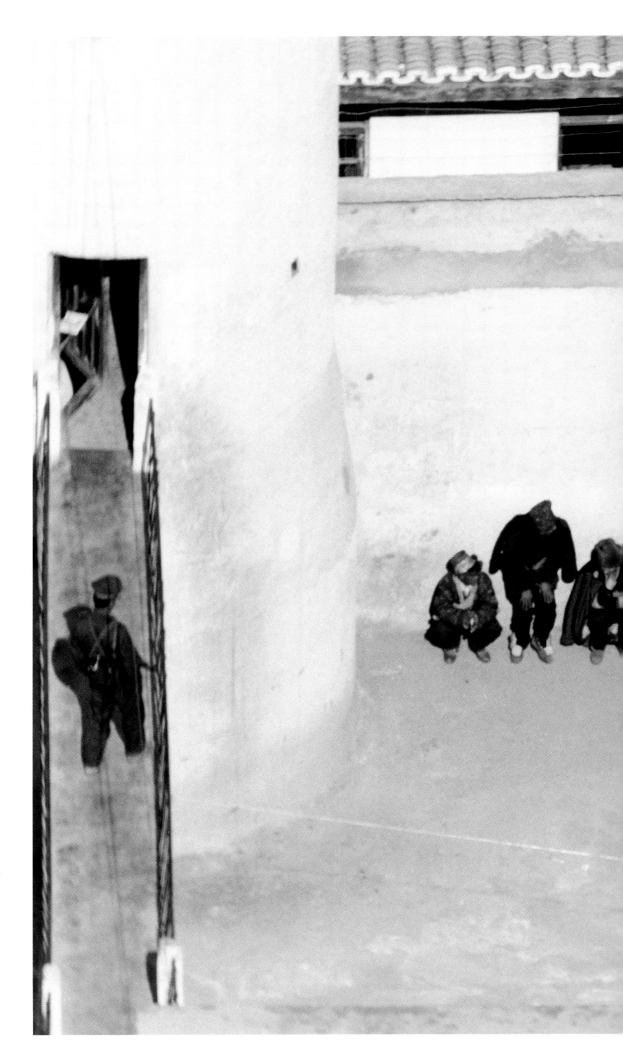

Steven Marshall,
Payul County Public Security Bureau Detention Center (Ganzi Tibetan Autonomous Prefecture, Sichuan Province), 1996. Payul's county seat, in a remote corner of Ganzi TAP, is only a short distance from the border with the Tibet Autonomous Region. Pre-sentencing conditions at county jails, especially during interrogation, are often harsher than those endured by sentenced prisoners. These men were brought from their cells and made to squat against the wall. Under a People's Armed Police guard's shouted supervision, each prisoner, in turn, rose to a stooped posture and addressed the others. After individual statements, the men were permitted to sit for a few minutes, then returned to their cells.

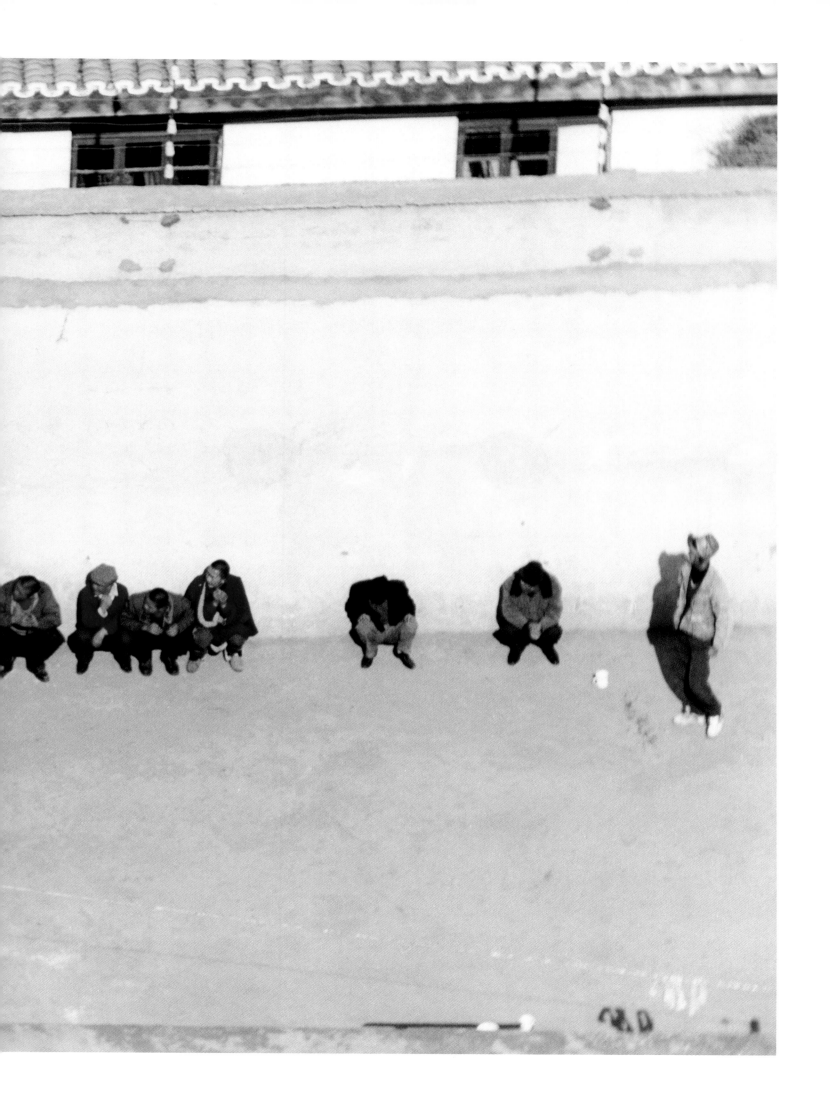

IN MAY 1995 THE DALAI LAMA ANNOUNCED

THAT A SIX-YEAR-OLD BOY LIVING IN

NORTHERN TIBET WAS THE REINCARNATION

OF THE TENTH PANCHEN LAMA, WHO, AT

HIS DEATH IN JANUARY 1989, WAS THE

MOST SIGNIFICANT OF THE TIBETAN LEADERS

TO HAVE REMAINED IN TIBET AFTER THE

DALAI LAMA'S FLIGHT TO INDIA IN 1959.

THE CHINESE GOVERNMENT FORBADE

TIBETANS TO RECOGNIZE THE CHILD

IDENTIFIED BY THE TIBETAN SEARCH TEAM

AND THE DALAI LAMA. IN OPPOSITION TO

THE DALAI LAMA'S CHOICE, CHINA CHOSE

ITS OWN PANCHEN LAMA. THE CHILD

IDENTIFIED BY THE DALAI LAMA, ALONG

WITH HIS FAMILY, HAVE NOT BEEN SEEN

SINCE MAY 1995 AND HAVE BEEN PUBLICLY

VILIFIED BY THE CHINESE GOVERNMENT

THROUGH THE OFFICIAL MEDIA. THE CHILD

APPOINTED BY THE CHINESE GOVERNMENT

HAS BEEN REQUIRED TO APPEAR IN PUBLIC

AND TO MAKE POLITICAL STATEMENTS

SUPPORTING THE STATE, DESPITE THE

RIGHT TO FREEDOM FROM EXPLOITATION

TO WHICH CHILDREN ARE ENTITLED

UNDER INTERNATIONAL LAW.

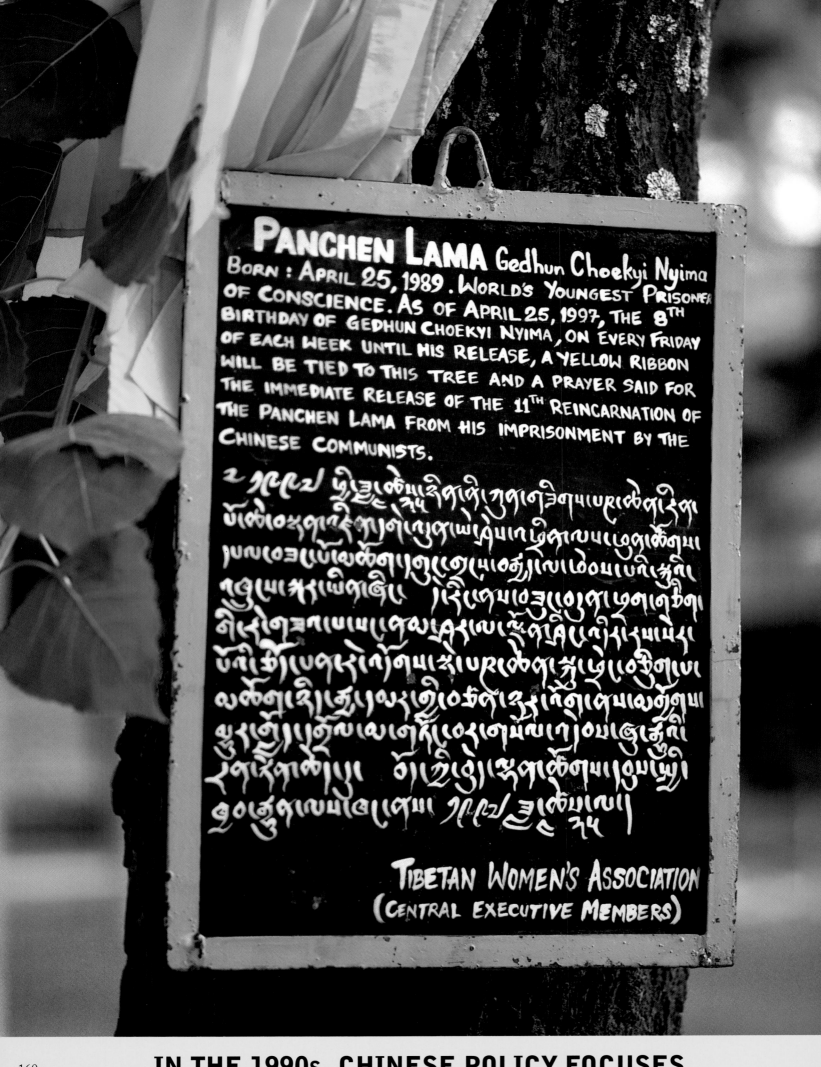

IN THE 1990s, CHINESE POLICY FOCUSES

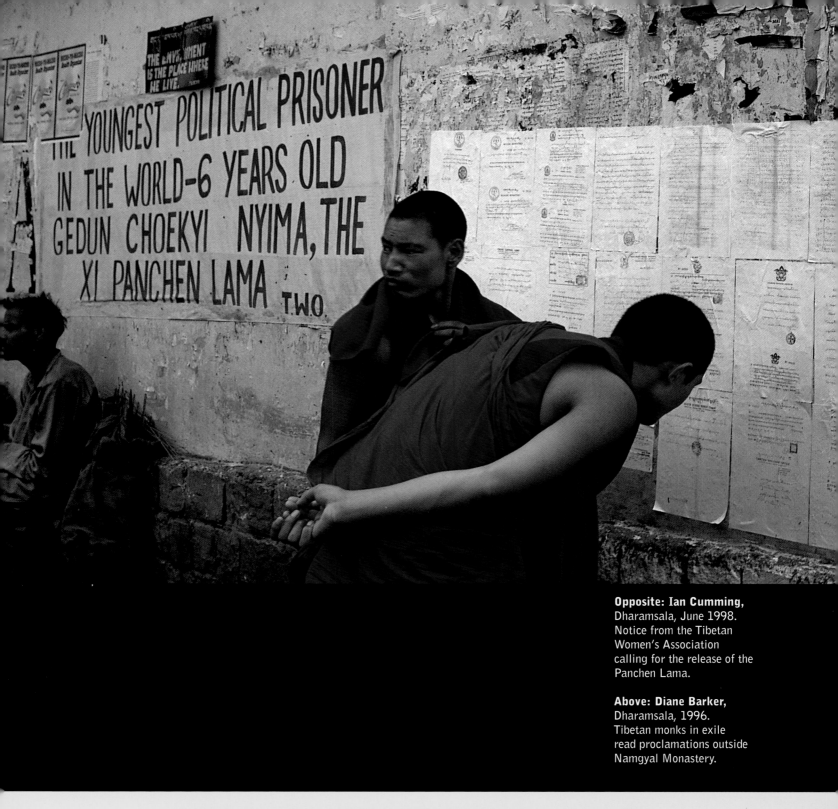

Opposite: **Ian Cumming,**
Dharamsala, June 1998.
Notice from the Tibetan
Women's Association
calling for the release of the
Panchen Lama.

Above: **Diane Barker,**
Dharamsala, 1996.
Tibetan monks in exile
read proclamations outside
Namgyal Monastery.

ON ERADICATING THE DALAI LAMA'S

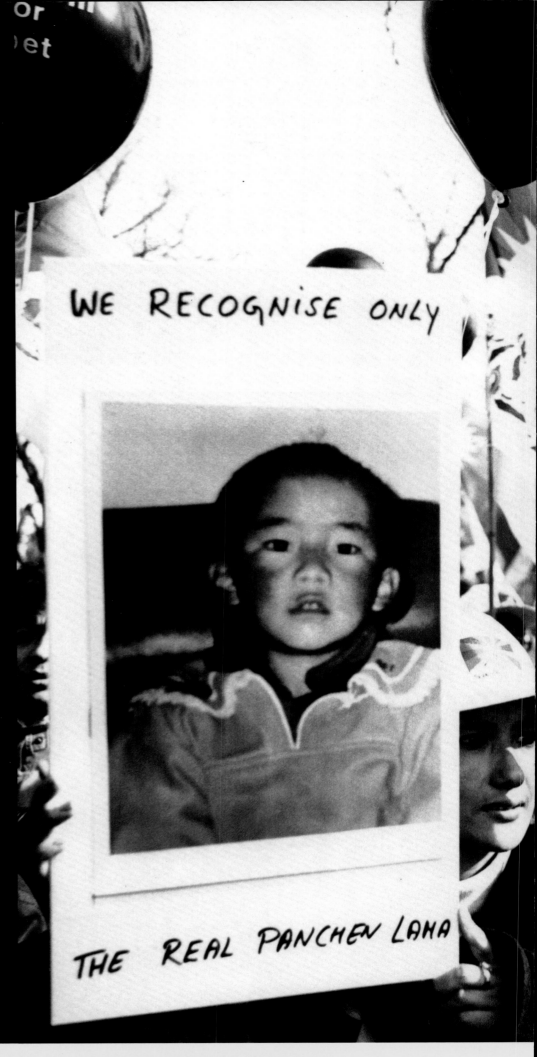

WE RECOGNISE ONLY

THE REAL PANCHEN LAMA

Right: Marcos Prado,
Brussels, March 10, 1996.
Every year on this date Tibetans
commemorate the Tibetan
uprising of March 10, 1959
and remember the atrocities
that occurred in Lhasa.

164–165: Russell Johnson,
Gansu Province, 1989. Monks
practice *cham* (religious dance)
in a compound courtyard of
Labrang Monastery. In many
Tibetan monasteries, *cham*
is performed for both lay
people and monks during large
religious ceremonies.

POLITICAL AND RELIGIOUS

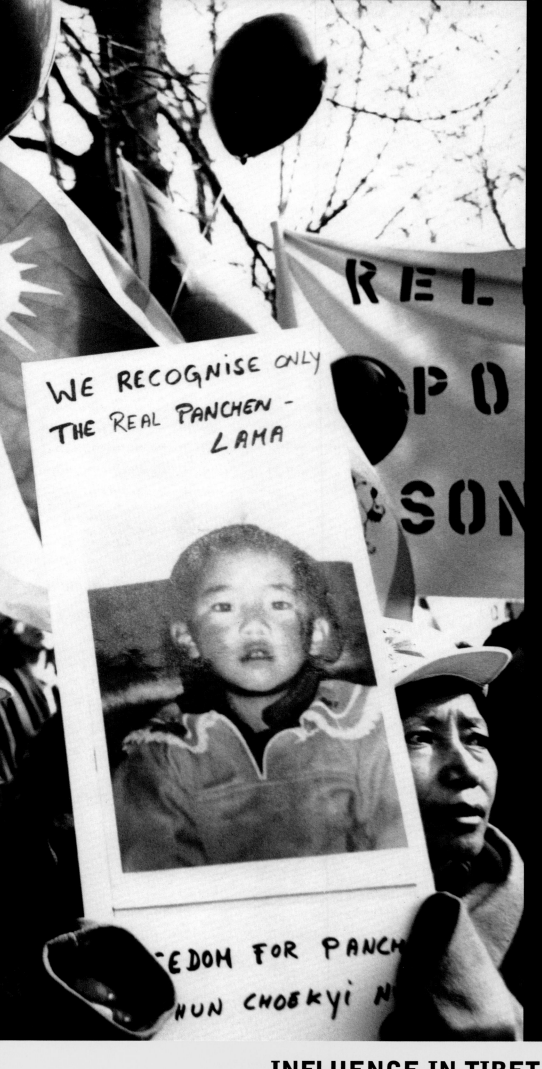

INFLUENCE IN TIBET,

AND ELIMINATING ALL ASPECTS

OF TIBETAN CULTURE

Marcos Prado, Lhasa, 1993.
At least four video cameras
survey the Jokhang Temple.

IDENTIFIED AS OBSTACLES

TO DEVELOPMENT.

AT PRESENT, SILENCE, PRISON, OR EXILE

ARE STILL THE ONLY OPTIONS FOR TIBETAN

DISSIDENTS. DESPITE THIS GROWING

AWARENESS, TIBET'S REALITY IS

DIMINISHED BY THE ROMANTICISM

OF WESTERNERS, ESPECIALLY

AMONG VISITORS TO TIBET

(WHO ARE ALSO SUPPORTING CHINA'S

TOURISM INDUSTRY), AND BY TIBETANS'

OWN MYTHOLOGIZING.

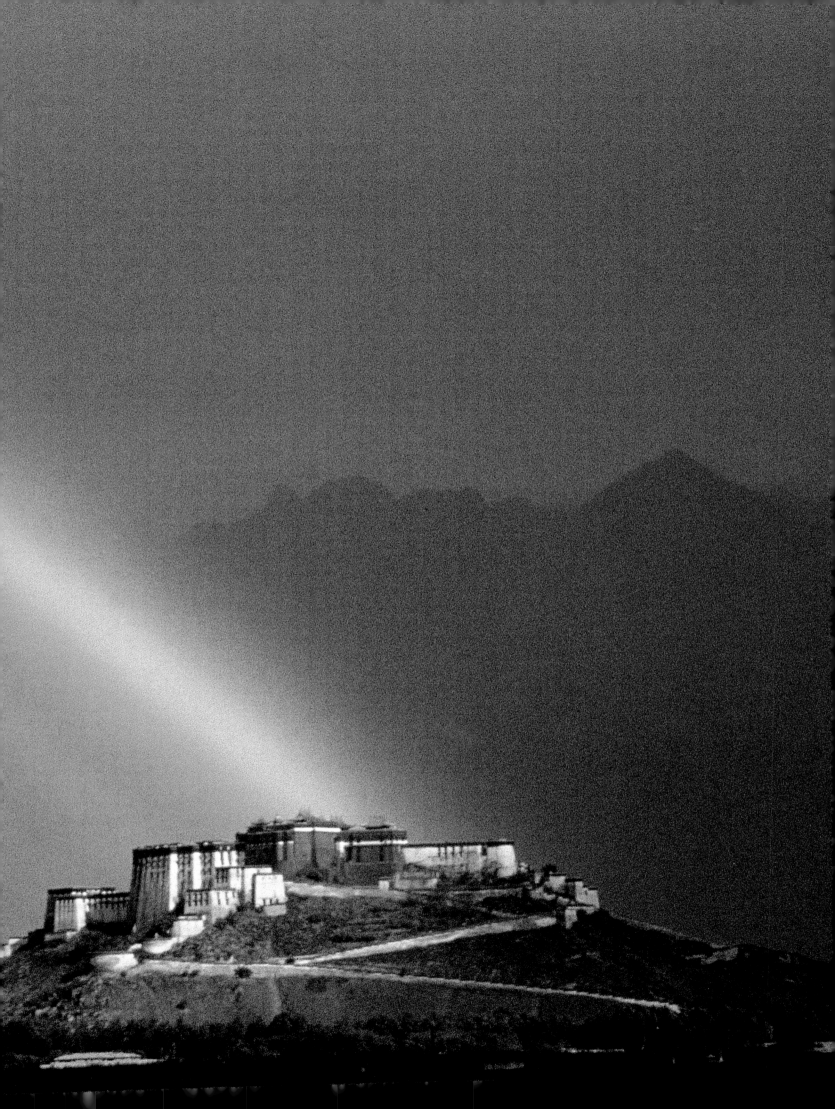

VIRTUAL TIBET

ORVILLE SCHELL

The Western imagination has long hungered for cultures and places remote enough to remain uncontaminated by the imperatives of modern life. One may debate, of course, whether any place on our increasingly small planet remains untouched by the homogenizing effects of jet travel and the global marketplace. What is not in question, however, is the yearning of disenchanted Westerners to believe in such places. Indeed, to acknowledge that such lands may no longer exist seems too bleak a thought for most of us in modern life to bear.

Fantasies of escape are naturally more powerful when rooted in real geography; the concreteness of a real place helps us believe in our romantic myths as something more than baseless, chimerical dreams. Few places on the globe have been afforded better geographical conditions for remaining isolated than Tibet, protected as it is from Inner Asia by the Kunlun Mountains and the deserts of Qinghai and Xinjiang to the North; from China by the rugged foothills of the Tibetan plateau; and from India by the Himalayas. Never mind that it is not the pocket-sized kingdom tucked in the mountains that many in the West may still believe it to be, but instead a vast and sparsely populated land as large as Western Europe.

No land has provided such an enticing target for a corpus of romantic transferences, nor more continuously fired the imagination of Western escape artists. Tibet is still imagined as "the cure for an ever-ailing Western civilization, a tonic to restore its spirit," as Tibet scholar Donald Lopez has written in his recent book *Prisoners of Shangri-La*. "To the growing number of Western adherents of Tibetan Buddhism, 'traditional Tibet' has come to mean something from which strength and identity are to be derived . . . a land free from strife, ruled by a benevolent Dalai Lama, his people devoted to the dharma."

I made my first trip to Tibet in 1981, when, after several decades of strict closure, the Beijing government finally gave foreign tourists, trekkers, and climbers limited access to "the roof of the world." Even though this was the first time I had been in an ethnically Tibetan region of China, it could have been said of me, as of so many other Westerners, that I had already long been journeying toward Tibet. In a manner of speaking, I had many times before reached "Tibet," that fabulous land of our Western imagination which I had inhabited first in a vicarious fashion through various books of exploration and adventure, novels, and articles in *National Geographic* that I read in my youth, even though I had never actually set foot on Tibetan soil.

If there was a first milestone in my travels—not to Tibet itself, but toward what I've come to call "virtual Tibet"—it would have been the moment in 1953 when at age thirteen I happened to pick up Heinrich Harrer's classic tale, *Seven Years in Tibet*, one in a long lineage of accounts of Tibet by Western missionaries, diplomats, explorers, adventurers, freebooters, soldiers, dreamers, spiritual seekers, geographers, ethnographers, and scam artists that extends back hundreds of years.

First had been the reports of Catholic missionaries in the seventeenth and eighteenth centuries, then those of British East India Company officials in the eighteenth century and of the Indian "pundits" sent secretly by the British Raj to map Tibet's "blankness" in the nineteenth century. There followed a motley crew of European travelers who managed to penetrate Tibet's peripheries and return home with overheated tales of their adventures. Based on these reports, a whole series of "Tibets," each more fabulous than the last, arose in the minds of Westerners, especially those curious about Tibet's unique and colorful form of Buddhism.

170–171: Galen Rowell, Lhasa, 1981. Rainbow over the Potala Palace, traditional home of the Dalai Lama.

Beginning with the accounts of those who had actually been there—as well as those who only claimed to have been there—in the course of time Tibetan fantasies rooted themselves in almost every form of popular entertainment: in magazines, newspapers, books, comics, children's stories, stage productions, and finally on the screen. When James Hilton's 1933 novel *Lost Horizon* was released as a film in 1937, it was the apotheosis of Tibet as a fantasy realm. With it, the notion of that land as the paradisiacal "Shangri-La" entered both the imagination and the vocabulary of Western popular culture, becoming one of the most powerful utopian metaphors of our time.

Tibet was the last place on earth still seeming abound in true "mysteries," including lamas who could "fly," magicians who could stop the rain, and Yetis, a race of half-human and half-ape-like creatures said to inhabit the snowy wastes of the Tibetan plateau and remarkably capable of eluding the best Western attempts at scientific verification.

It hardly needs to be said that Tibet's snow-capped mountains and alpine deserts do not offer the promise of easy tropical living held out by island paradises with their palm-fringed beaches and azure lagoons. Indeed, until recently, Tibet was entirely devoid of most amenities. Tibetans did not even adopt the principle of the wheel, except for purposes of spinning prayers, until the second part of this century when Chinese occupiers finally arrived.

Most of Tibet is thousands of feet above sea level and possesses one of the more inhospitable climates on earth. It has an indigenous cuisine that Westerners have found mostly inedible and, until recently, a largely nomadic population that engaged in only the most modest kinds of personal hygiene. What is more, Tibetans, despite a beguiling cheerfulness, have historically shown themselves to be capable of considerable savagery against one another, not to mention outside intruders. Yet this catalog of dubiously utopian attributes has seldom hindered rapturous Western dreams.

The formidable barrier of the Himalayas helped shield Tibet from the power of British-ruled India and from the outside Western world more generally until the late nineteenth century. In the modern West, where "wonders" had by then become by definition scientific; where the church had increasingly lost power; and where royalty was fast falling to democracies and dictatorships, the idea that somewhere there existed a feudal theocracy ruled by a compassionate God King and a colorful aristocracy, which labored not for industrial production or colonial expansion but for the spiritual enlightenment of humanity, and did so under golden monastery roofs, proved irresistibly attractive to a disillusioned West.

In addition, though many Europeans and Americans were captivated by other forms of "oriental" religion, Tibet's brand of Buddhism—steeped as it was in tales of magic and mystery, including accounts of unbelievable spiritual feats—held a special fascination. The idea of an entire people still enraptured by religion and engaged so ardently in a Buddhist affair of the spirit rather than materialism was irresistible to Westerners lost in a cult of material accumulation and spiritual anomie.

Buddhism, which ultimately mixed with nativist shamanism in Tibet, was founded by Prince Siddhartha Gautama. Born in the middle of the sixth century B.C. into a wealthy family on the border between present-day Nepal and India, he set out to wander as an ascetic to acquaint himself with the suffering of ordinary people. This is said to have caused him to renounce his life of privilege in order to search instead for the true nature of reality

and existence. Through these efforts he came to be known as the *Śakyamuni*, a Sanskrit word meaning "the hermit of the Sakya family."

His teachings, or the *dharma*, grew out of a realization he had while meditating under a bodhi tree, that human existence is bounded by the Four Noble Truths: life is filled with suffering; attachment and desire are the root of most suffering; liberation from desire and the self is possible; and such liberation—*nirvana* or "enlightenment"—can be attained by leading a compassionate life of virtue, wisdom, and meditation.

According to the Buddha Śakyamuni—whose recitations were transcribed by one of his disciples, Ananda, in sutras, meaning in Sanskrit "threads" or "strings"—the way to enlightenment was through adherence to a Noble Eightfold path, which committed followers to strive to maintain right views, right resolve, right speech, right action, right livelihood, right effort, mindfulness, and right concentration. In the Buddhist view, life's endless sufferings can be escaped only by accepting the impermanence and illusion of reality. As the Buddha says in the *Prajna paramita*, one of his most famous sutras, "Regard this fleeting world like this: Like stars fading and vanishing at dawn, like bubbles on a fast-moving stream, like morning dewdrops evaporating on blades of grass, like a candle flickering in a strong wind, echoes, mirages, phantoms, hallucinations, and like a dream."

Within a century and a half of Buddha Śakyamuni's death, Buddhism had divided into two main schools: Hinayana (still practiced in South and Southeast Asia today) emphasized the salvation of the individual, while Mahayana (variants of which are practiced in Tibet, China, Korea, and Japan) emphasized the need to strive for the collective salvation of all human beings. Neither tradition believed in a supernatural God-the-Creator. In this sense, Buddhism was as much a set of ethical teachings, a philosophy of life that could lead to a form of earthly "enlightenment," as it was the theology of a transcendental faith.

In 779 A.D., the Buddhist master Padmasambhava journeyed from India to Tibet to found the first Buddhist monastery, Samye, just south of Lhasa. By the thirteenth century, Buddhism had spawned a complex series of monastic orders whose rivalry mirrored the land's fragmented political structure. By then, the distinctive brand of Buddhist teaching that we know today as Tibetan Buddhism, or Vajrayana, had been codified and accepted as Tibet's prevailing faith. Vajrayana Buddhism added to the by-then standard Buddhist spiritual practices of meditation and chanting an assortment of other techniques including yoga, tantric sexual rituals, visualizations, and repetitive prayers to the Buddha himself that are carried out by means of recitation, prayer wheels, and prayer flags.

One of the most important features of Vajrayana Buddhism is the notion of the *bodhisattva*, or "enlightened being," who out of universal compassion for the suffering of others abstains from entering *nirvana* in order to help save those still trapped in the inescapable cycles of *samsara*, the conditionality of our existence. Tibetan Buddhism's most fundamental precept is that motivation determines actions, and that if one wishes to act compassionately and gain enlightenment, one must vigilantly strive to cultivate a high state of consciousness about what one does and how it may affect others. Why? Because upon death, what the Dalai Lama has described as the "imprint" of a former being's consciousness, or *karma*, will remain as a kind of residue that is "reincarnated" in a new animal, human, or divine form.

All of this was woven into an elaborate institutional fabric centering around thousands of monasteries. According to Tibetan Buddhist belief, when the reincarnation of a particularly enlightened being occurs in human form, that person is known as a *tulku*, which literally means "illusionary body." The most eminent Tibetan *tulku* is the Dalai Lama, who is traditionally viewed as both the spiritual and temporal leader of all Tibetans. Monastic life revolves around these *tulkus*. But monasteries have long been more than just ascetic religious retreats for Tibet's hierarchical priesthood. Since Tibet had virtually no cities, monasteries become the focal point of socialized life for the land's largely nomadic populace. Monasteries were where Tibetans were educated, where commerce was conducted, and where society interacted during religious festivals. By the time of the Chinese Communist occupation of Tibet in 1950, there were said to be more than 2,500 monasteries spread throughout Tibetan ethnic areas. Almost all of them would be destroyed or severely damaged in the decades of Maoist political upheaval that followed.

Much of this sorry interregnum went on unreported and thus unnoticed by the West, which was shut out by the Communist Party's policy of preventing access to journalists that stopped the free flow of information. Ignorance enabled most people in the West to go on imagining the Tibet of old, only dimly aware that something apocalyptic was transpiring. When I made my first trip to Tibet via Beijing I had already heard repeated stories of the savagery involved in the "peaceful liberation" of Tibet first by the People's Liberation Army and then the Chinese Communist Party, and this reality had already begun to encroach on my own fantasy of that fabled land. And so, by the time I returned in 1994, as a correspondent for a PBS *Frontline* documentary on Tibet's agonized relationship with China, I had come, more or less, fully down to earth. Far from being a land of tranquil isolation as I had imagined, Tibet was a cauldron of political turmoil and military domination.

If Buddhists see the world as illusory and de-emphasize the difference between dreams and waking consciousness, Westerners have tended to blur the distinction between what Tibet is and how they imagine it or want it to be, so that it has become the dreamiest of realities. But like any fantasies cobbled together from fragments of suggestive reality, our fantasies of places on or off this earth generally reflect far more about ourselves and our own yearnings than we perhaps care to know. Certainly, this has been true of Tibet.

Of course, China's President Jiang Zemin, like many of his countrymen, tends not to romanticize Tibet as Westerners do, and he remains incredulous—as he told President Clinton in 1998—that those who live in countries where (as he puts it) "education in science and technology has developed to a very high level" and where "people are now enjoying modern civilization" should still "have a belief in Lamaism" [Tibetan Buddhism]. Indeed, in the past few years many observers have come to believe that Beijing had simply decided to wait until the sixty-four-year-old Dalai Lama passed from the scene, counting on Tibet to become ever more Sinicized and so more amenable to Chinese rule as increasing numbers of Han Chinese immigrants arrived each year to build its new economy. To foreigners looking on from afar, the Chinese occupation and the dismantling of traditional culture and society seemed similar to other brutal forms of nineteenth-century European and American colonization, which were also based on no more than the flimsiest claims to sovereignty. Some

came to feel that the Chinese were not only crushing a traditional society, but the dream of Shangri-La itself. For them Chinese rule represented crushing a dispossessed people and a traditional society.

Thus in the mid-1990s, the Beijing government found itself confronting a new problem nearly as intractable as the Tibetan independence seekers themselves. To their dismay, Party leaders began to realize that China now abutted a symbolic space controlled by a far more fantastic kingdom than any that had ever existed on the Tibetan plateau. Moreover, as the decade proceeded, the citizens of this new kingdom threatened to take possession of Tibet as a form of intellectual property—to internationalize it and challenge China's version of its "liberation" in ways that seemed beyond the ability of Party leaders to grasp, much less control. This new kingdom was especially effective as an agent of global public relations and it had a capital of sorts, no less fabled than Lhasa but situated in Southern California, beside the blue Pacific Ocean. The Kingdom of Hollywood's fin-de-siècle seizure of Tibet as a subject for its films raised a curious new question: who in this global era would be the final arbiter to determine which version of Tibet would triumph—the real Tibet, China's Tibet, or the "virtual Tibet" that was being elaborated in the West and in a host of new Hollywood films including Martin Scorsese's *Kundun* and Jean-Jacques Annaud's *Seven Years in Tibet*.

There were dangers to having Tibet's new Western persona consigned to Hollywood's custody. For while a certain amount of "consciousness" might be raised, Hollywood's manufacture of myths for profit threatened to have a different kind of distorting effect. Indeed, even the Dalai Lama risked a certain devaluation of his persona of aloofness and ineffability by being run through Hollywood's powerful dream machine.

In a swirl of globalized bottom-line anxiety, conflicting imagery, bad publicity, political threats, wanton boosterism, and furtive negotiations, the Tibetans themselves—those scattered around the world in their diaspora or still oppressed within Tibet itself—stood oddly in danger of being forgotten. It wasn't that "Tibet" was being forgotten. Certainly not. As the films *Seven Years in Tibet* and *Kundun* neared their release dates in 1997, the buzz in the media about Western interest in China's occupation of Tibet, Buddhism, Tibetan adventures, the Dalai Lama, and Hollywood stars smitten with any of the aforementioned subjects hit near-manic proportions, so that it was increasingly difficult for those who took their Tibetan politics or Buddhism seriously to know how to comport themselves.

But even among the realists, and especially among supporters of the Dalai Lama's government-in-exile, the advent of Hollywood arriving on the scene like a fire brigade—with its stars, its money, and now its film power—renewed a sense of hope. After all, however dangerous Hollywood can be to pure principles, one could not doubt its power. And if there was one thing those who had made a crusade out of Tibet felt crippled by, it was weakness. At last, these activists hoped, compelling big-screen scenes of the halcyon days of Tibet (as it was once imagined to have been), might force the issue of Tibet and what was lost onto the U.S. foreign-policy agenda. Political arguments had been insufficient means to accomplish this end, but perhaps wondrous onscreen images of the Dalai Lama's story would do the trick. Among many exiled Tibetans there grew an almost millenarian belief

that the release of these films, and Tibet's identification with such pop icons as Brad Pitt, Martin Scorsese, Richard Gere, Steven Seagal, and the Beastie Boys, might finally precipitate the long-awaited moment when China would feel compelled by the power of world opinion to relent and address the question of Tibet in a more humane and conciliatory way.

In retrospect, however, such dreams were, if anything, less realistic than the exotic ones Westerners had so long held about Tibet itself and its redemptive, transformative powers. In a world of gigantism—IMAX movie screens, megastars, superpowers, massive corporations, hundreds of millions of dollars in grosses, global publicity blitzes—the hopes of actual Tibetans, even when played onscreen by bona fide Tibetan extras, even when weeping real tears over Tibetan "events" that never actually happened, were modest, yet utterly unrealizable. It was as if, in every sense, they were not functioning on the same scale as the worlds now intersecting and colliding around them over the "China market." There was no wisdom the Dalai Lama possessed, nothing he could either tell an American psychiatrist co-author, Hollywood's nouveau royalty, or his own frustrated people, no amount of "different thinking" that would truly affect this disparity. It was all well and good to imagine that with the help of Hollywood and other American power structures, Tibet might be redeemed. After all, it was very tempting to believe that this morality play would have a happy ending, that those Tibetans who had been scattered to the far corners of the globe might at last be delivered.

The truth is that there is probably no exogenous force—not U.S. pressure on China, not trade sanctions, not even the titanic power of Hollywood's ability to make global myths—that is sufficient to budge China's determination to defend its self-declared sovereign right to hold onto Tibet, one of the few remaining relics of the Chinese Communist Party's original revolutionary platform. By now, commitment to maintain the "reunification of the Motherland" has become unassailable, doctrinal canon. What makes this situation so tragic is that not only is this posture destructive for Tibet, it is just as destructive for China's global image at a time when Beijing leaders desperately seek international respectability and equal standing as a member of the respectable global community of nations. But with a yawning absence of strong leadership in Beijing, as the millennium ended it did not seem likely that the "Tibet question" would soon find resolution.

The only hope may be some tectonic change in China's own political structure—if not the end of the Chinese Communist Party as the unilateral leader of China, then some shock to the system—perhaps economic—that might cause party leaders to realize that tradeoffs need to be made for China to survive in the increasingly interrelated and competitive world. The "Tibet card," if played by Beijing, would go a long way to repairing those aspects of China's image in the world that still cause it to be viewed as a quasi-pariah.

Moreover, if and when China becomes ready to play this card, it could hope for no more reasonable partner than the Dalai Lama. If China chooses to wait until the Dalai Lama passes from the scene, no one can foretell how much deeper will be the descent into tragedy of this struggle—in which Western fantasies of Tibet as utopia meet China's fantasies of it as a bastion of feudal oppression to be liberated. Alas, both of these versions of Tibet ignore most of the realities of the actual (as opposed to virtual) Tibet and Tibetans. ■

178–179: Raphaele Demandre, 1996. Two monks on top of the mountain sacred to the bodhisattva, Samantabhadra, near the ancient border of Tibet and China.

180–181: Jeffrey Aaronson, Lhasa, 1988. On the roof of the Jokhang Temple, a monk protests the Chinese occupation of Tibet. As if handcuffed, his hands express what it is to be a prisoner in his own country. To avoid identification and arrest, he covers his face while being photographed.

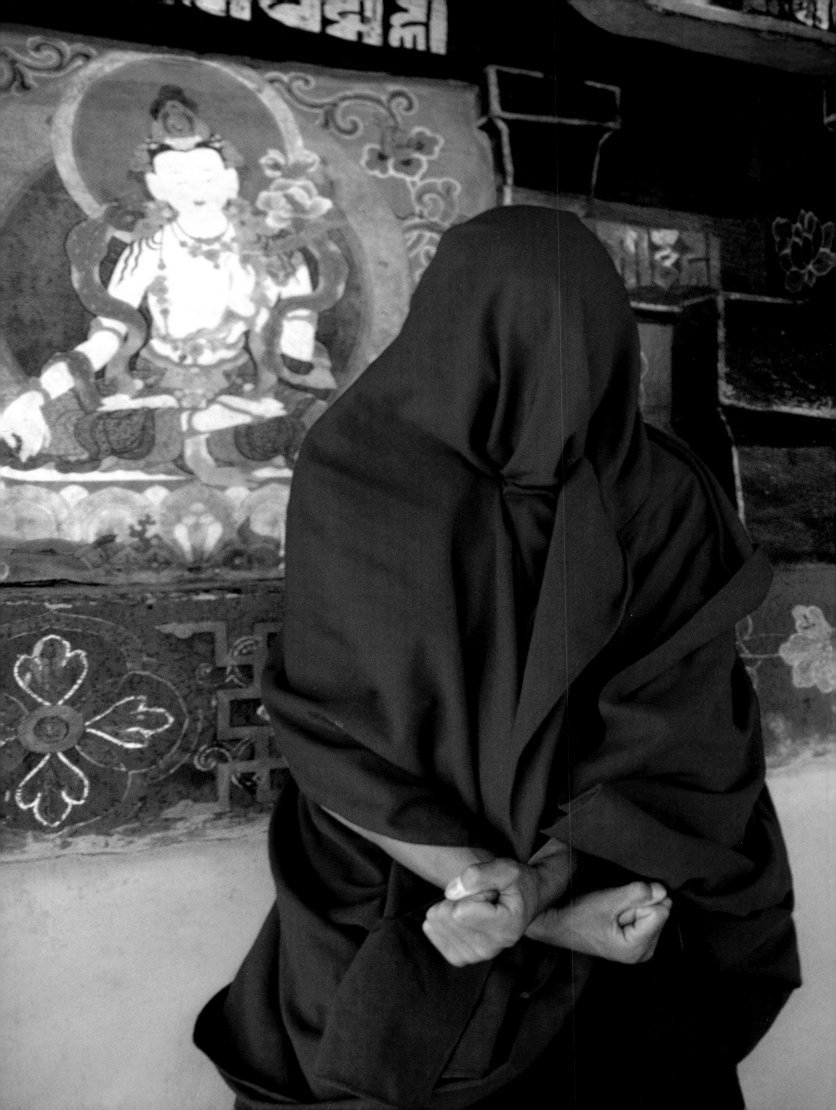

APPENDIX

Editors' Note: The following is a list of Tibetan and Chinese names and terms as they appear on pages 112–141. For the sake of accuracy, this list includes the standardized transliteration of Tibetan terms and names as well as both the standardized Pinyan romanization and the character forms for the Chinese names and terms.

Reference	Tibetan	Chinese	Reference	Tibetan	Chinese
Alak Shardong Rinpoche	A-lag Shar-gdong rin-po-che		Maba	Smad-pa	maba 麻巴
babchu	rbab-chu		Menba Dorje	Sman-pa Rdo-je	
Bayan	Ba-yan	Hualong 化隆	Namlo Yak	Gnam-lo yag	
Chabcha	Chab-cha	Gonghe 共和	*neibu*		*neibu* 内部
Chadrel Rinpoche	Bya-bral rin-po-che		Ngawang Choephel	Ngag-dnag chos-'phel	
Chentsa	Gcan-tsha	Jianca 尖扎	Nyelam	Gnya'-lam	Neilamu 聂拉木
Delinkha	Gter-lin-kha	Delingha 化隆	Nyingma	Rnying-ma	
Dhondup Gyal	Don-grub rgyal		Palden	Dpal-ldan	
Dorje Tso	Rdo-rje mtsho		Pema Thang	Padma Thang	
Dram	'Gram	Zhang-mu 樟木	Ping'an	Tsong-kha-mkhar	Ping'an 平安
fu		*fu* 副	Qi Yude		Qi Yude 祈玉德
Gendun Choekyi Nyima	Dge-'dun chos kyi nyi-ma		Repkong	Reb-gong	Tongren 同仁
Gendun Gyaltsen	Dge-'dun rgyal-mtshan		Rigdrol	Rig-grol	
Geutang	Sge'u-stang		Rinchen Dorje	Rin-chen rdo-rje	
Golmud	Gor-mo	Ge'ermu 格尔木	Rongpo	Rong-po	
Haibei	Mtsho-byang	Haibei 海北	*ruming*	*rus-ming*	
Haidong	Mtsho-shar	Haidong 海东	Saga	Sa-dga'	Saga 萨嘎
Hainan	Mtsho-lho	Hainan 海南	Sakor	Sa-skor	
Haixi		Haixi 海西	Sakya	Sa-skya	
Henan	Yul-rgan	Henan 河南	Samdrup Tsering	Bsam-grub tshe-ring	
Hualong		Hualong 化隆	Seitru	Se-khru'u/khru'u bzhi-pa	Sichu 四处
Huangnan	Rma-lho	Huangnan 黄南	Shawo Dondrup	Sha-bo don-'grub	
Huzhu		Huzhu 互助	Shigatse	Gzhis-ka-rtse	
Jamyang	'Jam-dbyangs		Sonam Tashi	Bsod-nams bkra-shis	
Jamyang Dargye	'Jam-dbyangs dar-rgyal		Taktsang	Stag-tshang	
Jamyang Lodro	'Jam-dbyangs blo-gros		Tashilhunpo	Bkra-shis lhun-po	
Jokhang	Jo-khang		Tenzin Nyima	Bstan-'dzin nyi-ma	
Kangtsa	Rkang-tsha		Tianjun	Them-chen	Tianjun 天峻
Khampa	Khams-pa		Tianzhu	Dpa'-ris	Tianzhu 天祝
Kyirong	Skyid-grong	Jilong 吉隆	Tingri	Ding-ri	Dingri 定日
lagya	*la-rgya*		Tsanmo	Btsan-mo	Zhamao 扎毛
Lama Kyap	Bla-ma skyabs		Tsegon Gyal	Tshe-mgon rgyal	
Ledu		Ledu 乐都	Tsering Gochen	Tshe-ring mgo-chen	
Lhasa	Lha-sa		Tsigorthang	Rtsi-gor-thang	Xinghai 兴海
Lhartse	Lha-rtse	Lhartse 拉孜	Tsongkhakhar	Tsong-kha-mkhar	Ping'an 平安
Lobsang Tenzin	Blo-bzang bstan-'dzin		Wuwei	Wu'u-we	Wuwei 武威
Lobsang Lungtok	Blo-bzang rgya-mtsho		Xining	Zi-ling	Xining 西宁
Lobsang Gyatso	Blo-bzang rgya-mtsho		Xinghai	Rtsi-gor-thang	Xinghai 兴海
Lodroe	Blo-gros		Yulgan	Yul-rgan	Henan 河南
Lukhar Jam	Klu-mkhar byams		Zhamao	Btsan-mo	Zhamao 扎毛

APERTURE GRATEFULLY ACKNOWLEDGES
THE GENEROUS SUPPORT OF

GERE FOUNDATION

ADDITIONAL SUPPORT WAS GENEROUSLY PROVIDED BY
DIANA AND JONATHAN ROSE

Aperture also wishes to express its profound thanks to Sidney Jones and Mickey Spiegel of Human Rights Watch for their commitment to this project, and extraordinary collaboration.

Human Rights Watch is indebted to many organizations and individuals for help in creating *Tibet Since 1950: Silence, Prison, or Exile*. We are especially grateful to all those in the Tibetan exile community in Dharamsala, most of whom must remain anonymous, who gave so generously of themselves. Many long-time residents and many new arrivals shared their stories with us. We wish it had been possible to share many more with you. Others who cannot be named helped with translation, with documentation, and with facilitating access to those who had been living in areas outside the Tibet Autonomous Region. We also wish to thank the many officials and administrators in Dharamsala who contributed their hospitality and help. We appreciate the support and assistance of Jamyang Norbu, director of the Amnye Machen Institute and his staff, one of whom, Christophe Besuchet, generously contributed his map-making skills to this publication.

Tibet Since 1950: Silence, Prison, or Exile would not have been possible without the support of two organizations. We are most grateful to Gere Foundation which provided essential funding, and to the Tibet Information Network of London whose extraordinary generosity in sharing resources and information was equally essential.

Two individuals, scholars both, shared their exceptional knowledge of Tibet. Elliot Sperling, Professor of Tibetan Studies at Indiana University not only contributed his knowledge of Tibetan history and politics to the project, but was an invaluable interviewing partner. Robbie Barnett, a research scholar at Columbia University, whose knowledge of conditions in Tibet today is second to none, made too many contributions to name, not least of which was the idea from which this book grew.

CREDITS

Unless otherwise noted, all photographs are courtesy of and copyright by the photographer, all rights reserved. Pages 2–3, 4–5, 6–7, 10–11, 20–21, and 77 bottom CORBIS/Bettmann ©; pp. 8–9 courtesy of AP/Wide World Photos; pp. 12-13 courtesy of Tibet Images; pp. 14–15 courtesy of Tibet Images/Illustrated London News; pp. 18–19 courtesy of Tibet Images/Department of Information and International Relations of Tibetan Government in Exile; pp. 26–27, 39, 64–65, 66–67, 70–71, and 72–73 photographs by John Ackerly, courtesy of International Campaign for Tibet; pp. 40–41, 42–43, 58–59, 62, and 63 courtesy of Tibet Images/Tibet Information Network; pp. 44–45, 46–47, and 48–49 courtesy of Agence France-Presse; pp. 52–53 and 77 bottom, CORBIS/ Reuters ©; pp. 54 and 68–69 photographs by Guy Dinmore, CORBIS/Reuters ©; pp. 60–61 courtesy of Reuters/Archive Photos; pp. 74–75 photograph by Stuart Franklin, courtesy of Magnum Photos; p. 76 top and bottom, and p. 77 top, photographs by Catherine Henriette, courtesy of Agence France-Presse; pp. 78–79 photograph by Michael Springer, courtesy of Liaison Agency; pp. 82–83, 86–87, 94–95, 98–99, and 180–181 photographs by Jeffrey Aaronson, courtesy of Network Aspen; pp. 102–103 photograph by Alberto Giuliani, courtesy of Grazia Neri; pp. 104–105 photograph by Carl de Keyzer, courtesy of Magnum Photos; pp. 108–109 photograph by Franz Stich, courtesy of Süddeutscher Verlag Bilderdienst; pp. 142–143 photographs by Richard Gere, courtesy of Fahey/Klein Gallery, Inc.; p. 160 photograph by Ian Cumming, courtesy of Tibet Images; p. 161 photograph by Diane Barker, courtesy of Tibet Images; p. 170–171 photograph by Galen Rowell, courtesy of Mountain Light Photography (www.mountainlight.com); map on endpapers by Christophe Besuchet, Amnye Machen Institute.

Library of Congress Catalog Card Number: 99-69002
Hardcover ISBN: 0-89381-794-5

EDITED BY MELISSA HARRIS AND SIDNEY JONES
DESIGN BY MICHELLE M. DUNN
JACKET DESIGN BY JOHN KLOTNIA

Printed and bound in Singapore.

The Staff at Aperture for *Tibet Since 1950: Silence, Prison, or Exile* is:
Michael E. Hoffman, *Executive Director*
Michael L. Sand, *Executive Editor*
Stevan A. Baron, *V.P., Production*
Lisa Farmer, *Production Director*
Nell Farrell, *Assistant Editor*
Phyllis Thompson Reid, Diana C. Stoll, *Copy Editors*
Lesley A. Martin, *Managing Editor*
Sara Federlein, *Development Manager*
Rebecca Wolsky, Tamara McCaw, *Editorial Work-Scholars*
Bruce Hager, *Design Work-Scholar*
Christopher Fondulas, *Production Work-Scholar*

Aperture Foundation publishes a periodical, books, and portfolios of fine photography and presents exhibitions—all to communicate with serious photographers and creative people everywhere. A complete catalog is available upon request.

Aperture Book Center and Customer Service:
P.O. Box M, Millerton, New York 12546.
Phone: (518) 789-9003. Fax: (518) 789-3394.
Toll-free: (800) 929-2323.
E-mail: customerservice@aperture.org

Aperture Foundation, including bookstore and Burden Gallery: 20 East 23rd Street, New York, New York 10010.
Phone: 505-5555, ext. 300. Fax: (212) 979-7759.
E-mail: info@aperture.org

Visit Aperture's website: http://www.aperture.org

Aperture Foundation books are distributed internationally through:
CANADA: General/Irwin Publishing Co., Ltd., 325 Humber College Blvd., Etobicoke, Ontario, M9W 7C3, Fax: (416) 213-1917.
UNITED KINGDOM, SCANDINAVIA, AND CONTINENTAL EUROPE: Robert Hale, Ltd., Clerkenwell House, 45-47 Clerkenwell Green, London, United Kingdom, EC1R OHT. Fax: (44) 171-490-4958.
NETHERLANDS, BELGIUM, LUXEMBOURG: Nilsson & Lamm, BV, Pampuslaan 212-214, P.O. Box 195, 1382 JS Weesp. Fax: (31) 29-441-5054. AUSTRALIA: Tower Books Pty. Ltd., Unit 9/19 Rodborough Road, Frenchs Forest, Sydney, New South Wales, Australia. Fax: (61) 2-9975-5599.
NEW ZEALAND: Southern Publishers Group, 22 Burleigh Street, Grafton, Auckland, New Zealand. Fax: (64) 9-309-6170. INDIA: TBI Publishers, 46, Housing Project, South Extension Part-I, New Delhi 110049, India. Fax: (91) 11-461-0576.

To subscribe to the periodical *Aperture* in the U.S.A. write Aperture, P.O. Box 3000, Denville, New Jersey 07834. Toll-free: (800) 783-4903. One year: $40.00. Two years: $66.00.

For international magazine subscription orders to the periodical *Aperture*, contact Aperture International Subscription Service, P.O. Box 14, Harold Hill, Romford, RM3 8EQ, United Kingdom. One year: $50.00. Price subject to change. Fax: (44) 1-708-372-046.

FIRST EDITION
10 9 8 7 6 5 4 3 2 1

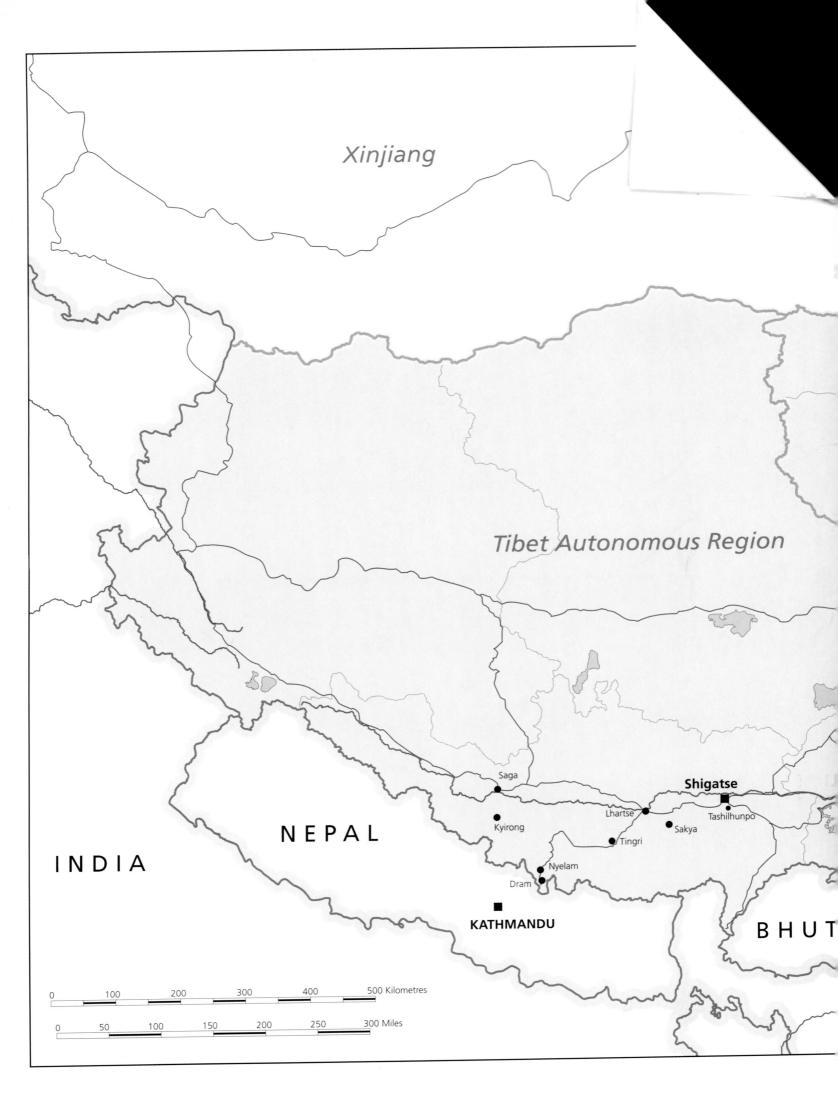

Xinjiang

Tibet Autonomous Region

Saga

Shigatse

Lhartse

Tashilhunpo

Kyirong

NEPAL

Sakya

Tingri

Nyelam

INDIA

Dram

KATHMANDU

BHUT

0 100 200 300 400 500 Kilometres

0 50 100 150 200 250 300 Miles